*Jean Pi[...]*

# *Mr Dick*
## *or*
# *The Tenth Book*

Translated by Christine Donougher

Dedalus

Dedalus has received support for this book from the French Ministry of Foreign Affairs, as part of the Burgess programme, run by the Cultural Department of the French Embassy in London, the French Ministry of Culture in Paris and the Grants for the Arts programme of Arts Council England in Cambridge.

Liberté • Égalité • Fraternité
**RÉPUBLIQUE FRANÇAISE**

Published in the UK by Dedalus Ltd,
24–26 St Judith's Lane, Sawtry, Cambs, PE28 5XE
email: info@dedalusbooks.com
www.dedalusbooks.com

ISBN 978 1 903517 68 0

Dedalus is distributed in the USA by SCB Distributors,
15608 South New Century Drive, Gardena, California 90248
email: info@scbdistributors.com    web: www.scbdistributors.com

Dedalus is distributed in Australia by Peribo Pty Ltd.
58 Beaumont Road, Mount Kuring-gai N.S.W. 2080
email: info@peribo.com.au

Dedalus is distributed in Canada by Disticor Direct-Book Division
695, Westney Road South, Suite 14, Ajax, Ontario, LI6 6M9
email: ndalton@disticor.com    web: www.disticordirect.com

First published in France 2004
First published by Dedalus in 2008

*Monsieur Dick ou le dixième livre copyright* © *Editions Gallimard, Paris 2004*
Translation copyright © Christine Donougher 2008

The right of Jean Pierre Ohl to be identified as the author of this work and Christine Donougher to be identified as the translator of this work have been asserted by them in accordance with the Copyright, Designs and Patent Acts, 1988.

Printed in Finland by WS Bookwell
Typeset by RefineCatch Limited, Bungay, Suffolk

A C.I.P listing for this book is available on request.

## THE AUTHOR

Jean-Pierre Ohl is a bookseller at Talence near Bordeaux. *Mr Dick or The Tenth Book* is his first novel. In France, it won three literary prizes: Bourse Thyde Monnier 2004, The Prix Michel Dard 2005 and The Prix Emmanuel Robles 2005.

## THE TRANSLATOR

Christine Donougher read English and French at Cambridge and after a career in publishing is now a freelance translator and editor.

Her translation of *The Book of Nights* by Sylvie Germain won the 1992 Scott Moncrieff Translation Prize.

Christine Donougher's translations from French for Dedalus are: 7 novels by Sylvie Germain, *The Book of Nights, Night of Amber, Days of Anger, The Book of Tobias, Invitation to a Journey, The Song of False Lovers* and *Magnus, Enigma* by Rezvani, *The Experience of the Night* by Marcel Béalu, *Le Calvaire* by Octave Mirbeau, *Tales from the Saragossa Manuscript* by Jan Potocki and *The Land of Darkness* by Daniel Arsand.

Her translations from Italian for Dedalus are *Senso (and other stories), Sparrow and Temptation (and other stories)*.

To Véronique

With thanks to Ezéquiel

I[. . .] have a very curious and new idea for my new story. Not a communicable idea (or the interest of the book would be gone), but a very strong one, though difficult to work.

Charles Dickens
In a letter to John Forster, 6 August 1869,
quoted in John Forster's *The Life of Charles Dickens*

If someone offers you a lovely bit of your childhood spread on a piece of bread, cry, 'Yes, childhood! Bravo! You at last: it's been so long!' But be no less wary of such of a dubious character.

Michel Ohl, *Sacripants!*

Mr Dick remained silent. He turned on his heels without a backward glance at me or his victim. I saw him leave the Swiss chalet, disappear into the underpass, then reappear on the other side of the Rochester road. Then the darkness swallowed him up. But roughly every ten seconds, it spat him out again, thanks to a flash of lightning illuminating the vast lawn and photographing his ever more distant figure caught in the same posture: that of a man in a hurry, walking with his elbows close to his body. Thus deceptively still, as in a game of Granny's Footsteps, he crossed the park towards the Victorian pile of Gad's Hill Place, and true to pyrotechnical form came a last flash of lightning by way of crowning finale, when I thought I saw him look back before disappearing, this time for good.

Then quietness returned – the quietness of a library. The storm has passed. The books, all identical, are still stacked high on the desk: *The Mystery of Edwin Drood Revealed* by Michel Mangematin. Fifty review copies to be sent out, divided into four piles: those neat piles that represent the arrogance of the major publishers and major booksellers, and that Krook has taught me to hate.

I lift Michel's hand and read the dedication broken off just as I entered the chalet: *To my friend and colleague Jean Preignac*, in recognition of my etern . . . That unfinished 'eternal' forces a smile out of me.

Then I turn the book over:

*The past century has seen the publication of some seven hundred thousand pages of commentary on the work of Charles Dickens – the equivalent of ten hectares of forest. And not for anything in the world would I have wished to be responsible for the death of the tiniest sapling. No, I should never have dared to add my obscure name to those of G.K. Chesterton, T.S. Eliot, Anatole France, Gide, Zweig, Maurois, Orwell, Nabokov, Sylvère Monod,*

*had I not been compelled by the overriding necessity to communicate an important discovery to as large a public as possible. Regard me if you will as a humble maths teacher who by an extraordinary stroke of luck has solved a problem the key to which has eluded his illustrious fellows at Princeton and Harvard. For it is the ambition of these pages to elucidate one of the most unfathomable mysteries of modern literature. It will no doubt be said there is little personal merit in this . . .*

The conclusion is almost illegible, stained with blood. I could pick up another copy but there is no need. I know the rest by heart.

*. . . to which I can lay claim. Indeed, nothing would have been possible without Évariste Borel and his invaluable manuscript, the complete text of which is published here for the first time. This book is dedicated to his memory in the hope I may prove worthy of it.*

It was magnificent – Mr Dick's gesture, I mean. The competence with which he seized the bronze bust of Dickens, weighed the object in his hands, estimated the force of impact necessary to achieve his end without the least ferocity. Then Michel and Dickens: their faces approaching each other as if they were about to embrace. Michel, still laughing, looking towards the image of the writer to whom he had devoted his life, the writer who a moment later was to put an end to that life through the intermediary of his metallic replica. The dull thud. And the calm, the ineffable calm of Mr Dick putting the paperweight back exactly where it belonged on the blood-covered table.

Perhaps I should now begin my book. Tell of Bobo the clown, Sitting-Pretty, Waterloo, the round bed and all the rest . . . But what's the point? To be published, stacked up in piles. Like bricks. Bricks of a wall I have been banging my head against forever.

I shall never become the hero of my own life.

# I

# Journal of Évariste Borel

## (Introduction and notes by Michel Mangematin)

Shortly before his death Charles Dickens went through a period of literary self-doubt. His latest novel, *Our Mutual Friend*, had met with a cold critical reception: even the general public shunned this vast fresco, its sprawling plot with conventional twists. At the same time Dickens's friend Wilkie Collins was enjoying unprecedented success with *The Moonstone*, a skilfully crafted suspense story regarded today as the forerunner of the modern detective novel. Cut to the quick by hostile reviews, jealous of his disciple's triumph, Dickens in undertaking *The Mystery of Edwin Drood* wanted to prove he was capable of adapting to modern taste and of penning a spare and tightly-constructed story to keep a new generation of readers spellbound.

When Évariste Borel arrived in England at the end of May 1870, Dickens had written more than half the novel, the first chapters of which had already appeared at monthly intervals in the weekly journal *All the Year Round*. The tone is very different from that of *Our Mutual Friend*: less baroque, with no digressions, or not many. The plot is concentrated on a handful of main characters – some ten or twelve, which is astonishingly few for a Dickens' novel – including the enigmatic Jasper, respectable choirmaster and yet opium addict, of whom we shall have more to say later. It is doubtless at the cost of a tremendous self-discipline that Dickens achieved this result so different from his usual style. During his periods of intense literary activity he would grant himself occasional brief interludes of recreation. This might explain the invitation to Gad's Hill Place extended to the young Frenchman.

The text that Borel submitted to the editor of *La Revue des Deux Mondes* immediately on his return is, alas, lost. But the text we now place before the reader may legitimately be regarded as the draft, or source. It

is in fact a private journal. The manuscript comes in the form of an ordinary school notebook from which the first three pages as well as the twelfth page have been torn out. This detail, in addition to the numerous deletions throughout the text, suggest that Borel carefully reread his journal in order to remove passages of a personal nature before copying out the rest with a view to publication.

It seemed to us important to reinstate insofar as it was possible the original version of this journal. On the one hand the deleted passages, fortunately legible in the main, confirm beyond doubt the provenance and authenticity of the manuscript. On the other hand, they provide some information about the author's personality and the contemporary literary world that may be useful to the researcher. In our edition these passages are indicated by square brackets.

I wrote to him yesterday. What's the use of waiting to see if he comes to London? He may well have moved to Kent for the summer. I shan't be able to extend my stay in England indefinitely [especially as there is no sign of the money order Father promised].

God, what those lines cost me! How in so few sentences to give any idea of my enthusiasm without descending to toadying? How to distinguish myself from the dozens of other novice writers who probably appeal to him all year round? [I used Aurore's letter of introduction without any qualms. After our argument at Easter she very likely won't ever invite me to Nohant again but who cares! I've put up for too long with her lessons in how to behave and her patronizing ways . . . I should at least get something out of it!

Dumarçay, that insufferable dandy I met at Dover, rang at my door this morning. A person like that needs an audience: he can't exist without the attention of others. In any event, he invited me to lunch.]

All I can do now is wait . . . wait, and endure the onslaught of these bizarre dreams that torment me every night. If only they were nightmares, they would probably wake me up. But no: when I call them to mind in the morning, they seem insignificant in content, unexceptional in form. No macabre feature, no disturbing symbol, no phantasmagoric detail to explain their ascendancy over me. It is in their very banality that their power seems to reside.

The most recurrent is that of the man at the window. Seated at a table, he has his back to me. A mountainous land-scape lies beyond. Even though at no time do I see his face, I am absolutely certain, on the strength of that paradoxical knowledge to which we pretend in our dreams, that he is a stranger to me. I don't know what he is doing. I don't know why I am with him in that room. And yet I remain there, watching him for what seems like hours. Some bond exists between him and me that no human expression can describe, a bond that even my awakening is incapable of dissolving.

2 June

[My meagre savings are disappearing like snow melting in the sun. I subsist on pies for a shilling apiece, and practically dare not quit my bed any more, knowing myself to be at mercy of those untimely spells of dizziness that have overwhelmed me more and more frequently in recent months, even when I eat my fill.

How could he have forgotten? For all I care, let him go round courting all the silly girls in the neighbourhood while Mother's 'still fresh in her grave', as might be said in a play by Eugène Scribe. Ridicule will avenge us . . . But he should at least keep his promises! I can see perfectly well it is only out of politeness that Mr Stone at Barclay's believes this story of the money order gone astray. In the meantime, here I am, desti-tute, in the most expensive city in the world, and in order to survive obliged to put up with the condescension and whims of my 'friend' Dumarçay.

Yesterday evening he was in excellent humour, for he had just met a 'very interesting' young girl by the name of Lilian Conan Doyle at the London Museum. To celebrate the event] he took it into his head to introduce me to a penny gaff (what in Paris would be called *un beuglant*), and dragged me off to a bizarre part of town, halfway between the City and the poverty-stricken areas of the East End where revellers of

14

every class mingle together. I agreed to go with him: I was famished.

On pushing open the door of the establishment we came straight into a room no doubt quite spacious but seemingly small, so crowded was it. The density of smoke, the smell of alcohol were suffocating. By great good fortune an obsequious individual with a cloth over his shoulder noticed our arrival at once and led us with much bowing and scraping to a kind of mezzanine gallery that ran round the room. Here apparently were the tables at which 'gentlemen' were usually seated. From this observation post we looked down on a very noisy motley crowd massed in front of a stage. At every moment a circular vessel cut through this heaving ocean of hats and caps: it was the tray of pints of beer borne aloft by the waiter sheltering beneath his load. People drank standing up, looking toward the as yet empty stage behind a closed curtain that several times fluttered, on each occasion prompting shouts and applause.

We ordered two beers. For the exorbitant price we were charged, no doubt the entire rabble on the lower floor could have been supplied with drink for a considerable part of the evening.

[That imbecile Dumarçay found new cause for pride in this: 'He realized who he was dealing with,' he said, stroking his silk shirt and expensive waistcoat.]

At the next table a little man in an old-fashioned frock-coat was finishing his meal. With Dumarçay blocking my view I could not see his face but for a while I enjoyed observing his precise, meticulous gestures; the way he put down his knife and fork with exquisite neatness after every mouthful of meat, and the way he wiped from his lips the tiniest drop of sauce or wine. There was a very strange calmness about this ritual, totally out of place in this world devoted to noise, commotion and excitement. When he had finished, having wiped his plate clean with a piece of bread, the little man laid his knife and

fork on it, the one crossed over the other, drained his glass, wiped his mouth one last time, and fastidiously folded his napkin. He finally stood up and our eyes met.

Was it the poor lighting, or the smoke from the floor below enveloping us as though in a mist? The impression I was left with was extraordinary: I thought at first his round face was completely devoid of any features, and it took me several seconds to discern in the middle of a kind of blur an atrophied semblance of a nose of almost no prominence, two round eyes with no eye sockets, a mouth so thin it just looked like a line. I immediately thought of those abandoned sketches you find in portfolios: a little rubbing out with an eraser and his face might have been reduced to the whiteness of a blank page.

He bowed politely and I returned his greeting. Then, picking up a big shapeless bag that he must have been holding between his legs throughout his meal, he descended into the crowd and disappeared from my sight.

The crowd had for some minutes been showing boisterous signs of impatience when the thick red curtain of dubious cleanliness finally opened in earnest. A man of powerful build, wearing a tail-coat too tight in the shoulders, appeared on stage, pompously greeted the audience and immediately launched into the famous aria from *The Barber of Seville* with the sole accompaniment of the trilling notes from an out-of-tune upright piano. He took great pains to roll his rs in imitation of the great Italian tenors but, like the straw sticking out of the scarecrow's sleeves, his appalling Cockney accent manifested itself in every '*barbière*'. Leaving aside this comic detail, I should be hard pressed to comment on his performance, which was rapidly drowned in a deafening hubbub. Besides, it soon became clear the performance resided not in his vocal talents but in his almost superhuman capacity to serve unflinchingly as the target for a countless number of missiles of every kind – paper pellets, cigar butts, rotten fruit – with which the public seemed to have stocked up for the

occasion. Every hit was marked with a triumphant hurray. And when after a final flourish the tenor placed his hand on his stain-besmirched chest, bowed and backed off the stage, an immense uproar accompanied his departure.

Without a break, the pianist went straight into the first bars of a popular song, and the lights dimmed as a woman in a short shirt came on. The uproar immediately turned into a murmur of approval and, taking advantage of the relative calm, the chanteuse started to sing the refrain of 'Goodbye, Little Yellow Bird'. In the shadowy half-light she simpered in a juvenile voice, twirling the flounces of her skirt as ribald remarks flew:

'Hey, little birdie, you know I've got one too?'

'Come over here, and let me pluck you!'

'Wouldn't you like to come and sit on my branch!'

Alas, growing bolder, she stepped forward and appeared fully illuminated. To the great disappointment of the audience, the little bird was revealed to be a matron well past forty. Her make-up had trickled down her cheeks and you could see the fat milky flesh of her calves gleaming like gelatine beneath her bunched-up skirts. It would have taken a gigantic cage to contain this pitiful sparrow, weighing one hundred and forty pounds at least.

She never got as far as the second verse: a regular bombardment turned her dress into an ashtray, litter bin, and receptacle for tomato juice. I think I even saw a comb and a boot flying in her direction. The 'artiste' was saved only by the intervention of the manager of the establishment who rushed on to the stage and escorted her into the wings under the protection of a blanket.

Unable to tolerate any more of this, I grabbed Dumarçay by the sleeve and started dragging him towards the exit. We were already downstairs when the manager reappeared on stage.

'Now then, ladies and gentlemen, quieten down, if you

17

please!' he said, shouting to be heard above the laughter. 'Here, without further delay, is our main attraction, Mr Dick!'

And he went off, soon followed by the pianist. A few moments later a man came out on to the middle of the stage and put his bag down. To my great amazement, I recognized the fastidious little chap who had been dining next to us.

['Poor bugger!' scoffed Dumarçay, his appetite whetted by the humiliation of the tenor and of the little bird. 'They're going to tear him to shreds . . .']

I could not drag him any further. Stuck right in the middle of the crowd, there was not one word of the sarcastic comments directed at the little man that he did not catch. An outrageously made-up woman shouted out, 'Come on, old man, get on with it, or are you going to keep us waiting till tomorrow?' And, laughing, the fellow standing next to her added, 'Leave him alone! Can't you see he's laying an egg?'

Mr Dick remained almost perfectly still. A faint smile played on his lips. He observed the public with a vacant gaze as though he himself were a spectator patiently waiting for the show to begin. Two or three times he raised his hand to his mouth and coughed discreetly.

Then something peculiar happened. Instead of reaching a crescendo the insults and quips died down. Gradually the crowd fell quiet. The laughter died in people's throats. On all these faces, twisted in grimaces of derision only seconds before, the same single expression appeared, a mixture of expectation and curiosity. It was an extraordinary thing to see them looking towards the stage in this way, so varied, so different from each other, and yet transfixed in the same pantomime attitude of hopefulness. Incongruous and intimidating, a deathly hush prevailed.

Mr Dick cleared his throat one last time and waited a full minute to make sure he had unquestionably won the crowd's attention. Then he retreated a few steps out of the glare of the footlights, turned his back on us and rummaged in his bag.

When he came to the front of the stage again he was a different man.

Dressed in a '30s-style frock-coat, he looked even smaller. A too tightly fitting waistcoat gave prominence to his respectable paunch – a paunch he had been totally lacking a few moments before. An enormous fob watch dangled on his chest, a telescope stuck out of his inside pocket, and a monocle was fitted to his left eye. But these changes of detail were nothing in comparison to the complete metamorphosis his face had undergone. Where latterly there had been just a white blob – that blur I mentioned – a physiognomy could now be discerned as if, thinking better of it, the draughtsman had retrieved the sketch from his portfolio and finally given his character all the attributes of a human being: a mouth still thin certainly but clearly delineated, giving an impression of great gentleness; the full cheeks of a bon viveur; and with a gentleness too in his almost child-like gaze whose candour was tempered by a glint of mischievousness.

I recognized him immediately, and I was not the only one. Before he had even opened his mouth there was a stir of excitement among the crowd. Through murmurs and whispers, a name spread round the room.

'Pickwick! It's Pickwick!'

Mr Dick obtained silence with a mere cough. Then in a melodious voice he addressed an imaginary interlocutor.

'Sam, are you sure this is the Eatanswill coach?'

Again Mr Dick went through the same routine: a few steps back, a few rapid gestures in the direction of his bag and . . . another metamorphosis! Ramrod straight, with good deportment, he looked almost tall and slender. He wore polished boots, gaiters, striped livery and a funny leather hat pulled down over his left ear. All around us people nudged each other with their elbows, exchanging knowing winks. Meanwhile, Mr Dick returned to the spot occupied a moment before by 'Pickwick'.

'Cert'nly, sir!' His voice was strong now, and bantering, with a strong Cockney accent. 'As sure as my mother was when she said, giving birth to me, "Ere's my son!" '

From the very first words there were bursts of laughter from all sides, and when he had finished speaking the cheers and applause made the whole building shake.

'Hurray! Long live Sam Weller!'

The men threw their hats in the air, the women clapped, and everyone clamoured for more with rhythmic insistence: 'Give us another! Give us another!' As for Dumarçay, his expression of astonishment was a comic sight.

'But what in the devil's name's going on here?' he shouted over the din.

'It's a Dickens impersonator!' I replied, laughing.

'A what?'

'A Dickens impersonator! A man capable of imitating and playing the part of any character from Dickens's novels. You've just seen the famous Samuel Pickwick and his witty manservant Sam Weller . . . And now this genial fellow with a slightly red nose, busy mixing a punch, is none other than the penniless Wilkins Micawber, a great friend of David Copperfield!'

Dumarçay listened with incomprehension. Looking round, baffled, he met the gaze of seamstresses and whores, of cabmen and errand boys, shop assistants, chimney-sweeps, linen maids, and out-of-work actors, of a party of young toffs who had come here for a bit of low life, and even one or two policemen. Exhilarated by alcohol and spellbound by Mr Dick's talent, all these men and women were brought together – rich and poor, strong and weak, handsome and ugly – by a novelist without equal, and at that moment they were closer to true literature than all our fine critics at *Le Figaro*, *Le Temps* [or the *Revue des Deux Mondes*]!

'It's . . . it's incredible! So all these people have read Dickens?'

'Only those who are able to read. The others have gathered in the evening round a more educated friend or neighbour, and have simply listened. Every month they look forward to the publication of a new instalment. And in the meantime they talk to each other about the previous one . . . This evening, tomorrow, in Melbourne, Los Angeles, Toronto, hundreds of thousands of people will read or listen to a reading of Dickens . . . When the boat containing the last part of *The Old Curiosity Shop* arrived in New York there was a riot. Everyone was waiting on the quayside, wanting to find out whether or not Little Nell was going to die! Gangways collapsed under the weight of the crowd! Now, here's Mr Pocket, Pip's tutor in *Great Expectations* . . . Look, he's lifting himself up by his hair, as if trying to wrest himself from the ground!'

'This is beyond belief!'

[I felt a kind of hatred take root in me. Dumarçay embodied everything I loathed: pedantry, priggishness, stupidity.]

'But what is it that so shocks you? That all these common people should have access to the art you claim to serve? For you, literature is a social privilege, a symbol of belonging to a caste, equivalent to your luxury cigars, expensive clothes, splendid apparel. What can you possibly understand of the magic of a true novelist?'

I spoke heatedly, almost with despair, and too loudly. Our neighbours were beginning to turn round.

'No one in France could have captivated such a disparate crowd . . . Neither Balzac, nor even Hugo.' [No more than 'our dear Gustave', as Aurore called him . . . to say nothing of Aurore herself, with her prettified country scenes in which wooden clogs are like dancing pumps and dung is served in a silk handkerchief tied up with a ribbon!]

Meanwhile, the stage was plunged into darkness. Just one dim footlight continued to illuminate Mr Dick, once again rummaging in his bag.

'In Dickens they see an image of themselves with an extra

dimension, heightened in a way that makes them even more real . . . He recreates them, as it were . . . and that's something that hasn't been seen since Shakespeare.'

Some elbow-digging and exasperated hushing compelled me to be silent. Mr Dick had returned to the front of the stage, dressed this time in a black velveteen jacket. His hair stuck to his forehead, his eyes blinked rapidly. Lit from below, his face, yet again unrecognizable, bore the mark of madness: it was a hard face with clenched jaws and eyes full of fury.

'Ah, Nancy, you she-devil . . . you've betrayed me!

He was addressing a wicker mannequin, wearing a wig of long blonde hair, that he dragged along beside him. A horrified murmur ran through the crowd when he drew a pistol from his coat.

One spectator called out, 'No, Bill Sykes[1]! Don't do it!'

Mr Dick gazed at his weapon and seemed to waver for a moment. But he still held the mannequin by the throat, and his eyes glinted with rage.

'You're going to pay for this, Nancy!' he murmured.

He struck the mannequin on the head several times with his pistol. The figure groaned beneath the blows. The head came away from the body and fell to the ground. Several women screamed. Near by, someone fainted.

When the lights came up again, Mr Dick was restored to his normal appearance: that of an unobtrusive little man whose face was hard to recall. He coughed, bowed, picked up his bag, and was gone.

---

[1] A character in *Oliver Twist*. A brutal and unscrupulous criminal, he ends up murdering his partner, Nancy, whom he suspects of having betrayed him to the police.

# II

'My God . . . it's straight out of Dickens!'

*The Little Angels Hostel*: the rusted sign swung in the wind, creaking on its chains. The door had been blue in some distant past, like the half wrenched-off knocker in the shape of a hand stiffened with cold or in anguish. And seeing this façade covered with a thick layer of soot, of those grimy windows whose curtains looked like dead eyelids, it was easy to imagine the hand had been abandoned by a visitor in a hurry to escape.

'It'll soon be the holidays,' said my mother, as we walked along, 'I've some important things to do, and I have to park you somewhere in the meantime . . . It'll only be for a week or two.'

It was long past tea time. I was cold and hungry – my coat had been left behind with the biscuits on the table in the back of the shop – I didn't know what she meant by 'park', and I didn't know what a 'home' was.

The unfamiliar syllables – *Di*, a childish sound, followed by the frighteningly explosive *Cken*, and a kind of mocking, grotesque hiss, *Sss*, like air escaping from a burst balloon – rolled round inside my head and one by one dispelled the questions that a moment before had been crowding in on me. Soon, in the bowling alley of my mind, there was only one skittle left standing, an enormous question mark, intimidating certainly but full of promise. *Di-cken-sss* . . . straight out of Dickens . . . Maybe there was more to this Dickens. Maybe this Dickens wasn't a question but an answer. Maybe out of this Dickens would come something to sit on, something to eat, something that put an end to fear.

At that moment in the far distance a train whistled. It was carrying away my father.

23

On a steep lane contiguous to the disreputable neighbourhood of Méria-deck, our little shop selling ladies' lingerie belonged to my mother. My father spent most of his time in the appropriately named Café de la Détente[1], whose windows (though dirty, by good fortune located just opposite our own business premises) allowed him to watch out for the arrival of our most attractive customers. Only then would he abandon his game of cards, button up his collar, rush across the road, and come bursting through the shop door.

'Thank you, Catherine' (he only ever called my mother Catherine in these circumstances), 'I'll see to the lady.'

After school I would install myself in the back of the shop and on a big table littered with the packaging of stockings and panties and bras, I would silently marshal my tin soldiers.

For the quiet, solitary little boy I was in those days, reading might well have been the ideal pastime. Though there was practically not a single book in the house, my mother considered it her duty to take me to the local library every now and then – almost as often as she took me to the dentist, and roughly speaking in the same spirit of concern for my health. But I didn't like the place, which was gloomy and stuffy, or the woman behind the counter, like some kind of customs officer, busy with her con-demnatory stamp marking books to be discarded, or the earnestness of my mother, full of a sense of responsibility for her educative role, or above all the books to be found there. I rejected those improbable adven-tures, those crudely depicted 'exotic' settings behind which you could still sense the novelist's chintzy writing paper. What I needed was a book that recounted the adventures of François, son of Robert and Catherine Daumal, living in Bordeaux, at 23 Rue St-Sernin. A book that told me how to live. In the absence of which I contented myself with my soldiers, a big picture-book on Napoleon's battles that my father gave me for Christmas, and an old issue of *Sporting Mirror* dug out from the back of a cupboard: Wimbledon 1931, the incredible tournament! With William 'Big Bill' Tilden on the cover, holding his head in his hands after losing match point.

---

[1]    *détente* meaning relaxation.

The door through to the shop was always open and while playing I missed none of my father's effusiveness and his idiotic compliments ('Madame, I absolutely refuse to sell you this. At your age, with your figure, you need something more . . . more decorative, more sexy, if I may say so'), nor the marital spats that nearly always ensued.

'Sadly, darling, I can't help it . . . It's like . . . like being caught up in a hurricane!'

'A hurricane?' my mother would repeat in her shrill little voice.

'Yes, you know what I mean . . . something that carries you away against your will . . . that you can't resist?'

In support of this specious argument he would pretend to flap his wings like a fledging swept up by the wind – a spectacle all the more ludicrous for his weighing over eighty kilos, and having the arms of a wrestler and the neck of a bull.

Sometimes mother would cry a little but actually these were not dramatic scenes. The only serious row I remember was about something completely different, that at the time I did not understand at all. It was quite late one evening but I was not yet asleep. We were all in bed: I in my little room, they in theirs, behind the thin partition that separated us.

'Do you realize, Robert, he's never even laid eyes on her!'

'Just as well! And the best thing would be if he never heard of her!'

'But that's monstrous!'

'The fact is, she is a monster!'

'For goodness' sake, the whole village adores her!'

'Oh yeah? Well, you go to the cemetery and ask your father if he adored her! She killed him, slowly but surely!'

'It's true, she was sometimes a little . . . difficult with him . . . but it was because of her leg.'

'Her leg! Ha! Forgive me for laughing!' (My father was practically yelling.) 'Her leg's just fine! I suspect she pours a drop of poison on it now and again to keep the infection going and give everyone a hard time!'

I later fell asleep and dreamed there was a gigantic leg wandering round my bedroom.

Of all the different makes of undergarments sold in our shop, my favourite was 'Close to Your Heart'. The packaging – beautifully sturdy parallelepiped boxes – delighted me. They stacked wonderfully well, providing my soldiers with solid impregnable ramparts. 'Close to Your Heart' was a venerable old label, whose reputation was based more on quality of fabric and robustness of stitching than audacity of style. It catered to mature respectable women. If we had sold only this type of article, it is a safe bet that my father would never have left his table at the Café de la Détente, with the result that I might never have read Dickens.

But one day 'Close to Your Heart' became 'Intimately Close to Your Heart'. The bras became shapelier, the panties skimpier, suspenders appeared, lace triumphed. The browns, the 'prim and proper' beiges gave way to sexy whites and voluptuous blacks. The lovely little boxes were replaced with shapeless sachets among which my dragoons, uhlans and zouaves wandered forlorn, ruminating on plans of desertion. Eventually, Monsieur Grandjean, the company's long-serving sales rep, with his moustache, his rancid smell and his crumpled, dubiously stained raincoat, was succeeded by the luscious creature I never knew by any other name than Mademoiselle Coralie.

Mademoiselle Coralie wore very short skirts and very high heels; she was very short-sighted – stylishly corrected with invisible lenses – and had very long eyelashes. She invariably affected a disdainful and provocative Linda Darnell pout that prevented her from being able to speak normally. Had I, despite my young age, discerned the sensual promises of such labial roundedness, enhanced with a kind of passive voraciousness by the redness of her 'Intimately Close to Your Lips' lipstick? In any event, I looked forward to her every visit, and one day I even managed to position myself discreetly by the door.

'Good mwahning, Mwadame Dwu-mwol, how wah you?'

Before my mother even had time to reply there came the sound of hurried footsteps in the street. Red-faced and breathless, my father burst into the shop accompanied by the wolf-whistles of his fellow card-players crowded in the window of the Café de la Détente.

'That's all right, Catherine, I'll take over.'

'Mwonsieur Dwu-mwol.'

26

With a long-considered and knowingly hypocritical gesture Mademoiselle Coralie tugged on her mini-skirt to make it more decent. Since the fabric was elasticated, she achieved the opposite result. Then she opened her catalogue.

'Of course, it's very ... uh ... suggestive' (my father slowly turned the pages, his eyes popping out of his head), 'but ... um ... is it comfortable?'

'Absolutely! It's what I always wear.'

Robert Daumal gulped audibly. The fate of our family was sealed.

The next day we were let out of school a little early. Finding the shop door closed, I came through the yard behind the shop. In his feverish excitement my father had failed to lock the back door.

The first thing I saw on entering was the devastating sight of my soldiers scattered all over the floor. I cried out and immediately rushed forward to pick one of them up, my favourite, a flag-bearer of the Rhine army whose flag pole had not survived the fall. Only then did I raise my eyes to see my father and Mademoiselle Coralie. He was desperately trying to button up his trousers. She, with her back turned to me, was on all fours hunting for her knickers among the scattered packaging. That milky-white splendour, combined with the bizarre smell that permeated the room and the warm wetness my fingers chanced to encounter when they touched the edge of the table as I put the remains of my poor flag-bearer on it, triggered a reaction between my thighs, a phenomenon whose signficance was only revealed to me much later.

At that point Mademoiselle Coralie retrieved her knickers, hastily wriggled into them and, treading on a household guard and a cavalryman in the high heels she had been wearing all the while, she rushed out into the courtyard just as my mother turned up with her bag of shopping.

I can still see my father's thunderstruck expression as the trap clamped shut around him. Mademoiselle Coralie had led him into the ways of sin, my mother cut off the path of repentance.

'Get out of my house!'

'Catherine, I . . .'

'Get out of my house right now!'

She was transfigured by a kind of wild glee. As if she had been waiting

for this moment for ever. Crouched under the table, I tried in vain to block my ears. Later on, my father appeared, carrying a suitcase.

'Robert, you can't just go away like that! He's your son, you've got to talk to him!'

'And tell him what? That his mother's throwing me out?'

'You've got to!'

'I'm sorry, son . . . I . . . it's not my fault . . . it's . . . the hurricane, you understand?'

Robert Daumal flapped his wings one last time and the hurricane carried him out of my sight.

'That's that,' my mother said simply.

She had had her great theatrical moment. Now her career was behind her.

'Welcome to Little Angels! What's this young gentleman called?'

When the door opened we got a full blast of fetid fumes that smelt like the bad breath of someone with liver disease. The worm-eaten parquet was in danger of engulfing you, the strips of wallpaper that had come unstuck halfway up, flapped and licked at you like tongues.

'François,' said my mother nervously. 'His name's François.'

The nun bent closer to examine me. Her breath was as nauseating as that of the building. Then she stepped aside to reveal a half-open door with the inscription 'Games Room'. She placed both hands on my shoulders and told me to go in. I obeyed with as much enthusiasm as if she had asked me to go inside her mouth.

It was a narrow room but very long. To the left of the doorway, in a dusty corner, with a rickety bookshelf on one side and a wooden bench on the other, were half a dozen children who whispered to each other as I came in. They were ridiculously crowded together in relation to the generous proportions of the room. One of them stuck his tongue out at me. Another darted a fearful glance at me that I took as a warning. Only two fanlights illuminated the scene. I could vaguely see something moving at the far end of the room. The ground suddenly seemed to tip forward.

'Keep going, child, keep going, no one's going to eat you!'

I took a few steps, clutching my mother, balancing on tiptoe as if I were on the edge of a precipice. Two doors stood open in the wall on the right, 'Toilets' and 'Dining Hall', emitting very similar smells.

I had reached almost the centre of the room and I was slowly getting used to the gloom. In front of me I saw a little girl with a round milky-white face and strange hairstyle – her thick red hair parted into two symmetric masses, coiled and pinned above her ears with hair slides. She must have been my age but her furrowed brow made her look older. Around her lay ripped cushions, crying dolls, broken cars and trains. She was seriously engaged in pulling the limbs off a wooden puppet wearing a chequered pinafore on which was embroidered the legend: 'My name is Bobo the Clown!' Despite the slit across his face Bobo the Clown was obviously in no mood for laughter. He surrendered to those expert little hands, his neck broken, his head dropped forward on his chest.

'Her name's Mathilde,' said the nun fondly. 'In fact, Mathilde is look-ing for a new friend . . . You see, she's had a little quarrel with the others . . . but I'm sure you'll get on very well together. Isn't she a pretty little girl, our Mathilde?'

Yes, she was pretty, our Mathilde. Green eyes. A small, slightly turned-up nose. Round cheeks. She was done with Bobo the Clown, and stared at me without a word. I barely recognized my mother's voice, distorted with anxiety.

'Uh . . . yes, very pretty indeed.'

Certainly, very pretty. But actually there was something about her that jarred with 'pretty'. The more I observed Mathilde's pale face, green eyes, regular features, absorbed dumbshow, the more I admired her and the less I found her to be 'pretty' in the sense I had always attributed to that word. I felt the need of some other word as yet unknown to a child's vocabulary. It was like the uhlan my father had given me the year before: though less gleaming than my lansquenets, less fine than my household guards, I liked it without knowing why. I had not even come up with a name for him: sometimes I simply called him 'the Terrible'.

'Go on, my pets, give each other a kiss!'

Mathilde looked me in the eye. She took one step forward, then another, trampling over the remains of Bobo as she did so. She stretched

29

out her hand, grabbed hold of mine, and began to pull me towards her with incredible strength. I was still clinging to my mother with the other hand but the little girl pulled so hard I thought for a moment my mother would let go. And then terror overwhelmed me. For the first time since I had stopped wearing nappies I wet myself. With pitiless curiosity Mathilde followed the progress of the damp patch round the flies of my trousers, then down my thighs. Then no doubt regarding my urination as a homage, she gave a satisfied pout and stroked the palm of my hand. It was an unexpected, indefinable feeling: I had never been touched like that before, so lightly, so precisely. The pleasant confusion it brought made me forget my fear and shame. I in turn looked deep into Mathilde's eyes. I looked at her as I had never dared look at anyone else, not even Mademoiselle Coralie, and I was about to lean forward to kiss her when the nun intervened.

'My God! He's not toilet-trained! How dreadful! At his age!'

'I . . . I don't understand,' my mother stammered. 'I assure you, he's never done this before.'

Mathilde smiled. Stupidly I offered her the mirror of my own smile.

I was sitting opposite my mother. Pine trees flashed past the window, an infinite number of pine trees.

It was the first time I had ever been on a train, the first time I had ever seen a forest so dense, so never-ending. I told myself that such a thing could not exist. It was a stage set. Incredibly fast scene-shifters were constantly moving the same pine trees backwards and forwards, a hundred of them at most, judiciously distributed to create this illusion of an unlimited number . . . My mother at least seemed totally taken in by the subterfuge.

'My goodness, it's so beautiful, so relaxing! How on earth did I manage to stay away from this forest for so long! We'll soon be home now . . .'

'Home?' I said in amazement.

I found it difficult to accept that at the end of the railway line stood the familiar building on Rue St-Sernin with its carriage gateway, inside courtyard, and three damp rooms. Or was it conceivable this train was

travelling in a circle, like the electric miniature models in the windows of toy shops? But no, the sun had not shifted since we left: still in the west.

'I mean, my home . . . at your grandmother's.'

This 'my home' upset me enormously, not to mention this grandmother I had never heard mentioned before, who was landed on me at just the worst moment. I adopted an obstinate expression and said, without looking at her, 'I prefer our own home.'

'We can't go back there. Someone else has rented it.'

She had found a buyer for the business in less than a week. All she had to do was cross the road and go through the door of the Café de la Détente. One of my father's card-playing companions was an estate agent, another a lawyer, and the third, a dry cleaner, was looking for premises to start a laundrette. I later found out the proceeds of the transaction had barely sufficed to cover the outstanding bills and pay the furniture removers. We were probably left with no more than five thousand francs but the speediness with which the sale went through and the way it turned up so conveniently had elated my mother, and this smug optimism so ill suited her that I felt ashamed of it, a little as if she had abandoned her sensible suits and beige raincoat and donned Mademoiselle Coralie's provocative mini-skirt and blouses.

'Do you smell that, François? That's the sea!'

'Well then the sea stinks.'

Which was true: a poisonous smell of sulphur and rotten cabbage was beginning to pervade our compartment.

'We're nearly there!'

I never went back to Little Angels. And for many years Mathilde and Bobo the Clown remained buried in my memory. Yet it was there, at the end of that dismal street, that I first encountered the two most important individuals in my life: Dickens and my wife.

# III

With my nose pressed to the window, I watched the factory's long spout spitting out a continuous jet of sawdust. The glow of the furnaces lit up the huge dune created by this waste. Like some insect tackling an enormous cow pat, a funny little vehicle with caterpillar tracks scaled it with difficulty. Pushed back by the vehicle's bucket, the sawdust trickled away to right and left in slow avalanches, and for a few seconds the dune was flattened. But the spout continued to spit, the mountain reformed, the insect coughed, baulked, skidded, before returning to the assault. Now and again car headlights picked out of the darkness the huge rolls of defective paper that lined the road and seemed to be waiting for some cyclops to grab hold of them and tear off a few sheets to wipe his behind.

'Psst! Come here, son . . .'

The siren sounded. Eight o'clock. My mother would soon be home now. In summer I would have been able to see her emerge from the factory office, wait at the red light, then cross the road towards me, a few seconds ahead of the tide of workers on the evening shift. But it was winter. It was dark. My grandmother was calling.

She was a pretty, fresh-faced, dainty little old woman, always impeccably groomed, with lovely silver-grey hair coiled in a chignon. Often, as evening approached, she would fall asleep in her chair by the fireplace, smiling in her dreams. Then she would wake with a start, blink a little, gently pull the lace collar of her blouse to make sure it was just so, and call me. She had a pleasant voice that sounded almost young. As I came up to her she would smile again. Her calm, luminous face would slowly turn towards me. She would pull me close to her. Her skin was not at all crêpy like that of old people. I could smell her perfume – Dawn Chorus, a young girl's scent that she purchased by mail order. She would run her

hand through my hair and pinch my cheek. Often passers-by would linger at the window to admire the tableau. Had they been able to open the window this is what they would have heard:

'So, you hate me, then?' Her manicured fingernails would dig into my cheek. 'Don't imagine for a moment I get any pleasure in seeing your rat face when I wake up . . . You know, all it does is give me the tiniest impression of being alive.'

She would start to stroke my hair again, searching for tangles to which she would give a sharp tug.

'Nice people have countless ways of reminding others of their existence: presents, smiles, little cakes, and blah blah blah. I'm not a nice person. There's nothing I can do about it. I have to bother someone. And there's no one else to hand but you . . .'

In a sense the converse was also true: I had no one else to hand either. No friends, not even any playmates. My mother was always home late. Besides she had less and less to say to me – I reminded her of something she would rather forget. As soon as I realized my grandmother's bullying was ritual, and therefore predictable, I ceased to be afraid of it and began to look forward to it, as other children look forward to smiles and caresses and sweets.

Sitting-Pretty: that is what I called her, primarily because she was crippled. Red and blue because of bad circulation and as hard as wood, her left leg had to remain perpetually horizontal. She had a special stool for this purpose. I practically never saw one without the other: the leg without the stool, or the stool without the leg. At night Sitting-Pretty was still in her chair. When I woke up she was in exactly the same place, a kind of cold star, a fixed sun that never set and never rose.

Hidden behind a door one evening, however, I saw my mother help her to bed. With the support of her walking stick to the left and her daughter to the right, Sitting-Pretty took very tiny steps. The bad leg would made a duller sound than the other on contact with the floor. Once she was in her room, the old lady had with the same exasperated gesture thrust aside her walking stick and her daughter, then had dropped on to the bed with a sigh, before laboriously hoisting up her inert leg.

'Is there anything else you need, mother?'

33

'Yes.'

Sitting-Pretty smiled weirdly, then the smile suddenly disappeared.

'A leg. A leg, you fool! Bring me a new leg, or else shut up and go away!'

I took to examining this famous leg more closely. There was no lack of opportunity. When I got home from school I had to keep the old lady company. Every lapse was immediately reported and punished with the confiscation of my soldiers (on this particular point my mother displayed a strictness that contrasted with her usual indulgence). As a rule, there was nothing in particular I had to do except listen to the sarcastic remarks she fired off at fixed intervals, like blank shots to scare the birds in the fields. But sometimes she would smile pleasantly before declaring in her lovely melodious voice, 'I'm bored, youngster. Get the book.'

I would immediately open the atlas at the place with the bookmark in it, and point my finger at random on the page.

'Colorado?'

'Denver!'

'Ohio?'

'Columbus!'

I never knew why this woman who had never left the town of Mimizan, and did not care a damn about history and geography – or any other form of human knowledge for that matter – had taken it into her head to learn by heart the capital cities of the States of the Union. In any event this peculiar and totally useless accomplishment appeared to give her the most immense satisfaction. Besides, as it went on, this stupid game came to fulfil another purpose: it put her to sleep.

'Nebraska?'

'Lincoln!'

'Kansas?'

'Ah hah! Topeka!'

I had grown to love this map: not for its bright colours, or its exotic names associated with vague recollections of stories of cowboys and Indians, but quite simply for the graceful, improbable polygons the states formed. 'Everything must be very plain and simple there,' I mused tracing with my fingernail the Euclidean contours of Montana.

'Well, ignoramus! Is Topeka right or wrong?'

'Yes, it's right.'

'You thought I was going to be stupid enough to say Kansas City, didn't you?

Soon the replies were rattled off a little less quickly. Her head would nod, jerking up at each new question. I would take advantage of this hypnotic moment between waking and sleeping to redirect my line of questioning:

'Wisconsin?'

'Mmm? Wisconsin? M . . . Madison . . .'

'What was it that Grandpa died of?

'Mmm . . . Grandpa . . . ummm . . . me . . . it was me that killed him off . . .'

'The attic was his room, wasn't it? Why does no one ever go in there? What's inside?'

'Mmm . . . the attic? . . . ummm . . . it's a messss . . . teerrrr'ble messss . . . .'

As soon she dropped off, I would study this permanent miracle: the perfectly circular boundary at the level of her knee separating the healthy flesh from the diseased flesh. This pure geometric circle reminded me of the frontier between Oklahoma and Kansas. Above the knee, a uniform, grey-pink expanse with no anomalies; below, an uneven surface of bumps and brown craters, ribbed with thick rivers, here, of red, there, of midnight blue, in which you could almost see the blood flowing. But at the fateful border the rivers resumed their underground course, the volcanoes ceased to erupt and the mounds levelled out.

'You like my leg? You want to take a photo of it?'

At first, too absorbed in my thoughts, I was unable to sense the imminent blow of her walking stick. But after a while I noticed that her awakening was always preceded by the sound of her swallowing noisily and with some difficulty, as if she were gulping down a dream, and I just had enough time to fling myself aside. The look she shot at me then, gleaming with anticipated glee, was the nearest expression to happiness I ever saw on her face.

'From where I'm sitting . . .' she would murmur ecstatically. 'I'll get you from where I'm sitting . . .'

And true enough, she did. Inevitably, the same evening, or the next day, or several days later, I would eventually forget the threat hanging over me, and find myself within reach of her stick. In any case she had other tricks up her sleeve, including being able to throw her slipper. It was a highly perfected technique which, if I had been able to copy it, would certainly have guaranteed my popularity in the school playground. With the tip of her stick she would remove the slipper from her bad leg, twirl it round until it gained speed, then with a firm accurate shot direct it at any available target. My behind. The slice of bread and jam I was going to put in my mouth. My fountain-pen, when, with my tongue poking out, I was just about to put the final full stop to my page of homework – which got me many zeroes. Or the television remote control. The slipper would fly through the air just at the moment Zorro unsheathed his sword, and I would find myself watching instead Chéri-Bibi battling it out with the Wimp from Les Batignolles. (Sitting-Pretty loved wrestling: she would watch it drinking sugared wine into which she dunked lady's-fingers, making great slurping noises that were supposed to make my mouth water.)

The worst thing was that I could not leave the slipper where it landed. Like a rabbit reloading the hunter's shot-gun, I had to put it back where it belonged before my mother got back.

But her masterstroke was Waterloo.

It had taken me a good two hours to set out the opposing forces. Everything was in place: Wellington, his infantry and his one hundred and fifty-six cannons, Ney's cavalry, Kellermann and the horse of the Guard, Grouchy, Blücher, Cambronne's veterans, all in position on either side of the Mont St-Jean plateau – a shoe-box lid covered with brown paper on which I had drawn some rocks, a few houses and a stream. Waterloo, at 11.29 am that 18th June 1815: I closed my eyes, took a deep breath and was preparing to launch the famous feint on the right wing, when a nasty whoosh disturbed the air, followed by the sad little jingle of the figurines clinking against each other.

'Scoreless draw,' chuckled Sitting-Pretty.

I opened my eyes. There was no denying it: the slipper had behaved with rigorous impartiality, simultaneously devastating Wellington's infantry

squares and Ney's assault waves. The whole lot – English, French, Dutch, Prussian – lay in a jumble, dead, disabled, or simply transfixed by the vision of horror represented by that infernal machine.

I drew two lessons from this incident. Firstly, that Sitting-Pretty was capable not only of pretending to be asleep but of reading my mind as easily as a drill is capable of boring into soft wood. And secondly, that I was going to have to find another pastime that was slipper-proof. Fortunately, it was not long before I did so.

The least that could be said was that 'Mimizan's healthy sea air' did not have the effect on my mother she was anticipating. After the euphoric first two or three weeks of being there, her condition rapidly deteriorated. I do not just mean her waxy complexion, the rings round her eyes, her raucous cough, but her whole being, which seemed to crack up and turn yellow on contact with the noxious fumes from the factory. And paradoxically, the more thin, diaphanous and ghost-like she became, the more she attracted attention. In everyone's eyes she was 'the abandoned wife'.

Yet I recall her total indifference when the first letter arrived. She opened it, read it, handed it to me without a word, and went back to peeling her potatoes. Her face betrayed no emotion.

My dearest,
Contrary winds have driven the vessels of our two lives apart. But this has not made us strangers to each other. There are some ties that can never be broken. These few lines are intended to provide you with evidence of that.
Hug the boy for me.
Your husband despite all,
Robert Daumal

PS Enclosed are a few straws wrested from the gale.

Then my mother calmly tore up the letter. She threw it in the dustbin along with the advertisement for lawn mowers in which the potato

37

peelings were wrapped, and put the envelope with the ten five-hundred franc notes in a drawer in the sideboard, underneath a big rusty key.

I understood why she did that, two months later, when we received the second letter.

My dearest,
Ah! What a long time it is taking for the storm to abate, and how difficult it is to face alone [he had underlined the word 'alone']. I hope that your shores at least are spared. My miserable garret is in very bad shape. The rain comes in. For old time's sake, would she who still bears my name be good enough to send a bit of dosh by return of post? [There followed a poste restante address in some dreary north-eastern town.]
Hug the boy for me.
Yours, eternally indebted to you,
Robert Daumal

Still without a word my mother went and fetched the ten banknotes and posted them off the next day to the address given. Catherine and Robert Daumal never had anything more to do with each other after that.

As for me, I had had time to check every lock in the house and was now in no doubt which one the old rusty key fitted.

While having no illusions, I was nevertheless keen to give myself every chance of success. I chose a rainy day – Sitting-Pretty slept deeply when it rained. I kept the soporific session of States of the Union going for a long time to make it more effective. And when the first snores came I waited a good quarter of an hour before going into action. Then I got to my feet, crept out of the room, closed the door behind me, fetched the key from the drawer, and headed for the staircase leading to the attic. But at the tiniest creak of the first stair, the closed door notwithstanding, I was stopped dead in my tracks by the old lady's voice, so sharp and clear it seemed to come from inside my head.

'Another step and you can say goodbye to your soldiers for a very long time.'

I hesitated for barely a second, driven by that blind force that prompts

us to sacrifice whole coffers of very tangible treasure for the smallest pinch of the unknown. Casting aside all caution, I climbed the last steps, fumbled for a while with the stiff lock that eventually yielded to my impatience with a prison-like sound. The door would not open. I forced it with a shove of my shoulder, and felt for the light switch.

'So? Are you in?'

I was now right above the old lady. Her voice still reached me just as clearly, through the wormeaten floorboards. But it had changed. I detected a note of curiosity, even envy.

'Yes.'

Because of the weakness of the light bulb and the dust covering it, the edges of the room, small though it was, remained in shadow.

'What can you see?'

'In the middle there's a mattress and a . . . a bizarre piece of equipment . . . like . . . some kind of workbench.

'It's a book press. And around it?'

'Nothing . . . Weird . . . thick . . . wall paper . . . all buckled up.'

'It's not wallpaper, stupid! Go inside!'

As I stepped across the threshold I tripped over something, and fell flat on my face. My fall made a peculiar sound, a kind of dull thud. It was not wood on the floor, or carpeting, or linoleum, or any other classic material, but a thick matter whose strange consistency, a cross between that of biscuit and bone, I fingered with revulsion, while a smell of mildew caught in my throat.

'They're books!' said Sitting-Pretty.

'Books?'

Yes, books. Hundreds of books formed a slightly unstable flooring. Layers of books, stacked on top of each other along the walls, like bricks, right up to the ceiling, all covered in the same yellow paper, stuck together with damp and spiders' webs and dust. I knelt down and with my fingernails tried to extract one individual from this tightly packed crowd.

'Before my leg, we got on well together, your grandfather and I. He wasn't a great talker, neither was I . . . we both kept ourselves to ourselves. And then there was my leg . . . At first, things were still all

39

right between us, he was working at the factory . . . With his shifts and overtime, we didn't see that much of each other . . .'

I finally managed to free it. There was a sound like that of a drumstick being torn off a chicken. The book hung from my hand: a dead bird. The page sections were only held to the binding by a big blob of glue. The spine and cover were a uniform yellow: no title, no author's name. I had brought to light a rectangle of ill-fitting floorboards. In the gap between two planks I could see the old lady's upturned face, and I could discern her strange smile.

'The day after he retired, he got up, installed me in the armchair as usual, and said: "I'm going upstairs." He emptied the attic. I could hear him throwing things down into the garden through the attic window . . .'

'What attic window?'

'There's one right opposite the door. Hidden behind the books. Then he took his mattress up there and moved into the attic. He only came down to get me up, feed me, wash me and put me to bed. At first all he did was smoke. I could hear the tapping of his pipe against the ashtray. But before long he started to read . . . he'd read anything, the fool. Anything at all, as long it was a Hachette's Children's Classic . . . It reminded him of his childhood! The idiot! I'm sure he didn't understand a word but from then on that's all he ever did, from morning till night, lying on his mattress . . . He didn't buy the books. Far too mean for that! He offered to clear people's attics. And when he came across a Children's Classic he'd always bring it home in the same rusty old bowl . . .'

'I can see it. It's behind the book press . . .'

'The best thing about it was, he didn't make any noise. I didn't even hear the sound of his pipe any more . . . until the day his eyesight started to go. At first he brazened it out. "It's fine," he said, "you look blurred!" He bought himself some glasses, then a magnifying glass, but even with the magnifying glass he could only read the large print headings . . . So he went to the hospital for some tests. They told him: "Nothing to done about it: it's bull's-eye maculopathy. It destroys the nerves from inside. Glasses are of no use at all for that. At your age the disease progresses slowly. You'll probably never go blind . . . but no question of being able to read any more!" Yet the next day I saw him go off with his bowl under

his arm! "What are you doing with that bowl?" I said to him. "Have you forgotten about your bull's eye?" He told me to get lost. I only realized what was going on later, when the press and all the other paraphernalia arrived . . . He couldn't read any more, so he was going to bind the books. The idiot! He set up the equipment in the attic, and he'd spend the whole day guillotining, trimming, sewing, cutting, gluing. We only communicated through the floorboards. "What's the point? Your books are already bound!" "No, I want to bind them myself . . . That way, I can still touch them, and they can become truly mine!" He was losing his marbles, the poor devil . . . The disease wasn't just destroying his nerves, it was attacking his brain as well!'

I put down the torn book and chose another from the floor. The binding still held together but bore the stigmata of my grandfather's blind handiwork: end papers and title pages ripped out, sections sewn together upside down, inside pages trimmed too much by a good two centimetres at least – and this one too with no title. Sometimes, the top paragraphs were mutilated, the characters in the illustrations decapitated. Despite the foxed page, I was able to read: *Chapter One: Arrival. Everything was in a state of confusion at the Château de Fleurville . . .*

'There was more than one occasion when I heard him shouting because the trimmer went crooked. But one day he gave a real yell. "What have you done to yourself now, you ham-fisted incompetent?" "Nothing. I've sliced my finger off . . . Mind you, by a stroke of good luck it happens to be my ring finger! I'm as good as divorced now!" And he opened the attic window and threw the finger into the garden.'

*Chapter One: The year 1866 was remarkable for a peculiar incident, a mysterious and puzzling phenomenon, which doubtless no one has yet forgotten.*

*Chapter One: I will begin the story of my adventures with a certain morning early in the month of June, the year of grace 1751, when I took the key for the last time out of the door of my father's house.*

Obvious introductory effects, heavy-handed delaying devices: like the books in the children's library in Bordeaux, the ones I picked up off the floor one by one revealed their gimcrack mystery. The baddies sharpened their weapons deep in the forest, the goodies prepared their smiles,

conspiracies were hatched, traitors sneered, Zulus roared, Red Indians whooped, pirates fulminated while drinking rum, sabres glinted as ships were boarded, cannons exploded. Murders, rescues, pardons, curses, tearful embraces: I felt remote from all these things! Despite the dust and damp, to me the floorboards I was uncovering little by little had greater lustre!

'That was the day I realized he was really mad! I never saw him any more: he asked a neighbour to come in and take care of me every morning and evening. He replenished his supplies once a week. He ate with his fingers, with no plate or cutlery, and he threw his rubbish out of the window. He even pissed out of the window. He only came down to shit. As soon as he finished binding a book he'd put it in place: at first on the floor, then along the walls. His voice became muffled because of the thickness of the books. He'd say: "I'm making progress! I already can't see you any more, soon I won't be able to hear you. I'm building my fortress . . ." '

*Buck did not read the newspapers, or he would have known that trouble was brewing, not alone for himself, but for every tide-water dog, strong of muscle and with warm, long hair, from Puget Sound to San Diego . . .*

*It was late in the month of March, at the dying-out of the Eagle Moon, that Neewa the black bear cub got his first real look at the world . . .*

Wet-nosed, moist-eyed, cats and dogs would lend a pawsie-wawsie. Grandmothers at the fireside would tell stories of princesses. Lashes of the whip and caresses came thick and fast; and children wept, laughed, indulged in all kinds of simpering and bravado to attract attention. Children everywhere! They were rife. They proliferated without copulating, grew old without ever growing up. But I was different, and a deep disgust overwhelmed me because I did not recognize myself in that pitiful horde. I was a real child. I wanted these pages to hold a mirror up to me.

' "There! Nearly finished! I've covered up the window . . . I'm going to block up the door, and then I won't hear any more about you, or anyone else, ever again! I'll be in my own home!" The lunatic!'

*Chapter One: I am born.*

*Whether I shall turn out to be the hero of my own life, or whether that station will be held by anybody else, these pages must show.*

A shiver ran down my spine. Automatically I had tossed the book aside along with the others. But before it had even touched the ground I regretted my action. In my haste to retrieve it I knocked over the pile and began searching frantically on all fours. For a brief moment I thought I had even dreamed the sentence, imagined it, so strong was the impression of familiarity, of its belonging to me, of having read it, thought it, before. Yes, for a few seconds I believed myself to be the author of one of the greatest novels ever written. But there it was, in black and white:

*Whether I shall turn out to be the hero of my own life, or whether that station will be held by anybody else, these pages must show.*

I turned the book in every direction: there was bound to be something to distinguish it from all the others. Yet it was the same paper, the same cover, the same page sections hacked about, top and bottom. I feverishly turned the pages, gleaning phrases here and there that seemed not to belong to a novel but to constitute a message intended solely for me: *a world not at all excited on the subject of his arrival; the blank of my infancy; something – I don't know what, or how – connected with the grave in the churchyard, and the raising of the dead, seemed to strike me; she brought with her, two uncompromising, hard black boxes* . . . But even certain passages that clearly could not possibly relate to me – *I was a posthumous child; my father's . . . white gravestone in the churchyard* – awakened in me a very intimate echo in which were mingled memories, dreams and nightmares. The titles of the chapters also made a very strong impression on me. I thought I detected in their simplicity, their reassuring but inexorable chronology – '*I am born*', '*I observe*', '*I begin life on my own account and don't like it*' – a kind of coded language addressed to me, and it seemed possible, by the sole virtue of my index finger, to journey down the long river of my life, to round the cape I had reached at present, and to glimpse the unknown that subsequently awaited me.

Still reading, I left the attic and came downstairs. When I opened the door a flying slipper almost wrenched the book from my hands. Without

43

thinking, I picked up the missile and threw it some distance out of the open window. Then with an air of defiance I sat down directly in front of Sitting-Pretty and overtly began to read.

Fully aware of what I was doing, I had just put aside my soldiers for the next seventy-five years at least.

'No one knows exactly what he died of,' she resumed after a long pause. 'I hadn't heard anything for a while, so I asked Madame Conscience next door to go and take a look . . . His body was blocking the door. We had to call the fire brigade.'

I glanced over the top of my book. She was watching me closely. In an attitude quite untypical of her, her neck was straining towards me, her gaze inscrutable. For a moment I thought she was quietly savouring her imminent revenge but there must have been something else going on, and the guarded almost hesitant tone of her voice confirmed this impression.

'So now you're reading too . . .'

'Yes,' I said jauntily.

I puffed up my chest like those early Christians who even in the circus arena refused to abjure their faith.

'Hm hm. My father was a carpenter. I didn't like going into his workshop because there was always sawdust everywhere . . . But one day he picked up a pinch of it between his fingers and said: "You see that? That's a trace . . . When you really do something, there's always a trace . . . With books, there's no trace." '

Our first conversation. This seemed a good enough reason to put down my book and think about what she had said. But I did not lose sight of the fact that it was actually thanks to the book that things had changed. The book gave me some importance. I was more powerful.

'When you eat there's no trace . . .'

'What about the shit? What do you do with the shit?'

'That's true,' I conceded. 'But when you sleep there's no trace either.'

It was her turn to think. She closed her eyes and after a pause said, 'Yes, there is. There are dreams. Dreams are sleep shit . . . but books only contain other people's dreams . . . And other people are useless. Books are useless . . .'

I was going to reply that even if this were true – even if this book were

44

useless – I was quite prepared to luxuriate for ever in this magnificent uselessness, to sacrifice for it a lot more than my tin soldiers, and in any case I didn't like sawdust either.

But the door opened. My mother appeared on the threshold with the slipper in her hand.

Without a word she walked across the room and put it back where it belonged. The old lady did not say anything either: she did not tell on me, regarding either the attic or the slipper. As for me, I was far too overwhelmed with emotion to speak. Like actors in silent movies, we played our parts with exaggeration: my mother, her face drawn, lost in her unfathomable thoughts; Sitting-Pretty, impassive *deus ex machina*, who with one word, a single word, might have changed the course of fate; and I, a picture of dumbfounded amazement.

Then my mother disappeared into the kitchen. Thereupon I experienced a new feeling towards her, as if these recent events gave me the right, or the duty, to feel sorry for her. I rushed after her, having hidden the book under my shirt.

'I was the one that threw the slipper.'

No reaction. Taken by surprise, I felt the key in my pocket and clutched at this piece of cold metal.

'I also stole the key.'

She took it and put it away in the drawer. I began to sweat profusely. The book was sticking to my skin. Not knowing what to do, I showed it to her:

'I took this from the attic.'

I was a mere supernumerary in the pale sunlight of her gaze. Slowly she began to prepare the soup.

The next day after class, I waited until the other pupils had left, then went up to the dais. Not having heard me coming, the teacher started. I had until then so blended into the anonymity of the class that this face-to-face encounter seemed to disconcert him. He warily noted my tired features, my reddened eyes – I had been reading all night.

'Yes? Was there something you wanted?'

I had not brought the book to school for fear of losing it or having it

stolen but I told him the names of the characters and quoted two or three key passages.

'Well,' he said harshly. 'Doesn't your copy have the title and the author's name on it?'

I might have told him about the blank cover, the badly trimmed pages. That would have meant recognizing the mysterious bond that already existed between the book and me. I preferred to lie.

'I don't have the book. It's for a competition.'

He carefully stacked a sheaf of written work, pretended to read the top one, then grudgingly came out with, 'Dickens. *David Copperfield*. Very overwritten, if you want my opinion. Too much pathos, too many clichés. It's not what people should be reading these days.'

I thanked him warmly. Without meaning to, he had filled me with joy and pride.

'Sometimes books do serve a purpose.'

Within a few months my grandfather's attic had revealed its treasures. A single glance was all it took me now. I could unhesitatingly pick out the tasty ceps from the boring old boletus: *Nicholas Nickleby*, *Oliver Twist*, *The Posthumous Papers of the Pickwick Club* (in an abridged version, though I did not know this at the time), *A Christmas Carol* had dropped one by one into my pouch. Scrooge and his miserliness, Jingle and his sentence fragments, Grimwig and his famous 'I'll eat my head' had become more familiar to me than the boys and girls at school, or even my mother: I kept company with them late into the night. They visited me while I slept. And in the morning I was reluctant to leave their three-dimensional world to flatten myself out until evening on the dismal white page of reality.

My favourite was Pip. I had read the first sentence of Great Expectations a hundred times over. I knew it by heart: *My father's family name being Pirrip, and my christian name Philip, my infant tongue could make of both names nothing longer or more explicit than Pip. So I called myself Pip, and came to be called Pip.*

I was envious of his enormous privilege. I studied myself in the mirror, searched the depths of my own gaze, and said to myself that perhaps,

deep down inside me too, there is some mysterious, unknown name, my real name. It was just waiting to come out. If I discovered what it was, if I could only frame it with my lips, then another life would open up to me, like a bobbin unwinding when you pull on the thread. Armed with this viaticum, as a character among characters, a name among names, I could take my place in a book, come into my own, go skipping from one chapter to the next, and finally experience the exhilarating sensation of three-dimensional existence.

But I was also jealous of Pip on account of Estella.

Cruel, arrogant, flirtatious Estella. Who with a mere glance could drive him crazy with love and shame.

*'Am I pretty?'*

*'Yes; I think you are very pretty.'*

*'Am I insulting?'*

*'Not so much as you were last time,' said I.*

*'Not so much?'*

*'No.'*

*She fired when she asked the last question, and she slapped my face with such force as she had, when I answered it.*

I pictured Estella with the features of Mathilde, the little girl at Little Angels. I was both Pip and Bobo the clown. With sighs of ecstasy I allowed myself to be dismembered and, just like Pip, after every slap turned the other cheek.

When I was too tired to carry on reading I would amuse myself by comparing my two heroes, Copperfield and Pirrip, Pip and Davy. In the darkness of my room I endlessly debated which of them was most like me. Eventually as I was on the verge of falling asleep, they would appear to me on either side of a big door: this was a huge temple, built of words. The doorway, the dome, the pillars were made of words, and when I touched them my fingers sank into them. The door opened on to an empty room. I advanced slowly, gazing in wonder at my hands which had turned into words. My legs gradually disappeared into the flagstones, I breathed words, my arteries were full of words. And when I reached the altar, just as I dropped off to sleep, I had become a word.

Sitting-Pretty looked up and grunted encouragement. For some time now the atlas no longer interested her. She preferred talking.

'I mean, when you've read a lot of books, you can then write one. That's a trace.'

'No, it's not. It's just slime, like that of snail on a leaf.'

'For instance,' I continued, ignoring her objection, 'I could write a book about you . . . but you're far too nasty, no one would want to read anything like that . . . No one would believe it. Even Miss Havisham is almost kind occasionally . . .'

She stared at me in amazement, then looked down at the book I held open in front of me.

'I don't know who this Miss Havisham of yours is but I'm sure she has both her legs . . . So it's easy to be kind.'

'Miss Havisham doesn't have the use of her legs any more. She's in a wheelchair. One day she wanted to get married. Everything was ready for the celebration, the dress, the banquet table, the wedding cake. But her fiancé didn't turn up. Miss Havisham is old now but she's never forgotten. In the room where the wedding celebrations were supposed to have taken place, she's left everything untouched. She asks young Pip, a poor boy from near by, to push her in her wheelchair round the table on which the wedding cake is rotting. To get her revenge against men, she wants Estella, her niece, to make Pip fall in love with her and then break his heart. But sometimes you get the feeling that Miss Havisham might have been able to love Pip.'

'Bah!' said Sitting-Pretty, turning aside.

Yet I sensed she was perplexed, and I saw that she followed me closely with her eyes when I moved towards the television. Zorro was just beginning. I changed channels and the wrestling ring appeared. An enthusiastic presenter with a strong southern accent was introducing the wrestlers: 'the barbarous Beast of Béthunhe and his blood-thirsty accomplice Jack the Strangler, against Hercules Duval, a fine athlete and current European champion, and Lightning René, the Little Prince of Gentilly, that legend of fair play!' Tag team wrestling. Just what Sitting-Pretty liked best of all. I could almost sense the inner struggle she was engaged in behind me.

'Superb armlock from Little Prince, who despite his five foot four inches has just floored that great brute the Strangler, and . . . nooo! The Strangler is digging his finger into Little Prince's eye, Little Prince is yelling . . . Foul! Ref, please, do something!'

'Bastard!' chortled Sitting-Pretty.

Then as I moved a little way from the box to be able to see better:

'So! What are you waiting for? Come and sit down!'

'Where?' I said cautiously.

'Well . . . here . . . on my lap . . .'

'Outrageous! It's outrageous . . . The audience can testify to this: the referee's saying nothing! The Strangler's increasing the pressure . . . ouch! ouch! ouch! Even my eyes are hurting . . . Little Prince reaches out to tag Hercule Duval . . . Go on, little fellow, you're almost there . . . but no, his arm's too short! Hercule's at the ringside, champing at the bit, the Beast is baiting him from a distance, and the Strangler . . . Oh my! Friends, this is murder!'

Stepping backwards I covered the distance that separated us. With her eyes fixed on the box Sitting-Pretty made a pretence of behaving naturally, as if I had already sat on her lap hundreds of times before. At the very last moment my heart skipped a beat.

'I . . . I'm going to hurt you.'

'No, you won't, stupid! In any case, I can't feel anything, it's completely numb!'

I sat down, taking infinite care, with one buttock on Oklahoma, the other on Kansas. Sitting-Pretty opened the sideboard that was within her reach, produced a bottle, a sugar bowl, a small box of biscuits, and generously filled two glasses with her concoction.

'Look . . . you dunk the biscuit, you let it soak up the liquid, and when you sense the end is about to drop off into the glass, hup! you swallow it!'

The factory siren blared. Shortly afterwards, there was a screech of brakes, a squeal of tyres. A dull thud could be heard through the open window.

I had never drunk alcohol before. The sugar was sickening, the wine bitter; the biscuit steeped in this mixture melted in my mouth like the fragment of a dream. A strange and pleasant warmth came over me. On

49

the other hand I was in agony. Sitting-Pretty's dead knee was digging into my butt and I dared not change position for fear of breaking the spell. To forget the pain I concentrated on the taste of the wine, picturing its slow progress inside my body, my organs enveloped one by one in this heady warmth. I felt as if a knife was being driven into my flesh while at the same time I was being injected with a powerful anaesthetic.

'Now the Barbarous Beast wants to be in on the kill . . . There we are, the Strangler's letting him take over . . . Forearm smash, and again . . . Armlock! Of course it's easy for you, Beast, your opponent can't even see straight! Little Prince is fighting back though . . . never has he deserved that nickname of his more than he does now! I wouldn't like to be in the position of poor Hercule Duval, helplessly watching this slaughter . . .'

'Get into the ring, dummy!'

I could smell Sitting-Pretty's scent, I could hear with extraordinary clarity the slightest gurgle of her stomach but I could not see her face. There was a tacit agreement between us: not once did our eyes meet. In my discomfort I rocked very gently towards Kansas to relieve my left buttock, and swallowed half a lady's-finger. I began to sweat. I had a slight headache. I saw some bizarre lights: they came from the street, and rotated on the ceiling, yellow and red. There was a feverish movement of shadows. I heard several different voices, one deep and solemn, the other high-pitched and voluble, a third, distant, metallic, interspersed with hissing. But I did not doubt for a second that all three of them came from inside my head.

'Yeeesss! Well done, Little Prince, well done! You take a rest now and let Hercule do his bit . . . and Hercules certainly knows his stuff, I assure you . . . Armlock . . . Waistlock . . . It's a different story now, isn't it, Beast? Forearm smash, and again . . . and again . . . and the referee has copped one by getting in the way but we're not going to shed any tears over that . . .'

When the old lady started to clap her hands I followed her example. I needed to move about, make a noise. I punctuated each forearm smash with a exclamation of delight, while Sitting-Pretty, close to ecstasy, drained her glass to the last drop and refilled mine, not bothering with the alibi of the lady's-fingers.

50

'And Little Prince isn't standing idly by, I can tell you, and from where I'm sitting I can see what the cameras can't see . . . Things are hotting up outside the ring! Well, fair play has its limits . . . Little Prince has a score to settle with the Strangler . . . Oooh, that's very painful . . . but no one's going to shed any tears about that either . . .'

I in turn drank up and we laughed till we cried. The policeman standing before us did not know what to do. The only course open to him was to watch the wrestling with us and wait, helplessly, until our hilarity subsided. At his side our widowed neighbour Madame Conscience chewed her knuckles until they bled and kept saying over and over again like a scratched record, 'Ohmygodmygod, ohmygodmygod, ohmygodmygod . . .'

Later, much later, when the body was lying in the back room and we were eating in silence the meal Madame Conscience had prepared for us, my mother was at last treated to a funeral oration:

'Crossing the road! The dumb cluck!' (The chicken being a particularly stupid animal, according to Sitting-Pretty.) 'If we lived by a bridge she'd have drowned . . .'

# IV

I learned of the existence of my uncle – someone I was never to meet – the day after my mother died. It did not come as a great surprise: I had got used to this family whose members turned up one by one out of the blue, like skeletons falling out of a closet. Four telephone calls was all it took for him to determine our fate. The paper factory rented the house for their security guard. Mother got the first plot in Mimizan's new cemetery – a wasteland wedged between the factory and the rubbish dump. Sitting-Pretty was packed off to an old people's home in Dax, and I to a boarding school run by monks on the outskirts of Bordeaux.

In the seven years I was there I encountered several hundred fellow pupils, several dozen teachers. However, I have almost no memory of their faces and when I think back to that period it is Monsieur Krook's face that appears before me.

On the first of every month I received a postal order from my uncle: my pocket money, the only tangible sign he gave of acting as my guardian. The following Saturday I would take the bus to the centre of town.

Monsieur Krook was located in Rue des Ramparts. The first time I entered his shop the place seemed to be deserted. It was a long corridor full of shelves, protected from the sun by a smoked-glass window. Right at the back was a grubby glass panel that gave on to a light well. Basically, you could find old books there: not first editions, the limited editions sought after by book collectors, but a very eclectic selection of works of no value other than that of their content. Unfashionable writers, little-known works, sometimes by novelists who were still famous but had been dropped by their publishers, 'classics' with familiar titles but actually read by only a handful of academics and those with a particular interest. Great disorder reigned on the shelves. The books were dusty, most of

them in bad condition. Gathered together on a small table near the door into the shop, a few rare trendy novels seemed to have taken on, in solidarity, the appearance of their dubious surroundings: the ink, though still fresh, was already fading, and you got the feeling that, despite their resolutely 'modern' poses, the smart dynamic young authors, smiling on the back cover, would soon resemble the old bearded pre-war hacks.

I realized at first glance this was the place for me. I was much more likely to find the necessary quiet, discretion and concentration here than in the big bookshops in the centre or among the high-class book dealers. The only thing missing was a mentor to guide me through this jumble but for the moment he was not to be found. I went round the shop from one end to the other three times without result. I twice cleared my throat before deciding to call out, timidly at first, then more loudly.

Only then did a strongly accented voice that seemed to emanate from some books piled up on a counter respond, 'No need to shout, my young friend, no need to shout, I'm not deaf . . .'

I looked more closely. Between one odd volume of an edition of Shakespeare's plays and a huge textbook on Greek literature that was falling to pieces I discerned a perfectly still head. A face smiled at me. The one line running horizontally across his forehead looked just like a band across the spine of a book. His yellow-tinged skin gleamed like old parchment. Only an ironic smile and a mop of red hair gave a human appearance to this almost mineral composition.

'Now first of all,' the voice went on, 'let's start with what really matters: are you a Bringer or a Taker?'

As he spoke the man cast a suspicious glance at the satchel I was carrying on my back, in which I was intending to take home my purchases.

'This is a very important issue, young man, because it will largely determine the nature of our future relations. As a Taker, you come in with empty hands and a full purse and you leave in the reverse state. You number among the blessed, among the race of Clients. It's not a question of money, mind you, but of space, vital space. You can't imagine the number of books behind that door, in purgatory, waiting for a space to become available! But a Bringer! My God!'

Ill at ease, I shifted from one foot to the other in front of Monsieur Krook. I saw him gradually recover the hues of life as he wakened from his siesta. When I talk of hues, I'm thinking mostly of red: the red of the blotchiness that slowly came into his cheeks, that of the little lizard-like blood vessels that streaked the whites of his eyes.

'Bringers! Sly ruthless monsters – some of my colleagues call them "suppliers" but I can't bring myself to use that word, it's too noble. Too noble for these publishers who dump their truckloads of waste outside my door every month! Middle-class house-owners who take it into their heads to empty their attics, and see no other solution but to empty them on me! Look, look around you. Am I not stuffed to the gills? But that doesn't stop them, no, they keep coming. Sweepers! Mind-sweepers! And you know what the most scandalous thing is? For this obscene force-feeding or evacuating – it depends on your point of view – they expect some remuneration! You have to pay these characters! And the worst of it is, that I, Krook, can't stop myself buying. I buy, and buy, I can't help it! Why? Because I'm tender-hearted, I'm too soft. I can't bear to see a book without a home!'

Slowly he unfolded his large frame: he was soon standing. How could I not have seen him? He was nearly six foot six. The kind of guy easier to imagine on a rugby pitch or in a highland forest than beneath the low ceiling of a shop cluttered with shelves. Dressed very modestly, he did however have a large diamond set in a fairly conspicuous ring on his left hand. I dared not look up: his mop of red hair almost brushed against the cobwebs dangling from a ceiling light.

'Bringers know this, of course, they take advantage without any qualms. The news has spread to Bayonne, Toulouse ... even Paris: "Apparently there's a guy in Bordeaux, Rue des Ramparts, who buys everything!" "You're joking!" "No, no, I assure you! He takes every-thing!" "Well, not *The Disciple* by Paul Bourget, ninth edition, broken spine, torn cover, mildewed in places, missing title page?" "Yes, yes! Even that! Everything, I tell you! All you have to do is soften him up a bit ..." And they're experts in softening up. A sigh here, a tearful look there. "Poor, poor book! To think it's never been given a chance! You're the only one who can help, Monsieur Krook, you're the man that's needed!

You could sell Ezra Pound to a merino sheep!" So I do what I can to fend them off. I invent excuses. As soon as I've got five hundred francs I deposit them in the bank opposite. I show them the empty till. I forget my chequebook five times a week. I only bring it in on Wednesday, then Thursday the following week, and so forth. Otherwise they'd pass on the word, the swine!'

Having concluded his tirade, Krook was willing to examine me a little more closely. He noticed my young age, felt my empty satchel, and smiled.

'Relax, my boy, relax! I'm sure we're going to be the best of friends!'

It was not only Monsieur Krook's height that intimidated me but also his smile. Nothing like those reflex switch-on smiles accompanied by little taps on the cheek to which adults treat little children in order to make themselves appear kindly. No, it was a man-to-man smile, by which he seemed to imply that I was capable of appreciating the irony of his words and the highly comic nature of life in general. There was something both exhilarating and intimidating about this.

'What are you looking for?'

'Dickens!' I said without looking up.

Krook burst out laughing.

'Dickens! That's a pity, he's just left. He spends all Saturday out drinking . . . but he has put away in a corner a few things that might interest you.'

Raising a cloud of dust, he showed me two volumes: a Children's Classic edition of *Oliver Twist*, and a very old illustrated edition of *David Copperfield* – on the cover, a little boy was trying to protect himself against the blows of a man who looked like a ruffian, while a young woman wrapped in a shawl tried vainly to intervene. I shook my head.

'That's a stupid picture.'

And looking Krook straight in the eye at the cost of a terrific effort, I added very quickly, 'I know that Dickens didn't come and see you today.'

Wearing a thoughtful expression, Krook scratched his chin with his ring.

'I know you do, my boy. Actually I think there are a lot of things you know. What would you say to this?'

It was a beautiful book. A very beautiful book, printed in 1885. Superb quality paper, splendid typography, in perfect condition. The title page bore this dedication: 'To my old friend Maxime Levers. In the hope he does not become obsessed with his lawsuit, Anatole France.'

*Bleak House*. This title appeared in all the bibliographies but I had never been able to track it down, either in my grandfather's attic, or in the school library, or any bookshop, and I came to believe the book did not exist, that it was just a title, a particularly attractive title, designed to appeal to readers. Holding it in my hands, I experienced the incredulity of a hunter who finds himself face to face with a griffon or a unicorn.

'That book, young man, is especially dear to me. Do you know why?'

The word 'dear' brought me back to painful reality. With a trembling finger I turned to the fly leaf. At the right-hand top of the page three figures were scrawled: 600. Six hundred francs! My uncle sent me one hundred francs a month. I would have to wait six months to get together such a large amount!

'Uh . . . no.'

'Look here: this character has the same name as me: Krook. Oh, he's a rather unsavoury namesake. A filthy rag-and-bone man, unscrupulous and greedy. But his death, my friend, his death! What a freak of nature! Do you know how he dies?'

'No.'

'By spontaneous combustion. Phtt. Went up in smoke, our Mr Krook. Disappeared. All that was left of him was a pile of ashes. There were plenty of charlatans at that time who claimed to have witnessed such a phenomenon. And there was a naive side to Dickens, all things considered he was an overgrown child. He believed this nonsense! Mind you, he wasn't the only one. There's a very similar scene in Zola, *Doctor Pascal*, if I'm not mistaken. Ah! Found it:

> . . . and here is – is it the cinder of a small charred and broken log of wood sprinkled with white ashes, or is it coal? O Horror, he IS here! and this, from which we run away, striking out the light and overturning one another into the street, is all that represents him.

'Naive or not, it takes some doing to write a scene like that! You need guts to do that! No one's ever come up with a better way of getting rid of an unpleasant character! No one would dare to do it these days. Contemporary writers would fall back on plausibility . . . What tosh! Shall I tell you why Dickens is one of the greats? Because he had guts! What do you think? I assure you, at sixty francs, it's a bargain!'

'Sixty francs?'

'Yes, sixty francs.'

'It's just that . . .'

'Well, what?'

Krook took the book from my hands, gave a strange whistle, and began to shout.

'Skimpole! Come here! I'm going to give you such a rollicking! He's my assistant, he's just arrived from Edinburgh. What with pounds sterling, old francs, new francs, he's utterly confused. He adds noughts to everything in the shop. Skimpole! Show yourself, you blockhead!'

Skimpole did not show himself. I held out my one-hundred franc note, took the change, and packed my treasure in my satchel. I was about to go when the bookseller detained me by tugging on my sleeve.

'Hey, not so fast, young man! Let's do things properly. In my country, two honest men who conclude a deal don't go their separate ways without having a drink together. This way, please.'

I trailed after him into the back room. Three of the walls were covered with shelves filled with books. Occupying pride of place on the fourth wall was a huge poster printed in Gaelic (I later found out it was the manifesto of the Scottish National Party) and several dozen photos of writers, only one of which was familiar to me, the famous picture of 1865: Dickens, sitting astride a wicker chair in the garden of Gad's Hill Place, reading to his sister-in-law and housekeeper Georgina Hogarth. Behind them, the famous geraniums he was so fond of.

Alongside this photo was an old engraving depicting a man in the dress of a courtier. He held a quill pen in his right hand, a roll of parchment in the left, and had a mocking smile.

The bookseller had followed my gaze.

'Thomas Urquhart of Cromarty . . . the first translator of Rabelais

57

into English. A splendid fellow! Skirt-chaser and solver of trigonometry theorems. He spent a good deal of his life in Cromwell's prisons. Some people say he died laughing on hearing that the Stuarts had been restored to the throne. My mother always claimed we were related to him. She treated her *Pantagruel* as a family relic. I owe my first feelings of literary excitement to Urquhart, as well as . . .' Krook lowered his voice slightly. 'As well as a few minor unpleasantnesses. But where can that good-for-nothing Skimpole have got to? Ah! I know, the boats. Since he came to Bordeaux he spends his whole time on the docks. He seems to have discovered the poetry of the great ports. And to think that imbecile spent his whole childhood in Leith! Never mind! We'll have a drink without him.'

With the back of his hand he cleared a space on his desk, which was covered with bills and purchase orders, and produced a bottle of whisky. With the diamond in his ring he scored the bottle about a centimetre below the level of the liquid, then he filled two glasses.

'Thus far and no further. In life, young man, you have to know when to stop. The most noble passions need protective railings. What would become of me without this ring? A drunkard, that's what I'd be, a beastly drunkard, unworthy of this splendid, sixteen-year-old Lagavulin malt.'

Warily, I sipped this liquid with amber reflections and a peaty taste. My second glass of alcohol. I recalled the sugared wine. I expected to feel the same excitement, the same uncontrollable mirth as on my grandmother's lap. On the contrary, a delicious calm came over me. Everything suddenly seemed much simpler. The alcohol lured me, guided me to a distant future where, like David Copperfield, I would at last be the hero of my own life. Long years have passed since that October Saturday. But I have only to wet my lips in a glass of that same Islay whisky, described by some as 'peat blood', taking the same shortcut to make the same journey in reverse, and once again I am that young boy of twelve, in the back room of the bookshop. I can see Krook watching me with an amused look in his eye, and I can see Dickens. Dickens in his suit, bizarrely stiff and formal despite his relaxed pose. I can hear Dickens's voice – suburban accent, lisp – and I tell myself that from

that moment on I was always moving away from the path I should have taken.

'Spontaneous combustion . . .'

Krook held his empty glass up to the light, admiring the last tawny drops glistening like tears, and dreaming aloud he said, 'That would be magnificent! To disappear without trace . . .'

'Disappear?'

'Yes. You know, young man, the cemeteries are as overcrowded as bookshops are. As for that stupid ritual of cremation for the non-religious . . . No, if the book – I mean, the body – could just evaporate . . . Like that!'

Krook snapped his fingers. And, as if in response to his wishes, the last rays of the setting sun came shining through the window like a flashlight that dazzles us before plunging us into darkness.

On the bus that took me back to school I clutched the book to my chest and blessed the name of the mysterious Skimpole. A traffic light turned red. The bus, imprisoned in a long line of cars, stopped in the middle of Rue St-Sernin. It was already dark. A milk-bar with aggressive neon lighting had replaced the Café de la Détente. So it took me a while to recognize our building. The owner of the dry cleaner's had removed the dividing wall that had formerly partitioned off the back room. The four enormous front-loading washing machines with doors like vacant staring eyes occupied exactly the same spot where I used to play with my tin soldiers, and where my father had shagged Mademoiselle Coralie. A middle-aged woman sat knitting in front of one of them, keeping an eye on her washing. I was seized with a desire to get off the bus and go and sit down next to her. Contemplating the memories that tumbled among the knickers, bras and nightdresses.

With *Bleak House*, my obsession took a different turn: I changed from adoring votary to lustful lover. No longer did I turn the pages with a trembling finger, smitten with admiration. I devoured in great haste, without taking the time to savour them, the twists of the plot and the flesh and blood of the main characters: Esther and her smallpox, Jarndyce and his legal case, Lady Dedlock and her cold-as-marble

despair. But I delighted most of all in the little tidbits with which Dickens had served up the dish, secondary figures, improbable ectoplasms scattered through the thickness of the pages like gargoyles on the heights of cathedrals: Mrs Jellyby, the philanthropist, who imperturbably engages in moralizing correspondence about the distant 'natives of Borrioboola-Gha' while her own children, left to themselves, almost fracture their skulls on the staircase; the horrible old Smallweeds who throw cushions at each other and then get themselves 'shaken up' like pillows; the shooting gallery assistant Phil and his 'curious way of limping round the gallery with his shoulder against the wall, and tacking off at objects he wants to lay hold of, instead of going straight to them, which has left a smear all round the four walls, conventionally called "Phil's mark".'

They were real. They existed. Beside them, my life had little more substance than the shade of the big oak trees outside the dormitory windows.

The following Saturday, when I returned to the bookshop and Krook greeted me with a deeply resentful 'Already?', I thought he was reproaching me for my voracity. But it was nothing to do with me. At the back of the shop, a very pretty woman of about thirty, wearing a light skirt and a bolero, was glancing over the shelves under the furious gaze of the owner of the premises. And yet she was a Taker: one of those ideal customers who make no noise, ask no questions, and go away with their arms full of books without demanding even the smallest discount. When she left Krook breathed deeply, inhaling the vanilla perfume that still lingered among the books.

'Now pull yourself together, Krook,' he murmured to himself.

Then he turned to me.

'So, you've already finished your book. What are we going to do about you, my boy?'

He had regained his smile and gave me a friendly handshake.

'Let's see . . . Here we are! Why not this?'

'*The Mystery of Edwin Drood* . . .'

'Hachette, 1884. Certainly not the best translation but it's a little foxed. I think it would be in your price range . . . Or else, if you're patient, I'll find you a . . .'

60

'No, no. I'll take it.'

'Goodness me! What enthusiasm!'

Like the first time, he led me to the back of the shop but before uncorking the bottle he took a long look at me, sizing me up.

'Can I ask you a question, young man? How old are you?'

'Uh . . . fifteen.'

'Yes . . . let's say, more like twelve or thirteen. I fear I slightly misjudged the dosage last week.'

He raised the bottle, winked, and make a mark just below the surface, then poured into each glass the equivalent of half a thimbleful.

'That seems more reasonable. Cheers!'

Not without pride, I knocked it back in one. I felt perfectly relaxed. This was not the effect of the alcohol but a pleasant sense of security, of belonging. Without paying any attention to me he started tidying up his bills. I was no longer an outsider. Krook had adopted me once and for all.

'I'd like to ask you a question, sir.'

'Hmm? Go on.'

'That woman earlier, who was she?'

He turned in surprise. But soon an amused smile played on his lips.

'That woman? No one. A stranger. Quite simply a beautiful stranger. I'm wary of beautiful strangers because – Good Lord! To think I paid three hundred francs for this pile of rubbish! – because they come back and haunt me in my dreams, and the more beautiful they are, the longer they stay with me. I even measure their beauty by the number of nights I spend with their ghost. The little salesgirl at the bakery, with her turned-up nose, she's good for two nights. With the lawyer's wife at number 10b, it was a week. But with that girl today, I've a strong feeling it'll be a month! Does that satisfy you?'

'Yes, but is it such a bad thing to dream about women?'

'Normally, no, but in my . . .' He broke off, poured a little whisky into his glass. 'You know, young man, the usual practice is for children to confide in adults, not the other way round. Let's take things slowly, shall we? Now you tell me a secret, and next time we'll go a bit further. One secret in exchange for another. OK?'

61

'OK!' As it happened I did have something that I very much wanted to tell him, something no one else had ever heard. 'I have dreams too.'

He started laughing. 'That's no secret! That's normal at your age!'

'No, not that kind of dream. I dream about words.'

'What do mean?' Krook kept staring at me. He seemed almost worried all of a sudden.

'I don't know. I see them in my dreams. They move around. Sometimes they touch me. I don't know anything about them, except for the fact they're words and they're alive.'

'Alive,' he repeatedly thoughtfully. 'Yes, alive, that's right. That's exactly right.' Then he resumed his work as if nothing had happened. 'I really ought to tell you something about Drood. Would you believe. . . . but no, you'll see for yourself.'

This little additional mystery only whetted my appetite. No sooner had I got back to the dormitory than I started subjecting *Edwin Drood* to the same fate as *Bleak House*. I gobbled it down. Two hours was all it took me to get to the end of the introductory chapters. I made the acquaintance of the disquieting Jasper, concocting unspeakable schemes in an opium den. Then the same Jasper, respectable choirmaster in the small town of Cloisterham, and suspiciously curious about the cathedral crypt. His pupil, Rosa Bud, for whom he harbours a passion no less obsessive than it is secret, and whom he holds enthralled by his hypnotic looks. And finally Edwin, Jasper's nephew, engaged to Rosa by the wish of their deceased parents. I immediately took a dislike to this rather lacklustre character of conventional affability, and his disappearance two-thirds of the way into the novel wrang no tears out me. Was Edwin dead? And if so, who had killed him? Certainly not his rival Neville Landless, a reckless hothead, too obvious a suspect, but perhaps his sister Helena, she too endowed with hypnotic powers – an aura of mystery surrounded these two characters, on account of their childhood spent in the Indies ... More likely, Jasper, resorting to murder most horrible to gain possession of the innocent young girl Rosa and thereby condemning himself to the hell of his guilt. And who is this fellow Datchery that turns up out of nowhere in chapter eighteen? A new

character? But then why does he wear a wig? Could it not be Neville in disguise so as to confound Jasper? Or Bazzard, the theatre-mad clerk who must know something about the art of disguise? Or Edwin himself?

On Sunday evening shortly before midnight, with my torch batteries running down, I got to page 324 and read:

*Mrs Tope's care had spread a very neat, clean breakfast ready for her lodger. Before sitting down to it, he opens his corner-cupboard door; takes his bit of chalk from its shelf; adds one thick line to the score, extending from the top of the cupboard door to the bottom; and then falls to with an appetite. THE END.*

An exclamation escaped me. The boy in the bed next to me groaned but did not wake. Bare-footed on the freezing-cold tiles, I scampered off to the toilets and locked myself in until dawn. But this second reading did not reveal the clues I thought I must have missed. Krook's truncated warning came back into my mind, and I had to recognize the obvious: *Edwin Drood* was unfinished.

From Monday to Thursday I drifted from the dormitory to the class-room, from the classroom to the refectory. I felt horribly deprived, as though by the sudden death of a friend I'd just made. I wanted to shout my protest in the face of the world. On Thursday night I had an absurd dream: Datchery was sitting at the table in his small bachelor lodgings, eating bread and cheese. Suddenly the walls of the room began to tremble, the roof opened up, and the livid face of Dickens appeared above him. 'The end,' whispered Dickens in a lugubrious voice, before picking up Datchery in his two fingers — I clearly saw a wig of long grey hair fall on to the table — and tossed him out of my sight, into the void.

In the morning I opened *Edwin Drood*. The leather binding was cold. The sound of the pages turning was a deadened, sepulchral sound. For the first time in my life a book inspired me with disgust.

Until then I had been reading the same way that you drive a car: without thinking about the engine. But the car had stalled — *Edwin Drood*

63

had broken down. I lifted the bonnet. Instead of pistons, spark-plugs, and screws, I found dead flesh. A heart to pump energy from one chapter through to the next, no longer beating; arteries to oxygenate the paragraphs but the blood had ceased to flow. All this was laid out before me, obscene meat, the entrails of a corpse. Sculpted in their unfulfilment, Jasper, Drood, Datchery, the opium den, Cloisterham cathedral were like organs without a function. I suddenly understood the significance of the spell unfinished masterpieces have always cast over men. They present the shocking but fascinating spectacle of death. Requiring only the simplest extrapolation, they provide an insight into what every book – and every living being – is in its basic substance: a cadaver in reprieve, more or less skilfully cloaked in a shred of eternity.

I heard alarms bells ringing. But it was probably already too late: I could no longer live without this spectral immanence, the sickly smell of death.

The years went by. At seventeen I had exhausted my passion. I was no longer the frantic lover but the surfeited, fastidious, obsessive collector in search of curiosities. I had of course read all of Dickens but also all the biographies, all the critical studies in the Mably Library. I ransacked jumble sales, house clearance sales, second-hand bookshops. I had the predator's sharp eye and extraordinarily keen sense of smell. In the most unlikely hunting grounds I was able to flush out the game: it took me only a few seconds to spot a passing allusion to *Oliver Twist* in a fifteen-hundred-page pedagogical treatise. Certain magic words – Pip, Copperfield, Pickwick, Drood – brought to a white heat by my covetousness, gave off a glow capable of shining through the pages and bindings like a beacon cutting through fog.

Especially Drood. I knew by heart the vast corpus of Drood literature, that grandiose and chimeric hotchpotch, that unprecedented literary autopsy that has been going on for over a century. Every possible solution to *The Mystery of Edwin Drood* (referred to by specialists among themselves as MED) had at some time or other been envisaged and expounded. For a few dilettante geniuses – Conan Doyle, Shaw, Chesterton – it was a mere hobby offering relaxation from their real work. But for others

– school teachers, failed journalists, exegetes of the non-existent, sleuths of the unverifiable – it was the work of a lifetime. There were the Protesters of Innocence, those who against all reason maintained the innocence of John Jasper, naming improbable alternative suspects, elaborating weird stories based on Thugee rites or mesmerism, and chewing over and over the slightest 'clue' left by Dickens to support their case. The more serious-minded Resurrectionists did not attempt to defend Jasper but were of the opinion that Drood was not dead, that he would inevitably have reappeared at the end of the novel to thwart his uncle. The Undertakers, their fraternal foe, defended the contrary thesis. Lastly, others, less ambitious, confined themselves to the secondary issue of Datchery's identity, like philologists who have given up the attempt to decipher some mysterious language in order to devote their whole life to a single hieroglyph. Of course the latter tore each other to pieces, and were divided into rival factions: Bazzardians, Droodians, Landlessians. I could, with my eyes shut, have laid out on the battlefield of Dickensian studies everyone involved in this little world, as easily as I used to position Grouchy, Cambronne and Blücher. As with tin soldiers, it was a game that could be endlessly replayed: this gave it a sickening charm.

Until that Sunday at the St-Michel market. It was past midday. It was threatening to rain. The stall-holders were already beginning to pack up when I came across the pamphlet. *Spiritist Review, French magazine of the International Spiritism Movement, August 1929: Homage to Allan Kardec. Celebrities relate their first spiritualist experience.* Poor-quality paper, yellowed pages stuck together with damp, inept typesetting: the kind of crap any good book dealer would waste no time in throwing into the bin. Except that a signature at the top of this obscure rag caught my attention.

'Sonny! Hey, sonny!'

Grudgingly I raised my eyes from the pamphlet. I had already located, a few paragraphs on, one of those magic words that attracted me like a magnet.

'You'd better make up your mind now, son: either you buy it or you put it down because I'm shutting up shop, you understand?'

I paid some derisory sum and walked briskly to the terrace of the Café des Arts. Not bothered by the wind that despite the protective screen blew rain into my face, I sat down at the first empty table to resume my reading.

# V

# My First Spiritist Seance

## (by Arthur Conan Doyle)

Seventy years ago to the day Allan Kardec became dis-embodied. This doggedly scrupulous thinker has done so much for the spiritist movement that it may seem unnecessary to celebrate his memory. Yet the battle I have been waging for years now for scientific recognition of its precepts has not yet succeeded in winning for them the credit they deserve. This battle is of great importance to me, both intellectually and personally. In fact, allow me to recall that the day on which Kardec left the physical world is also the date of my birth. Coincidence or sign of destiny? The future may tell us.

Sceptics of every shade and hue believe it to be a fact that my involvement in the spiritist cause dates back to 1916. They stress that during that troubled period recourse to what they call 'the irrational' was common currency – a kind of bulwark against the appalling embrace of death. They are doubly mistaken: first of all, my spiritist convictions have never undermined my faith in reason, quite the contrary, and I have always taken care to apply to the study of these phe-nomena the scientific methods dear to a certain detective of my acquaintance. Furthermore, as early as 1887, I pub-lished in *Light* magazine a defence and example of spiritism, and created at my home at Bush Villas a first circle of practitioners.

But to reply to your enquiry, I would have to go back three years earlier, to 1884. By the merest chance, the last surviving witness, apart from myself, of that particularly unusual seance

has just passed away. And I therefore think I can give your readers an account of it without betraying the promise I made to myself.

At that time I had established a medical practice in Portsmouth but there was a shortage of patients and the few undistinguished stories I had published in *London Society* or the *Cornhill* magazine only just afforded me a little marmalade to spread on my toast. My cousin Lilian had several times already charitably lent me some assistance, in defiance of the disapproval of her father (my uncle, with whom I had fallen out). So on that dreary morning of 5th July 1884, I feverishly opened her letter.

My dear cousin,
Armand and I have been following with interest your first ventures into the world of literature! You know that we receive at home every week – if you came, you could meet some important people who might promote the development of your career. And next Thursday in fact we will be presenting to our guests an 'attraction' that will surely be of interest to you!
We're counting on you!

PS My father is away from London for several days.

Of course I had been hoping for some more 'tangible' assistance – in the form of a cheque or money order. But the invitation was nonetheless enticing. Since moving to London, Lilian's husband Armand Dumarçay – an extremely wealthy Frenchman, owner of a number of factories on either side of the Channel – had been spending freely of time and money to restore to the literary salon of Cambridge Terrace the lustre it used to have in my grandfather's day when you might have met on the same evening Wordsworth and Dickens, Thackeray and Carlyle. And it was with mixed feelings of apprehension

and pride that the following Thursday I pushed open the door of the large house in Regent's Park.

Lilian had not been lying. Round the huge fireplace, seated in Georgian armchairs that were more handsome than comfortable, were James Hogg, director of *London Society*, Alfred Byat, at that time a very prominent critic, and more importantly two of the greatest writers of their time whom I revered – and still do – as gods: Messrs Wilkie Collins and Stevenson.

Aged about sixty at the time, his health failing and undermined by the excessive use of laudanum, Collins was unfortunately no more than the shadow of the magician who had spellbound public and critics alike with *The Lady in White* or *The Moonstone*. Behind thick glasses his myopic bloodshot eyes settled cautiously on people and objects as if the very act of seeing were painful. His face was seized with nervous twitches and furthermore the right side was also peculiarly asymmetric, caused by some facial rheumatism. With his hands on his knees, he rocked back and forth in his chair with the mechanical regularity I have had occasion to observe in certain opium addicts. At odd moments in the course of the conversation, which he evidently perceived through a kind of fog, there was not much more than a smile, a frown, an ironic expression to betray intermittently the subtle mind that age and suffering had imprisoned in that unattractive body. It must surely have taken a lot of persuasion – or an argument of considerable weight – to wrest him from the solace of his phials and the peace and quiet of his room.

What a contrast with Mr Stevenson! Although he too is in poor health – in fact he had just been in Bournemouth recovering from a bout of his chest ailment – the Scotsman seemed composed, in good spirits, confident in the future. How could he not have been? A few months earlier *Treasure Island* had met with considerable success. Throughout the Empire no one talked of anything else but the adventures of

Jim Hawkins and Long John Silver. Beneath a fine neatly trimmed moustache there was a faint smile on his thin lips. His piercing eyes seemed fixed on some mysterious point beyond the room, where perhaps the beginnings of his next masterpiece were already shimmering. If I had been less awed, or less naive, this unexpected encounter between a star in its decline and a star at its zenith might have inspired in me serious reflections on the transience of literary celebrity. Standing behind his armchair, Fanny Stevenson had laid her hands on her husband's shoulders, no doubt to keep him warm in his famous cape but probably also to claim a share of that celebrity.

As might have been expected, Collins bestowed on me a mere closing of his eyes, and Stevenson a cordial but distracted handshake (at the last minute discretion led me to forgo the idea of mentioning the Edinburgh connection between his family and my mother's). Armand Dumarçay, noticing my perplexity, saw fit to introduce me to another guest standing a little to one side.

'My old friend Évariste Borel. He has come specially from Paris.'

The man greeted me stiffly. It was hard to say how old he was, for his grey hair was at odds with his bearing which was that of a gawky adolescent. His attire was very careless, even for a Parisian. Ill at ease in these archetypally British surroundings, he was already revealing signs of impatience which our hosts with good reason might have considered impolite.

'And are you also a man of letters?' I asked out of sheer politeness.

He rudely looked me up and down.

'Schoolmaster!' he muttered.

I did not like his furious little eyes, his scornful grimace. There was in him an unpleasant combination of excitedness and arrogance, fervour and cynicism.

However, conversation round the fire was flagging. Hogg suppressed a yawn.

'Well, my dear friend, what about this surprise of yours? What are we waiting for?'

Dumarçay gave a sly smile. 'Patience . . . We're waiting for Mr Dickens.'

I could not help observing Wilkie Collins. Like everyone else, I knew of his relationship with the immortal author of *David Copperfield*, and the remark seemed to me in very bad taste. But Collins showed no reaction; he continued rocking in his chair.

At that moment a distant doorbell rang.

'I think I can guess what you're up to, Dumarçay,' Byat said, placidly puffing on his cigar.

Two very dissimilar individuals were led into the drawing room. One of them, a red-faced stocky man, talking in a loud voice with large gestures, introduced himself by the name of John Wilkinson, a businessman from Baltimore.

'And this is my friend and employee Morris James.'

I then recalled an article that had appeared in *The Times* a few weeks earlier, announcing the arrival in London of an American medium who claimed to have written the ending of *The Mystery of Edwin Drood*, dictated to him in 1872 by Dickens himself – who died, as everyone knows, two years before. 'Neither Mr James nor his impresario Mr Wilkinson' – the *Times* journalist commented sarcastically – 'have been able to provide us with the precious document . . . The only existing copy was apparently destroyed in an unfortunate fire in 1877. But they cite in support of their outlandish story the testimony of a leading light of the literary world, Mr Stone, critic of the *Springfield Daily Union*, and they place themselves – for a modest remuneration – at the disposal of all London fans who might wish to relive that experience!'

I have always considered *Drood* to be Mr Dickens's worst novel. I think that surprising and regrettable incursion into

the genre of the mystery novel was solely inspired by jealousy of his friend Collins. Alas, a composer of symphonies does not necessarily have the gift for comic song. In my view there is no doubt about Jasper's guilt. It is so obvious from the very first pages that the reader is left feeling a kind of embarrassment. As for the famous Droodian controversy – is Drood dead or alive? – it seems to me pointless. Yet some of my friends, including writers of great talent, think Dickens deliberately tranquillized his readers, allaying their suspicions, and that he was preparing a stunning sensational twist. Possibly. But what I chiefly identify in this belief is a phantasm cherished by many novelists: a work whose last paragraph – last line, even – would completely overturn its meaning and plunge the reader into a kind of daze close to mystic ecstasy, as if after long hours climbing in the mountains they were suddenly to come face to face with the sea . . .

Morris James was a strapping young fellow, with a freckled face and big calloused hands. In a suit that was too tight for him, his powerful limbs were ridiculously constricted. Unused to wearing town shoes he had a bad limp in his left foot, and he spoke in monosyllables with a dreadful yankee accent. In short he displayed all the characteristics of a country bumpkin someone has vainly tried to make presentable.

As I observed him I noticed that Fanny Stevenson had taken my cousin aside. I was too far away to follow their conversation but a few words were distinguishable – 'bankrupt', 'notorious', 'swindler' – and the American woman's angry expression amply conveyed the scant regard she had for her compatriot Wilkinson.

No doubt she was arguing for the pure and simple cancellation of the meeting. I knew Dumarçay well enough to know he would never consent to such measures. In any case it was too late. Most of the guests had taken their places at the heavy round table intended to serve for the occasion. Some, such as Mr Stevenson, out of mere politeness, others, like Mr Hogg,

out of curiosity, yet others prompted by the secret hope of unmasking some kind of fraud – among them, Byat, who wore a sceptical smile. As for Wilkie Collins, taking Armand's arm, he had simply slipped out of one armchair into another and was now facing the medium, with the indifferent expression of a bridge player who has not yet been dealt his cards. For my part I was seated on Morris James's left, and the scowling Frenchman, Borel, on his right.

A writing-pad and pencil had been placed in front of the medium, who picked up the pencil in his fat fingers and held it a few centimetres above the blank page while Wilkinson called for silence. Morris James closed his eyes and fairly rapidly established contact – at least that is what he claimed – with the spirit of a certain Plainwhistle of Bristol, hanged two years earlier for the murder of his wife and two children. (The following day I had no trouble in tracing the story in the newspapers of the day . . . which proves nothing, of course: Wilkinson and James could very well have carried out the same research.) In clumsy handwriting James transcribed the dead man's message, which I was given the task of reading aloud – taking it upon myself to correct his grammatical errors: 'I am very sorry for my act of madness, and would like you, please, to pray for me.' Then it was the turn of a peasant from Ukraine who did not give his name, and complained of having been attacked and killed by a British soldier during the Crimean War. 'But I bear no grudge against the English. Where I am now there is no hatred!' At these words Byat burst out laughing.

'Better and better! Our friend's now translating from Russian!'

Morris James opened his eyes and gazed at the sheet of paper with a dazed air. Obviously accustomed to this kind of incident, Mr Wilkinson began to speak. With the imperturbable self-confidence of the travelling salesman boasting the merits of his mechanical broom, he explained xenoglossia to

us, that capacity of mediums in a state of trance to understand languages of which they have not the least understanding in their waking state.

'So, Mr James speaks Russian fluently because he is in direct communication with the mind of the deceased.'

'To be sure,' Byat muttered into his beard, 'he speaks it even better than English.'

Ignoring this remark, Wilkinson turned to the medium.

'Please, Morris, concentrate harder. Could you summon Mr Dickens?'

'I . . . I don't know,' said James. 'I'll try.'

I have to say, at that stage of the seance I came close to sharing Byat's doubts. Wilkinson's attitude, his horse-trader manner and his overly smooth patter did not inspire me with confidence. As for James, his mind seemed to me as unsubtle as his fingers, and as far as I could tell he had as little aptitude for making contact with the departed as for painting miniatures or repairing watches. But what happened next put an end to my speculations, at least temporarily.

Morris James had closed his eyes and under Wilkinson's instructions we had reformed the circle, when the table – an ancient piece of furniture in solid oak that must have weighed a good four hundred pounds – gave a kind of shudder before rising two or three centimetres into the air. Byat immediately bent down to try and catch the Americans in the act of chicanery, which immediately caused the table to drop.

'Don't break the circle!' cried Wilkinson.

Then he asked Morris, 'Have we lost it?'

'No . . . the spirit is still here . . .'

'Who is it? Let it identify itself!'

The pencil slowly moved across the page and I read the letters one by one as they took shape: 'D . . . I . . . C . . . K . . . E . . . N . . . S . . . Dickens!'

This time a gleam of interest lit up Wilkie Collins's dull eyes. But this was nothing compared to the way Évariste

Borel's eyes were set ablaze! So far the Frenchman had been hardly less sarcastic in his comments than Byat. He kept shaking his head and sniffing loudly. But from that moment on he stared fixedly at the pencil and paper, as if all his reservations had been swept aside by the mere invocation of Dickens's name.

'Does he have a message for us?' asked Wilkinson.

'Yes . . . yes . . . wait! It's going . . . too quickly . . .'

In fact the pencil was now racing, transcribing snatches of phrases, fleeting allusions, groups of words that, removed from their context, were difficult to understand the meaning of.

'. . . the fight of my life . . . cherished me . . . when my father showed me the house . . . I failed to . . .'

James eyes rolled back, his hand clutched the pencil as if to prevent it from escaping his control. And yet, I soon noticed with amazement, the writing that emerged from this convulsive gesture was much more fluid and neat than before. The letters were joined together with ease and regularity – the t and the h in particular were combined in a very distinctive kind of flourish, the spelling was correct.

'Poor, poor Mary! . . . all those suffering children . . . I hear crying . . . will forget all about me . . . the graves of the Copperfields . . . they are all around . . . passed by . . . the cloth on the coffin . . . in the river . . . my god! Save that man, he's going to . . .'

Suddenly James threw the pencil with incredible violence across the room and gripped the table with both hands.

'I . . . I can take no more!' he cried. 'He's right here. My god! He's trying to . . .'

'Good lord!' murmured Wilkinson. 'He's going to speak!'

Indeed Morris James opened his mouth but the voice that we heard was not his. It was a higher-pitched voice, slightly drawling, with a trace of a cockney accent and a hint of a lisp. The expression on his face had changed too: his features had hardened, the eyelids drooped a little. His lower lip became

more prominent, especially on the left side, jutting out in a kind of pout, and his light-coloured eyes darkened.

'The strength!' uttered the voice. 'I lacked the strength!'

Then Wilkie Collins rose, as white as a sheet, and holding his head in his hands he cried, 'Send him away! Send him away!'

'Not now!' thundered Wilkinson. 'He has more to tell us!'

'Could he answer some questions?'

Mr Stevenson had been so discreet until then I had almost forgotten him. His calm voice was at odds with the general hysteria. He observed the medium with measured 'professional' attention, as he might have examined a specimen – perhaps with the object of one day turning his observations to literary advantage.

'I don't know,' said Wilkinson. 'We can always try.'

'Ask him about Drood,' whispered Borel.

At the mention of that name the medium stiffened. He ran his hand through his hair, slicked back with sweat, revealing his broad white forehead with a single line across the middle of it.

'Drood!' the voice repeated. '. . . didn't have the strength . . . great struggle in the chalet . . . until evening . . . I had to do it . . . the circle . . . the circle since Pickwick . . . my head! My head! . . . Georgina! Yes, on the floor . . .'

'But Drood! What became of Drood?'

'Alive!' the voice said simply.

'Liar!'

With a furious gesture the Frenchman pushed his chair away from the table and crossed his arms, ignoring Wilkinson's remonstrations.

'Join the circle again, please! This is extremely dangerous!'

'But Jasper wanted to kill him,' said Mr Stevenson, as calm as ever. 'That is so, is it not?'

'No! Jasper is . . . innocent . . . the Landlesses . . . horrible rites . . . the revenge of the Thugs . . . oh, my head! My head!'

'Imposter! You're nothing but an imposter!'

Borel hurled himself at James and shook him by the shoulders. Wilkinson and Byat tried in vain to make him let go while Dumarçay, having slipped on the waxed parquet floor as he came running to help, was crawling under the table. To add to the general confusion Mr Collins chose that moment to faint. In the minutes that followed I devoted myself entirely to his wellbeing. Assisted by Hogg, I carried him into an adjoining room. The writer's body seemed strangely light. His pulse was very faint, his brow feverishly hot. Half-conscious, he gripped my arm and muttered very urgently, 'Send him away! Send him away!'

A little later, under the effect of my sedative, he fell asleep. I returned to the drawing room to find Lilian in tears. It was she who described to me the sorry end of this strange seance. It took the combined strength of four men to frog-march Borel out of the house. Struggling against them all the way, he had woken up the whole neighbourhood with his protests. 'Imposters! You're a band of imposters!' And Lilian was very much afraid her father might hear of this scandal, especially as Wilkinson had threatened to bring a legal action for the assault on James. However, a few minutes' private discussion with Dumarçay had miraculously calmed his anger. As for the medium, he had just as miraculously regained his doltish and disgruntled appearance and was apparently prepared to give the Frenchman a thrashing at the first opportunity.

Outside the rain was falling. Hogg, Byat and I jumped into the first cab that came along.

'What is to be made of all that, gentlemen?'

Byat said with a derisive laugh as he stuffed his pipe, 'A hoax!'

'It was certainly Dickens's handwriting,' remarked Hogg. 'I have several letters written by him.'

'My dear fellow, I know someone who is a past master in

that kind of exercise . . . He can do you a fake Keats in a half an hour!'

'Perhaps so . . . but the voice?'

'Everyone knows that Dickens had a lisp. Speech defects are a godsend for mimics!'

'You credit that Connecticut bumpkin with a great many talents . . .'

'That's exactly what's so ingenious about it! I've been to America twice . . . They have a name for that kind of person over there: a carpetbagger. Believe me, this James's rustic manner is a sham. I believe he's more shrewd and cunning than our best lawyers. I even think . . . Well now! What can they possibly have to say to each other?'

We had just turned into Fleet Street. A cab was parked outside a modest family boarding house. Inside the carriage I recognized the figure of Fanny Stevenson. Outside, under the rain, Évariste Borel and Robert Louis Stevenson stood facing each other. The Frenchman was talking animatedly. Leaning against the cab, the writer was taking in every word. Nodding from time to time, he viewed his interlocutor with the same wise and attentive gaze that I had noticed a little earlier in the evening.

'In any case,' sighed Hogg after a pause, 'what a golden opportunity for a publisher . . .'

'What do you mean?'

'If those three had been able to work together . . . The forcefulness of Dickens, Collins's ingenuity, Stevenson's elegance . . . What a masterpiece they might have written!'

Who knows, dear reader of the *Spiritist Review*? Perhaps one day another seance will bring these three geniuses together. This exceptional challenge, among thousands more, now falls to the worthy heirs of Allan Kardec. The horizon is distant, the task inexhaustible. Light will never definitively triumph over darkness. Even today I cannot say with certainty whether the performance of Mr Morris James – who passed away in

Boston three months ago, your June issue informs me — was based on illusionism or the authentic merits of a medium (these two hypotheses are not in any case irreconcilable: it has often been the case that by their contrivances unscrupulous charlatans bring into disrepute very real talents). Our presence on earth finds its ultimate justification in this: the perpetual pursuit of a truth that remains hidden.

In memory of Allan Kardec.

For weeks I went through all the records I could lay my hands on, including those held by the British Council: nowhere was there any reference made to this important seance that Conan Doyle described, or to anyone by the name of Évariste Borel.

One night I had the following dream:

I was flying over a desert, crisscrossed with paths in a perfect grid layout. Travelling from all four points of the compass were caravans slowly proceeding on their way into the desert, forming circles, arcs of a circle, triangles. Little by little, I became aware of the bizarre shape of the vehicles of which these caravans were constituted. They were letters, and these letters formed words. On the desert's blank page the words drew a nose, a mouth, staring eyes. A face.

# VI

'Look who's here! It's the Eunuch.'

'Preignac? Why do you call him that?'

'Because that's what he is.'

'A eunuch? How do you know?'

'We're distantly related. My great-aunt knew him as a young man. When France fell to the Germans he fled on foot, along with the best part of his regiment. One evening he went a little way off the road to take a leak, stepped on a mine, and boom! Lost his balls! And you know what? It was the eighteenth of June 1940. When my father's had a few, he still tells that story. He says Jean Preignac's balls were the first to answer De Gaulle's call to fight on!'

Chuckling together, the two students joined those filing in. I held back a little, pretending to be looking for something in my bag. I always followed the same procedure: I waited until everyone was settled before I took my place in the lecture theatre, one row above the last to take their seats. In this dark and confined space, with its old knotted wood panelling and flights of stairs that creaked when you stepped on them, where you breathed the sweat of several generations of students, I always felt oppressed. The idea of someone sitting behind me, looking down from above on my haircut or my notes was quite simply intolerable.

How did I come to be here? By virtue of the law of excluded middle, I suppose. After the baccalauréat you either have to start work or enrol as a student. Well, no urgent necessity obliged me to opt for a job. When I came of age my uncle's pocket money turned into a modest income, and I do not know what administrative device converted my school fees into a student grant. Nor did I have any uncertainty in choosing between arts and sciences. Though average in nearly all subjects, I was absolutely

hopeless at mathematics. As for the much-vaunted, Aspects of English Literature option, I would have preferred to avoid it. I did not want to get Dickens mixed up in this rigmarole. Unfortunately, the only alternative – The Russian Novel and Society – was fully subscribed. During the summer, channel two had broadcast an American made-for-television film adaptation of *Crime and Punishment*, with an ex-baseball champion in the role of Raskolnikhov. Besides, the students who had failed their exams and were repeating the year very soon allayed my apprehensions: for Jean Preignac, English Literature began with Shakespeare and ended with Shakespeare.

If my life had actually been a novel Jean Preignac would probably have been among those unsuccessful minor characters cut out at proof stage. The author has done what he can. He has given this grotesque grub a suggestive surname, an eccentric life-story. He has exaggerated the characterization, in vain. The embryo has not come to life. The puppet strings remain visible. One day the editor calls: 'Sorry, old chap, but it's still too long. You need to cut about twenty pages.' 'But I've already . . .' 'Now in chapter six, for example, the passage with your Jean Préchac . . . 'Preignac . . .' 'It's of no interest. It breaks the rhythm.' 'But I thought that by introducing a touch of irony . . .' 'It doesn't make anyone laugh. It's got to be cut.'

But this is a real-life story and however pathetic and unintentional it might have been Preignac's role cannot be passed over in silence. I can still picture him as he appeared the first time I saw him: an unlikely cross between a village priest – similarly tonsured, with a little pot-belly, ingratiating smile – and a senile street-hawker. He was the first to succumb to the soporific power of his monotonous voice. And so as not to fall asleep completely, every two dozen words he gathered a kind of impetus, accompanied by a curious clearing of his throat that reminded me of the noise of the friction-powered toy cars of my childhood. After a few seconds the impetus foundered in the mire of his thick diction, the sentence ground to a halt like the toy car reaching the end of its course. Then came another clearing of the throat, and so on, for an hour. By this mechanism the Ministry of Education gong pinned to his jacket lapel was set swinging wildly.

81

'But soft! What light through yonder window breaks?' droned the friction toy. 'It is the east and Juliet is the sun!' At this point the squeak of the door opening drowned out his voice. Someone made the steps creak and came and sat down just behind me, noisily laying his books on the bench. He grazed me with his hand as he did so.

'. . . since she is envious; Her vestal livery is but sick and green, And none but fools or dickens do wear it.'

Preignac had insisted heavily on the two syllables – *di-ckens* – letting his no doubt would-be teasing gaze wander over us. But he was defeated in his object: the torpor, the philistinism of the groundlings were equal to his own uselessness. If the friction-powered car had kept going unchecked for the past fifteen years it was because its wheels were operating on a perfectly smooth surface, the asphalt of minds previously levelled by the Faculty's diggers and bulldozers. At the very most, two or three 'serious students' in the front row exchanged a few puzzled glances, or turned to their English Literature textbook to find a literary timeline.

'Well, ladies and gentlemen, which of you can explain the incongruous and to say the least, um, anachronistic presence of this word in the bard's text?'

Slowly Preignac's gaze climbed the tiers and seemed to settle on me. I felt a violent wave of nausea.

'For instance, you at the back . . . yes, you, sir?'

I was about to start screaming when a voice behind me responded.

'Mangematin. Michel Mangematin . . . Dickens as used here derives from the word dick, sir, a familiar term meaning something like foolish or crazy . . .'

It was a clear pleasant voice with a hint of affectation.

'Charles Dickens often played around with his own name . . . he sometimes signed his letters Dick . . . and in *David Copperfield* there's a very sympathetic character, a gentle loony who answers to the name of Mr Dick.'

'Excellent, my friend, excellent . . .'

'Furthermore, Shakespeare and Dickens shared a weakness for bizarre or comic names . . .' And the voice added casually, '. . . as you point out in your book . . .'

82

This time the groundlings reacted. That Jean Preignac should be the author of a book, it has to be admitted, was truly unimaginable. It was tantamount to suggesting that a friction-powered car could win the Twenty-Four Hour Le Mans race. A shockwave went through the amphitheatre. As for Preignac himself, he looked like a cartoon character: his lower jaw had dropped almost to his chest.

'You . . . you've read my book? But it's been out of print for . . .'

'Anyone who wants to take the trouble can always track down a good book . . .'

This was too much for Jean Preignac. He was sweating profusely. His hands trembled with emotion. His rolling eyes, his pallid complexion signalled he was close to fainting. Fortunately, the bell cut short his ecstasy.

'Www . . . well, well . . . until next Tuesday then . . .'

Not without difficulty, I resisted the temptation to turn round and look at Michel Mangematin but I heard him muttering as he gathered up his belongings.

'Pathetic old fool!'

'You'll be the ruin of me, Skimpole, I swear! And when I am ruined, you just try and get yourself hired on one of those wretched cargo boats! No one will take you, not even as a cabin boy!'

Since that day long ago when I came across his name among the protagonists of *Bleak House* I knew that Skimpole did not exist. But by common consent Krook and I had maintained this fiction. The bookseller resorted to it every time he gave me a good deal. His own generosity made him uncomfortable, as if it implied a special relationship between us that it was difficult for him to admit to. Doubtless for the same reasons we referred only rarely and never in any depth to my passion for Dickens even though it was obviously not unconnected to the interest he took in me. For a long time I mistook for discretion an attitude in him that now seems to me more uneasy, a kind of reticence, a fear that he felt towards me. In fact he was someone with many other latent ambiguities: this often open-handed dilettante could sometimes be extremely tough in his business dealings. I discovered this one day in October, shortly after that famous class of Jean Preignac's.

Krook had taught me how to play chess. I played sitting at his desk, with him standing in the doorway so he could keep an eye on the shop. That morning the shop-bell tinkled. Krook disappeared, grumbling. He had my rook pinned with his knight, threatening my king and queen with an inescapable fork. Losing interest in the game, I let my gaze wander. Over time the colours of the nationalist poster had faded a little and I had identified one by one all the writers whose portraits graced the wall. Stevenson in his cape, smiling weakly on the terrace of Villa Vailima. London on horseback ambling through the Valley of the Moon for the last time a few days before his death. Joyce and Svevo on a bridge in Trieste. The young Nabokov poring over a chessboard in a café in Berlin. And Thomas Urquhart, ironic and soldierly in the dress of a courtier. I had read some of their books. I had pored over their works without really getting into them. An invisible thread kept me on the brink of them, or rather an elastic leash, deceptive in its elasticity, first allowing me a glimpse of freedom before drawing me back again, gently but firmly.

'Come on, Krook, be a good fellow!'

I recognized the voice and quietly slipped into the shop. Krook stood stock-still behind the counter, just like the first time I had seen him. His customer was talking excitedly.

'I need this book, Krook.'

'I don't doubt it.'

'I have to have it!'

'Pay for it.'

'Damn it, stop playing the tight-fisted Scot . . .'

'I'm not a tight-fisted Scot. I'm a prudent Scot.'

'But I tell you, I haven't got a cent!'

'That's a great pity.'

'I'll be getting a new chequebook tomorrow. I'll come and pay you first thing.'

'Very well. Then you can have the book tomorrow.'

'Now Krook, be reasonable! Have I ever cheated you?'

'You've never had the opportunity.'

'Oh, bloody hell! I'll go buy it somewhere else.'

'If you like.'

The customer took a step towards the door, then thought better of it.

'You know very well there isn't one anywhere else. Come on, Krook, please . . .'

The bookseller calmly set about tidying his shelves.

'I'll have you know, my young friend, that in this establishment any form of credit is unthinkable. My books are not stray dogs to be lured with a bone, only to be abandoned two streets away. They need a proper master. Right now, this book belongs to me. If you want to become its master, pay for it. It's not a problem about money, it's a question of principle.'

Michel Mangematin turned to me. He did so suddenly, deliberately, as if he already knew I was behind him, as if I had been waiting there for all eternity, at his convenience.

'You couldn't lend me eighty francs, mate, by any chance?'

What was the significance of that 'mate'? A sign of recognition between two 'young people'? Or had Mangematin seen me at the university, perhaps even in Preignac's class? And in that case, had he noticed my disquiet when the Eunuch had asked his question about Dickens? His composure, his piercing gaze gave credibility to this otherwise somewhat unlikely hypothesis. There was in his question a subtle blend of entreaty and ultimatum that only left me with a choice between offensive refusal and servile consent. I rapidly considered the alternatives before replying casually, 'Why not?'

Then his eyes lit up with a mocking glint as if he found my capitulation particularly rapid and put it down to a weakness of character. As for Krook, his manner as he gave me my change seemed a little cold, which did not prevent the three of us from ending up in the back room round the bottle of Lagavulin.

'Now where on earth has that cretin Skimpole put the third glass?'

The third glass was not to be found – in my opinion it had never existed. Krook eventually took from the table a toothbrush holder that he used to keep pencils in, gave it a wipe of sorts with a cloth, and he drank out of that. I had a copy of *Little Dorrit* in my hands and Mangematin had Forster's *The Life of Charles Dickens*: as much as to say the conversation was already in progress.

85

'It's high time,' said Mangematin, 'that Dickens was taken out of the Children's Literature section to which he's has been relegated for over a century.'

If what is meant by fascination is that kind of mysterious plus-value that can transfigure ordinary, even homely looks, then Michel Mangematin was fascinating. As you listened to him, you forgot his prematurely thinning hair and precocious paunch, his close-set eyes, his weak mouth. He might be regarded as pretentious or charming, devious or subtle: in any case you could not deny him your attention. Krook often observed him with a strange look, as if he could not decide whether to give him a pat on the back or throw him out. And women, I later discovered, experienced the same confusion when confronted with him. After half an hour they either slapped his face or gave him their telephone number.

'He's a modern, a forerunner of Kafka and Gombrowicz. Never mind the philanthropic jeremiads, the superficiality, the improbabilities: the important thing is the absurdity of the situations, the absolute novelty of the language . . . And that ridiculous buffoon Preignac is not the man capable of such a task!'

'And yet, sir, you read his book.'

Mangematin looked momentarily disconcerted by the formality of the way I addressed him.

'*Shakespeare in Carpet Slippers*. I found it remaindered at Gilbert for five francs. A load of platitudes. But I need him. He's head of the English department. A little boot-licking could save me five years as a professorial assistant!'

I was not surprised. Ambition was written all over his face. But then why Dickens? Why, in the academic stakes, back this old hack instead of choosing a thoroughbred with a string of trophies to his name – Proust, for instance, or some promising filly like Duras?

He went on a bit longer about the future of Dickensian studies, then suddenly changed tack.

'I passed Graziani, the department registrar, on my way over here . . . He reminds me of that character in Nickleby, the dancing master . . . what's his name?'

86

'Mantilini.'

'That's right, Mantilini. "My essential juice of pineapple!" Hah, hah! And Preignac ... don't you think he's got a slight air of William Micawber about him?'

'Wilkins. Wilkins Micawber.'

This little game went on for a good fifteen minutes. Mangematin deliberately mangled names, pretended to get his dates mixed up, and I corrected him. Very slowly, he changed his attitude towards me, like a champion used to easy victories who at last finds an opponent worthy of him. For the first time I saw him rub his hands in that way that was so characteristic of him: the right palm stroking his clenched left fist, a gesture half-way between that of a boxer kneading his joints and that of a gastronome sitting down to a good meal. It was a gesture I was to see dozens of times subsequently, and always in the offing there was a book, object, or person connected in some way with Dickens, or else a pretty girl. He came up close and looked me in the eye.

'Have you ever heard of . . .'

The phrase remained suspended. I could tell he was in a quandary, torn between mistrustful jealousy that forbade him to reveal his secret and irrepressible pride that compelled him to declare it.

'Have you ever heard of Évariste Borel?'

It was astonishing to hear these syllables on someone else's lips. It was like being robbed of a precious possession. As if I had discovered my private diary between the covers of a popular novel with a print run of a hundred thousand copies. Fortunately Krook replied for me.

'Évariste Borel . . . I've read that somewhere.'

And he rushed out into the shop.

'If it's Anatole France's *Journal* you're looking for,' Mangematin called out to him without taking his eyes off me, 'it isn't there any more! I bought it from you last week . . .'

The bookseller came back sighing. 'Of course, of course, how absent-minded of me! Sometimes I forget my books are for sale. I seem to think I own them for ever.'

'I'll sell it back to you if you like, now that I've found what interests me. It was in June 1875, France was dining with some friends at La

87

Coupole. Someone got up from a neighbouring table and came over to him . . . "a funny little fellow" are the words he uses . . . The stranger is badly dressed . . . He speaks rapidly, obscurely . . . He behaves in a conspiratorial manner and whispers in France's ear that he has "something that might be of interest" to him. France smiles in the belief he is dealing with "a lunatic" . . . "And what might that be, my dear friend?" "It concerns . . ." – here, the stranger again lowers his voice – "it concerns Dickens!" France bursts out laughing but the other fellow is nothing daunted, quite the contrary. "You like Dickens, do you not, Monsieur France?" Suddenly intrigued, France nods. "I was there when he died . . . I know, about *Edwin Drood* . . . I heard it from his own lips . . . It's written down in black and white, I'll let you read it . . ." The man is pale, a hunted look suddenly comes over him, and France feels a little uneasy . . . "Why not right now?" The man casts a wary glance at France's fellow diners. "I . . . I don't have it with me," he stammers. "Come back tomorrow at the same time." "All right, I'll be here tomorrow but . . . to whom do I have the honour of speaking?" "Borel," says the other man, "Évariste Borel . . ."

Mangematin had an undeniable acting talent. Having listened to him, open-mouthed, Krook knocked back a glass of whisky and asked, 'And then what happened?'

'And then Borel didn't turn up. France went back to La Coupole the next day, and the day after that. He never saw him again. But never mind, there are other sources.'

Anatole France! How could I not have thought of him! I would gladly have scratched my cheeks as punishment for my negligence. But Mangematin was staring at me. Some kind of answer was required.

'Yes,' I murmured as though to myself. 'I think I've come across that name two or three times in *The Dickensian* or in the literature on *Drood*. But out of the whole procession of people that descended on Gad's Hill Place just after Dickens's death, no one so much as mentions this Borel. Neither Dickens's children, nor the Ternans. Nor Forster,' I added, pointing to his book.

'Borel had already left.'

'What about Georgina Hogarth? Why did she never mention him?'

'That wet blanket? She never said anything! It was a battle to get a good-day out of her!'

'Maybe, but the speculations of a few Dickens enthusiasts and your mysterious anecdote – that doesn't seems to me to be a great deal on which to build a case. And besides, why would Dickens have confided in a complete stranger about the ending of *Edwin Drood* when he had refused that favour to his best friends and his official biographer?'

'Because he realized he was going to die! Because he wanted someone to know!'

'Mere supposition. That's not going to get you Preignac's chair.'

'Borel existed!' he said emphatically, paling. 'I tell you, he was at Gad's Hill Place on Wednesday the eighth of June 1870. I shall prove it. I shall find his written account of it and finally resolve the mystery of Edwin Drood!'

Krook stared at us in turn, amazed.

'Well, my young friends, I think in these exceptional circumstances we're going to treat ourselves to a second glass.'

In the heat of our discussion Michel had no doubt said more than he had intended but a quarter of an hour later he had recovered his breeziness.

'Well, you old Scottish skinflint,' he teased as he sipped his Lagavulin, 'when are you finally going to show us your library?'

'You'd only be disappointed, my friend! In the fifteen square metres of attic space that are home to Skimpole and me, there's no question of accommodating a great many books. So I've limited "my library" once and for all to ten volumes!'

'Let's guess: Rabelais, for sure . . .'

'In Urquhart's translation . . .'

'*Quixote* . . .'

'*Gulliver* . . .'

'*Roderick Random* . . .'

'*Tristam Shandy* . . .'

'*Pickwick* . . .'

'Excellent, my friends, excellent. You know me better than my own mother! Add to those *The Master of Ballantrae* – without the last

chapter of course, a shameful piece of slap-dash! It's often the way with Stevenson. *Dead Souls, The Possessed,* for Kirilov, and there you are . . . that's all you need . . .'

In good spirit we gave our learned opinion.

'Wait!' I said suddenly. 'That's only nine!'

Krook smiled, baring his malt-coloured teeth.

'Yes, indeed! The tenth book is . . . the book of books!'

'The Bible?'

'Monsieur Mangematin! Don't be stupid. No, I mean, in a certain sense it contains all others. It is in its way the very quintessence of literature . . .'

'*The Odyssey*!'

'*Bouvard and Pécuchet*!'

'*Moby Dick*!'

'*Journey to the End of the Night*!'

This time Krook laughed heartily.

'No, no! You're not even close. And besides you won't get it! You're still too innocent, too enthusiastic. You have far too elevated an idea of what you believe literature to be. In short, you're young. Now, let's strike a bargain!'

The bookseller raised his glass and invited us to do likewise.

'I, Thomas Krook, being sound of heart and mind, do promise to make a gift of the tenth book to whichever of you is the first to guess the title. So be it, by St Lagavulin! Thus far and no further . . . Cheers, gentlemen!'

Awaiting me when I got home was the first of the postcards, a view of the town centre of Bismarck, North Dakota, a few buildings on a gloomy avenue.

That day marked the beginning of the four most discreditable years of my life. There was nothing very glorious about the others, far from it, but at least they did not leave this taste of bile in my mouth. And why should my memory, so lazy in other instances, restore to me with this wealth of detail the long months when I was in Michel Mangematin's company nearly every day? For I have forgotten nothing: the unduly

narrow corridors in the university building where he would always con-
trive to walk in front of me; the swing-door of that little bar in Cours
Clemenceau which he would walk through and not hold it open, letting
it close on me; the comfortable banquettes he would claim for himself,
leaving me the wobbly chairs; above all the countless sarcasms my
name inspired in him. So depending on his mood, I was 'the epileptic'
(*haut mal*, rhyming with Daumal, being the old term for epilepsy),
Atlas (*mal de dos*, another play on Daumal, meaning back-ache), or
more frequently '*le poète maudit*' (because of René Daumal) – in
which case he would sniff, suggesting that while the 'real' Daumal
had managed to give proof of some literary talent, I was myself totally
devoid of any. With a name like his, Mangematin should have displayed
some circumspection on this score. But quite the contrary, putting
into practice one of those sporting expressions he was so fond of,
according to which 'attack is the best form of defence', he would
have a go at any surname that happened to come his way. Whether
your name was Dupont, Martin, Boustigala, or Chernichevsky, you did
not have to wait long before feeling on this abstract and nonethe-
less extremely sensitive part of your being the stinging bite of his
sarcasm.

But five minutes later, overcome with a sudden feverishness, he
would embrace me, exclaiming, 'Ah Daumal, my only true brother, my
Pickwickian!'

At Krook's he played a more subtle game. The Scotsman slightly
intimidated him. I was obviously too much at home in the shop. Some-
times I was allowed to rearrange the paperbacks. Michel also envied me
the privilege of allowing myself to be beaten at chess. His jealousy led to
grotesque scenes. When I was given a fifty-franc discount, he would
bargain for sixty. If I managed to identify one of those comic quotations
from Swift or Sterne that Krook relished, he would summon Smollet and
Fielding to the rescue. One Sunday at the St-Michel market I lighted by
chance on a copy of Hogg's *Confessions of a Justified Sinner*, with a
dedication signed by André Gide. I gave it to Krook. Mangematin found
out. A little while later he turned up at Rue des Ramparts with a package
under his arm: *The Third Book*, in the translation by Motteux and

Urquhart, a magnificent nineteenth-century reissue he had ordered from London and for which he probably paid a fortune.

Krook would address us as 'my young friends', no doubt hoping to outwit us with his possessive plural. His ring descended towards the bottom of the bottle more and more often, the Lagavulin flowed freely but to no avail. Even drunkenness could not turn us into the perfect duettists he dreamed of.

Finally, one day when I was alone with him in the shop, he manfully broached the problem.

'I wonder if you and your friend Mangematin . . .'

'*Aunt Julia and the Scriptwriter* – shall I put that under V or L.'

'Under V . . . I wonder if you shouldn't see a little less of each other . . .'

He observed me out of the corner of his eye, wielding his feather duster over a pile of books. The dust formed a cloud that settled slowly on the adjacent pile.

'It's odd,' he went on, 'when you're together your qualities cancel each other out, your talents run contrary . . .'

'Oh look! There's nothing between Vailland and Vallès . . .'

That did the trick: I had previously used the same ruse to deflect an embarrassing conversation about my family. Krook groaned and immediately lost the thread of his thoughts. His eyes flashed.

'Young man, I thought I'd already told you: no Valéry in my shop, as a matter of principle! He hasn't got enough balls! Not enough balls to be a novelist, not enough balls to be a real poet, or a real philosopher. A very French syndrome that, turning yourself into an aesthete, a thinker . . .'

At that very inauspicious moment a man in a raincoat came into the shop. The nonchalant glance he gave the books betrayed the browser. Krook barely noticed him.

'There's more store set by a piece of fancy writing than a work of real substance. Bah!' he exclaimed with a grimace of disgust. 'Cleverness, subtlety, French elegance. It's all rubbish, and it comes at a heavy price! Your truly great authors are vulgarians, uncouth . . . but how many professors of decorum would you not exchange for a Rabelais, a Balzac! For a Céline, how many . . .'

All of a sudden he became aware of the ploy and pursed his lips. His face paled. He gazed at me sadly.

'You're a well-assorted pair, after all, stubborn as mules, and a touch scornful . . .'

Meanwhile, vexed by our indifference the man had planted himself in front of us.

'How are they arranged, these books of yours?'

As Krook did not open his lips, I took it upon myself to answer.

'In alphabetical order.'

'Ah, right . . . but . . .'

The man frowned, giving himself an air of wiliness.

'. . . alphabetical order of what?'

This time Krook forestalled me.

'Alphabetical order of motor cars!'

The customer's eyes widened.

'Yes,' Krook went on, 'Camus, for instance, died in a Sasel Véga, so I put it under S . . .'

He was looking at me as he spoke, his voice trembling with rage.

'. . . while Sartre was a lifelong devotee of Citroen, so he comes under C . . .'

'Ah, yes,' said the bewildered customer, 'that's clever . . .'

'Indeed.'

At that moment a middle-aged matron with a perm banged on the window with the handle of her umbrella. The customer fled, looking back over his shoulder mistrustfully.

After a long pause Krook sighed.

'You're not inclined to talk, young man. So let's go and have a drink.'

'But I haven't bought anything today!'

'So what! Traditions are established in order to be overthrown.'

We drank a lot that evening. The Lagavulin had a bitter taste.

'You know, Krook, it's bizarre, but when I was younger and I saw you standing there like a giant under the glass roof, with your ring and a bottle in your hand, it was as though I was attending some kind of mass. And you with your little ritual – the glasses, your "magic formula" – you seemed like a priest.'

93

'Naturally enough,' said Krook calmly. 'I am one.'

The ring scored a precise line one centimetre below the previous one.

'You're joking?'

'Not at all. I'm a priest. A real one. A Roman Catholic priest. And this is my parish.'

He slipped two fingers behind the nationalist poster, on the bottom left-hand side by the drawing pin, and held out to me a small cracked black-and-white photograph: a tiny church surrounded by tombstones in a stunning landscape.

'Bridgend, on the isle of Islay, a few kilometres from Lagavulin.'

'It's magnificent . . .'

'A paradise. A sinecure. Eight distilleries. They draw water from the tiny glens that run through the peat moors . . . It's all about whisky there. That's where I was sent when I left the seminary, and I was there for three years. I put a lot of effort into it. People seemed satisfied with my services. What with the masses, baptisms, marriages, burials, and catechism, I didn't have a minute to myself. In a word, bliss.'

He abruptly put the photo back.

'There was a girl from the island, studying literature at Edinburgh, who would come and spend the holidays at Bridgend. I don't know how she found out I might be a descendant of the Urquhart family. One day she came to see me at the presbytery. She told me she wanted to do her doctoral thesis on Rabelais. She had a big bum and freckles on her shoulders. Today I'd rate her just about good for one night. But I was young at the time. Barely two or three years older than she was. We talked for quite a long time about Urquhart, Rabelais, and Lesage, drinking whisky – I remember I used to hide the bottle with the communion wine so my cleaning lady wouldn't find it. Later we went for a walk on the beach and then . . . The next day I went and confessed all to the bishop. He asked me to leave the priesthood.'

'I thought the church authorities were indulgent about that kind of . . .'

'Not in Scotland, where we were competing with the Presbyterians, those cold fish who watch our every move. "We cannot afford the least mistake." That's what the bishop said.'

'But it's over now. You're not bound by your vows any more.'

'It's not as simple as that.' Krook gave a little laugh. 'Your friend Mangematin would be able to come up with a metaphor to describe me . . . He'd say I was like those athletes eliminated in the qualifying heats. They return to the stadium at night and rerun the course, just for their own sake. To prove to themselves they could have won.'

It was later, walking back up Rue des Ramparts, that I first had the impression I was being followed. Footsteps echoed behind me as I walked, then stopped when I stopped. In Place Gambetta they became indistinguishable from those of the crowd but I still felt a fixed gaze on the back of my neck. I abruptly turned the corner into Rue St-Sernin and waited. No one appeared. I stayed a long time in front of the window of the laundrette watching some washing spin round while the person it belonged to, sitting by the machine with a walkman clamped over his ears, sang one of the latest hits at the top of his voice.

How could I blame Mangematin? The day after every snub, I would be ringing his doorbell undeterred, like a dog bringing back between its teeth the stick that will be used to beat it. For his part, he was not the man to encumber himself with a stooge or scapegoat. Lofty solitude would have much better suited his reputation as a lady-killer and future luminary of the university. Unpleasant rumours about us began to circulate, which in the long run could have tarnished his image with women, and perhaps even harmed his career one day. But he could not help himself. He would force my presence on social gatherings where I knew no one, take me to stay with his parents at Arcachon for the weekend, call me up if I gave no sign of life for two or three days. And always these hugs, these grandiloquent expressions: 'Stupendous Daumal! My brother in Dickens! My Pickwickian!'

Life had not prepared us for this. It was as if the postman had delivered to each of us a bizarre gadget with the word 'friend' on the package but with no instructions on how to use it. At the university every morning we would greet each other with a groan before sitting down on the same bench.

I recall a very strange scene. It was a Saturday. Michel had arranged

to meet me outside the Grand Théâtre. He was friendly, obliging, and also a little reserved. No doubt he had something in mind. We were strolling along Rue des Piliers-de-Tutelle when he stopped dead in front of the window of an English shop. Among the jars of marmalade, Shetland pullovers, mugs and Paddington Bears, he had spotted two curios: a brass paperweight in the shape of a bust of Dickens, and a smaller figurine made of lead, inspired by a famous photo of the writer dressed as a gentleman farmer, with his arms folded and wearing a frown, looking outraged, as if some unlikely person had dared to contradict him.'

'I must have them!' he exclaimed.

Inside, there was a smell of biscuits and lily-of-the-valley. While his purchases were being wrapped, Michel gave me a funny look. 'What's wrong? You think I'm being ridiculous?'

'I didn't say anything.'

'No, but it's what you're thinking.' He laughed and added, 'Maybe that's basically what's missing in you.'

'What?'

As he signed his cheque he shamelessly weighed up the sales girl's charms. 'A little childishness. Ingenuousness. I'd give a lot to know what happened to you when you were a kid.'

Though devoid of hostility, this remark riled me more than his usual teasing. A little while later, as we were sitting down to lunch at the Bar Clemenceau, I remarked drily, 'Ingenuousness, you were saying. I wonder if you're the best qualified person to talk about that . . .'

'Well, believe it or not, I am! It's what gives me the edge. That slight lapse of intelligence that allows me to take seriously everything I do. Something you're incapable of.'

He hesitated a moment before taking the two objects out of his bag and pushing them towards the middle of the table, like a child offering his collection of marbles. 'Look! We can share, like brothers!'

'What do you want me to do with those?'

'I mean, we can share Dickens, Borel. The book I have in mind, we can write it. Together.'

The bar-room's old coffered ceiling looked like an upside-down chess-board, a game where the words 'win' and 'lose' had swopped their

meaning. There were sinuous cracks in the plaster. I thought of the desert, the caravan of words.

'It's just a fantasy,' I murmured. 'Borel. Dickens. Just a fantasy.'

Michel looked taken aback. Then he put away the two Dickens, murmuring, 'Just as I thought.'

Shortly before my departure from Bordeaux I learned the meaning of the term 'a backward pass'.

With women, Michel's greatest asset was his total insensitivity to failure and humiliation. 'To score,' he used to say, 'you have to take a shot at goal as often as possible. Three, four times, you miss. The ball goes into the stands, the spectators whistle. But you don't care, because on the fourth attempt you find the top corner!' The moment he fancied a girl he made his intentions clear: offended cries of indignation, slaps across the face were like water off a duck's back. I, on the other hand, would only try my luck with a chance for a penalty. And even from that ideal position I often ended up sending the ball on the wrong side of the posts.

I was soon left perplexed by the extremely friendly attitude towards me of a number of young women who had given Michel the brush-off in no uncertain terms. Wary of what was going on, I did not respond to their advances until that Sunday morning when the telephone woke me.

'Hello, François, it's Nathalie.'

It took me a while to identify this Nathalie. We had exchanged a few words at a party the Thursday before. She was a pretty brunette with green eyes, quiet, sentimental, and she wanted to be a nurse. Exactly the type of girl that as a rule does not call a man she does not know at nine o'clock in the morning. Besides, I could tell she was nervous at the other end of the line.

'Since the weather's so nice . . . and you have a car . . . I thought we might go to the seaside . . .'

Taken by surprise, I was about to refuse when I remembered the letter from the estate agent. The paper factory had not renewed the lease: the house in Mimezan was empty and the agency was offering to find a new tenant for me.

'Good idea,' I replied. 'We could go to Mimezan.'

'Mimezan? Uh ... that's quite far, isn't it? I was thinking of Arcachon ...'

'You'll see ... Mimezan's very pretty ...'

As she was about to get into my car, Nathalie shrank back.

'It's a DS, isn't it? My parents had one when I was little. I thought they didn't make them any more ...'

'It's a '62 model but it goes very well.'

This annoyed me. We did not exchange a word the whole way. Nathalie seemed already to be regretting her telephone call. She kept her eyes fixed stubbornly on the road ahead. I turned on the radio but because of the pine trees we got no reception and could not hear anything. I rummaged in the glove compartment and found what I was looking for: Sarah Vaughan. I put in the cassette.

> *Here we are at last, it's like a dream*
> *The two of us, a perfect team.*
> *Isn't it a pity we never met before ...*

Nathalie cast a questioning glance at me but I remained stony-faced. Then I took malicious pleasure in seeing her wrinkle her nose when a little beyond St-Paul the first whiffs reached us.

'What's that smell?'

'The paper factory. You very soon get used to it. You'll see.'

The house needed a coat of paint. Still remaining silent, I parked in front of the gate.

'Aren't we going to the beach?'

'Later. There's something I have to do first.'

As arranged with the agency, I went to fetch the key from old Madame Conscience. Then we let ourselves in and I started wandering from room to room. The smell was even stronger inside. For a moment I thought of opening the shutters but I finally made do with an electric lamp and the light that came in through the fanlight above the kitchen door.

'Whose house is this? Is it yours?'

Nothing had changed, neither the worn floorboards, nor the wallpaper on which you could still discern lighter rectangular patches where my mother had hung her Van Gogh reproductions and her embroidered alphabet. The only visible sign of there having been a tenant was a new lavatory cistern: you would think whoever it was had only used the house to relieve himself when he came home from work.

'What's up there?'

I gripped her by the arm and ushered her downstairs.

'That'll do!' I murmured. 'Now you're going to tell me why you're here. It was Mangematin's idea?'

She lowered her eyes. My hand had left a red ring round her wrist.

'Stop me if I'm wrong. He tried to pick you up, and you put him in his place. Then suddenly he had a change of attitude. He took on a really peculiar look and said . . . what exactly did he say?'

'He said . . . I was quite right . . . he wasn't worthy of me . . . he only wanted to . . .'

Nathalie swallowed her saliva with difficulty.

'. . . to fuck me . . . and now he felt ashamed . . . he regretted his behaviour . . . And then he added . . .'

'What?'

'That he knew someone who was right for me, someone really nice.'

'Go on.'

'He started to talk really fast . . . to talk about you. He said that, of the two of you, you were by far the brighter, the more intelligent, the more sensitive. That sometimes he teased you in public and adopted an air of superiority but it was all an act. A kind of game between you. But you both knew perfectly well how far you could go. That you were the master and he the disciple. Then he left the room but he came straight back in again. He said I was very lucky because . . . because you were sincere, passionate, loyal, and because . . .'

Seeing her trapped like this, an innocent pawn in the game that pitted us, Michel and me, against each other, I softened a little.

'Because?' I said, rubbing her sore wrist.

'Because you were . . . in love with me. And he said you would never

99

admit it, you were too shy . . . that if I wanted to get to know you I would have to make . . .'

. 'The first move?'

'Yes, the first move.'

Nathalie looked up. A dim glimmer of hope glistened in her eyes but rapidly died away. After all she was his pawn.

At that time I was living in Rue de la Croix-Blanche, in a small house – what had in fact been a shed – at the bottom of a certain Madame Bosc's garden. Twice a day I had to pass through her apartment. That evening as soon as she heard me turn the key, my landlady came out into the corridor. She was a middle-aged woman, still attractive, the widow of the former vice-principal of the neighbouring lycée. She was still wearing black, her dresses getting shorter as the months went by, and a perfume that made me think of chicken curry.

'You have a visitor,' she announced, very excited. 'Such a nice young man, with an odd name. Of course, I let him into your room. I'm having a little coffee in a quarter of an hour. If you'd like to join me, don't hesitate!'

I opened the door to my room to find Michel sitting there, smoking a cigarette. He had put two chairs round a small table occupied by my plastic chess set. The old chest with iron fittings that I used instead of a wardrobe was open.

'Well? And Nathalie?'

Pure Mangematin. Bravado, swank, swagger, provocation. His freshly shaven baby-face. His smile. I was exhausted. The smell of the factory still clung to my clothes. I felt like taking a shower and sleeping till the next day. Yet I did not throw him out. There was one small point that intrigued me: a fleeting expression I had caught in his eyes. A stage direction at odds with the character. I sat down opposite him but he immediately lowered his gaze and advanced the king's pawn. He began to talk very fast.

'The centre forward can't always score, you see. After all, the better he is, the more defenders he has on top of him. So from time to time he slips in a backward pass. Well, you certainly don't look happy! Wasn't little

Nathalie any good? And yet the ones who play hard to get are often the best . . .'

It was the Spanish game. Perhaps he had specially studied this opening in an old Tartakower manual that had been lying around for years in Krook's bookshop.

'I didn't touch her,' I said, moving my knight to f6.

'Oh yeah?'

Michel looked at me, then stared at the chessboard for a long while. This variant was not covered in the manual. He wavered between several alternatives before choosing the worst: he took the knight with his queen.

'So you disdain anything that comes from me? It's like Dickens . . . It's as though he doesn't interest you any more.'

'I don't have the time. I'm working on my master's.'

'Leconte de Lisle? That's the most nerdy dissertation topic chosen by anyone in the whole year!'

'There are some very fine things in his *Antique Poems* . . .'

'Yeah, yeah . . . "And with piercing glaucous eye peer into the crib . . ." Do you take me for a fool? Sometimes I wonder if you didn't choose him just to annoy me . . .'

'I don't see why it bothers you that I should be working on Leconte de Lisle.'

Michel put me in check with his rook – another mistake.

'It bothers me because I don't understand it!'

Without replying I pulled back my knight: discovered check. Michel contemplated his moribund king.

'A loser in life, a killer at chess,' he murmured. 'There's something that doesn't make sense . . . unless . . .'

Suddenly he brandished the *Spiritist Review* that he had hidden under a cushion.

'Unless you're hiding something from me!'

He got up and began pacing up and down, talking, while I rearranged the pieces.

'I was right. Borel's text is connected with *Drood*. He never stopped thinking about it. He had information, definite information, from Dickens himself – now I'm sure of it!'

Then, drawing level with me, he stopped and added in an almost gentle voice, 'I've been honest with you. I offered you a chance to collaborate. Why didn't you tell me about this?'

Vexed! That was the word I was looking for. Michel was vexed. After everything I had had to put up with from him, it ought to have been funny . . . But at the same time his total inexperience in terms of being humiliated made him almost touching. This new capacity upset the order of things. For the first time I envisaged the converse of the unhealthy influence he exercised over me. Instead of taking comfort from it, this unsuspected power terrified me.

Through the open window Madame Bosc's percolator could be heard sputtering.

'And with Nathalie,' I said closing the chessbox, 'were you honest with her too?'

'That's an entirely different matter. That was just a . . . a present from me to you.'

'Thank you.'

He gripped the windowsill. For a few seconds I really thought he was going to cry. But then the widow came out holding a tray, and made her way towards the garden table. She strutted over the broken paving stones. It seemed to me her black skirt had become even shorter. Michel was immediately himself again. Not a trace of emotion. He switched on his big shameless smile, refocused his enveloping gaze, and rubbed his hands. Had he been bluffing me once again?

'That coffee smells good! Coming, madame.'

Then he turned to me.

'Very well,' he said calmly, 'it doesn't matter. I just have to learn not to trust you. Some players are dangerous even without the ball. There's a Mankiewicz tomorrow night at the university film club. Will you be there?'

'Probably.'

With his hand on the door knob, he gave me a piercing look. 'I'd also like to know . . .'

'What?'

'What Borel and Stevenson could possibly have had to say to each other . . .'

The next day I went back to Mimezan, alone this time, and rented a lawn mower. (I had not even bothered to go by the university to find out the results for the master's degree dissertations. I was later informed by post that my thesis, 'Metaphor and Metonymy in the Poetry of Leconte de Lisle' had been designated 'Fair'. As for Michel, he had been awarded a distinction, 'Very Good with the congratulations of the jury', for his 'Dickens Before Kafka: the Victorian Novel, Precursor of Modernity'.

I worked for a long time: the garden was overrun with brambles and I had to cut them back by hand before I could use the mower. Once they had been cut right back the weeds looked almost like a presentable lawn in the twilight gloom. Pleased with myself, I was about to turn off the motor when the blade dug out of the ground a little white object the size of a stone that was propelled against my chest. I picked it up and sat on the edge of the terrace. A sea breeze dried my sweat. It blew towards the hinterland the dreadful smell of sulphur and the thumping sound of the machines. Thus rendered silent, odourless, the factory was different. It was possible to imagine it being as comfortable as a house: its vast proportions seemed the work of a baroque architect with little concern for ergonomics, and its unreal lights gave the scene a Christmassy brilliance. The caterpillar-tracked vehicle descended the hill for the last time and went to lie low in some corner. The siren sounded.

It was a long time since I had felt so happy. The factory, the house, the cemetery formed a kind of protective triangle around me, within which nothing could happen to me. I decided to sleep in the house on an inflatable mattress I had brought with me.

It was the next day, leafing through the local *Sud-Ouest* newspaper at the Bar de la Marine that I came across the advertisement:

Notre-Dame School (Mimizan)
seeks French master

I would have stayed anyway. I had made up my mind to do so the previous evening with my grandfather's finger gripped in my hand.

# VII

7 June 1870

Mountains. A man with his back to me, sitting at the window. We do not speak, we do not move. Nothing happens, as usual. Yet there is something new: I become aware of details I had never noticed before. The man's clothes, for instance: they are strange. There is also a smell: strong, nauseating. And the mountain. It moves slowly towards us – unless the opposite is the case. Above all, there is the letter. Dickens's letter is lying on the desk. How did it get there? How did the man manage to . . .?

'Sir . . . sir!'

The train came out of the tunnel at the same time as I broke free of my dream.

The first thing I did was to check the contents of my pocket: the letter was there of course.

Gad's Hill Place, 4 June 1870

Sir,

Our mutual friend Madame Sand speaks very highly of you. But it is above all your letter that has given me the desire to meet you. You are, apparently, a young and brilliant teacher of English. This decrepit and hard-working autodidact has the pleasure of inviting you to visit him on the morning of Tuesday, 7th June (I shall be in London from the 9th, to organize a new series of public readings and won't have a minute to myself), as long as you undertake to spare him anything resembling a lesson in any subject whatsoever. Take

the 6.15 train and get off just before Rochester: a carriage will be waiting for you at the station (please be punctual).

I look forward with great anticipation to making your acquaintance.

Yours
CD

PS Bring a good pair of walking shoes with you.

'Forgive me, sir, you said you were so anxious to see the place . . .'

'Yes . . . yes . . . indeed, thank you.'

Huddled in the far corner, the old woman cast anxious glances at me. Slowly I recalled our meeting at the station in London. She was a pathetic sight, all alone on the platform, struggling with a suitcase, an umbrella, and an enormous hatbox. 'Would you be so kind, young man? Put it there, if you would. It's for my sister. Apparently the latest collections have yet to arrive in Rochester. My goodness, what vanity! We'll be fine here, facing the front of the train. I wonder what she can possibly want with all these hats. She's an invalid, poor thing, she never leaves her room.'

'You must have been having a nightmare. You were talking in your sleep.'

'And what did I say?'

'Good heavens! It was none of my business! So I blocked my ears! Now, we're nearly there.'

The train slowed and came onto a viaduct some fifty metres in length spanning a riverbed. The water looked deep. It followed a small ravine before turning eastwards, parallel with the railway line, in the direction of the sea.

The old woman, looking very pale, had gripped the armrest.

'My God, it's been five years already. And yet every time, my heart stops beating and I don't feel quite safe until . . . there! We're out of danger now!'

In the distance clouds of gulls flew over the shipyards at Chatham.

'Why did the train come off the rails?' I asked gently.

The old woman quivered with indignation.

'Why? Because of the brandy of course! The foreman was a drunkard. He frequented the same dens of perdition as my wretched brother-in-law. He must have mixed up the week-day timetable with the Saturday timetable. There was a man with a red flag posted up the line but not far enough. And when the engine reached the bridge there were two rails missing . . . Carried forward by its own speed, it managed to cover the gap, as did the first of the second-class carriages. But all the first-class carriages and the other two second-class carriages behind fell into the river-bed – all except one that remained suspended in space, held there simply by the coup-lings attaching it to the second-class carriage in front of it, in which I was travelling, luckily. Which only goes to show that my dear departed father was quite right when he said money doesn't guarantee us happiness!¹'

Whereupon she produced a locket from her bag. It con-tained the photograph of a cadaverous-looking old man with a furious expression and broad forehead, bearing the follow-ing inscription: Ephremus Mind 1794–1855. She took advan-tage of her bag being open to stuff into my hand a bundle of edifying pamphlets – 'Alcohol: Enemy of the Christian', 'On Wantonness as the Mother of All Vices', etc. – that I pretended to read with the greatest of interest.

'And then?'

---

¹   The account given by Miss Mind accords with the facts, except that the accident did not take place on the London to Rochester line. Either the elderly spinster is slightly losing her wits, or – and this is the most likely explanation – she existed only in the imagination of Évariste Borel. Let us remember that Évariste's mother, Constance Borel, was born Constance Esprit – *esprit* being French for 'mind'.

'We were gathered on the bank, trying to help the poor wretches who were being swept away by the current or who were trapped under piles of metal, when suddenly we saw a little man with a remarkable beard. In my confusion I did not recognize him straight away. With some planks of wood wrested from the seats, he managed to construct a kind of gangway that allowed two ladies – a very pretty young woman with a hat (Lord, what a dreadful hat!), and another older lady – to reach the bank without getting their feet wet. Then someone behind me said, "Look! It's Charles Dickens!" It was at that moment that Satan gained a hold on me . . .'

Miss Mind blushed like a schoolgirl at the memory.

'Alas, instead of praying for all those unfortunate souls, despite their groans as they breathed their last, I could not take my eyes off him. I had eyes only for him. As God is my witness, if I have ever sinned in my life, it is because of him . . . Mr Dickens! Already, as a young girl, I used to buy the monthly issues of *Pickwick* and *Oliver Twist* as soon as I had a few shillings saved, and I devoured them in secret! Sometimes on the frontispiece there was his portrait. Honest to goodness, what an attractive man I thought he was! For all that my father punished me, or made me read the Reverend Ingram's tracts on the pernicious influence of popular novels, it didn't make the slightest difference! So imagine what it was like seeing him there in front of me, in the flesh!'

Miss Mind cast a guilty glance at the locket and hurriedly consigned it to the bottom of her bag.

'Anyway, a man who celebrates Christmas in such a beautiful manner cannot be fundamentally bad! An enchanter, a magician . . . but a Christian magician! And good Lord, on that day, what nobility, what devotion! The pretty young woman was bleeding a little from her forehead. He made her as comfortable as possible, then went down to the river and filled his top hat with water to clean the wound. Who was she? I don't wish to know. I know that Mr Dickens is a

married man but I cannot believe . . . and besides she called the older woman "Mother", which proves that nothing improper could have occurred on that train, would you not say? Ah! you should have seen him then, running from one casualty to another, with his hat full of water, offering words of comfort to every individual, helping the workmen to lift the wreckage, taking a child in his arms. Help was slow in coming, no one knew what to do, people kept running into each other. He was the only one who kept his head. And then there were those horrible screams . . . A man lay by the river, his legs crushed, a gaping wound in his skull. "I'm done for, I'm done for," he cried. "No, my friend," said Mr Dickens firmly, "you're not done for, we're going to get you out of here." He gave him some water, and looked all round, shouting, "Is there no one to help me?" Meanwhile, the man had stopped groaning: he was dead. He was slowly carried away by the current. In the place where his head had lain the grass was red with blood, and the water at the river's edge was red also. Then something quite bizarre happened.'

The old woman lowered her voice as if she were afraid the portrait of her father, stuffed in the bottom of her bag, might hear what she had to say.

'I didn't understand at the time. I was very close to Mr Dickens. His face was set, greyish . . . like that of the dead man on whom his eyes were fixed, watching him as he drifted away with the flow, blood streaming from his skull like his very last thoughts. And then a gleam came into Mr Dickens's eyes. My God, that terrible gleam! If I'd not seen him a moment earlier rushing round among the casualties like an angel of mercy, truly I would have sworn that my father was right after all, and that man was the devil! It was extraordinary. The cries of anguish and suffering no longer reached him: he was at work! I'm certain I'm not mistaken. I followed his line of thought. I saw him frown, pat himself down in search of something, and I heard him cry out all of a sudden, "My raincoat! In the

carriage!" He leapt up and started walking towards the bridge. "Charles!" wailed the young woman. "Forget about it! You can buy another!" And without looking back he said, "Don't be stupid, Ellen! It's not my raincoat I'm worried about!" Two men attempted to detain him. He waved them aside without a word. He looked very calm, totally determined. He stepped on to the planks, hoisted himself through the broken window, and then he was gone. Everyone held their breath. The carriage was still hanging over the edge of the void. The iron bodywork creaked a little under the additional weight. It was almost a murmur, a confabulation . . . the mass of metal might have been debating whether or not it was going to plunge from the bridge . . .'

There was no visible sign of our approaching the station but Miss Mind nonetheless gathered her belongings on to her lap – her bag, umbrella, and the hatbox that came up to her chin: like most old people, and often children too, she liked to be ready.

'And then soon after, a hand appeared, then a head. It was Mr Dickens wearing his raincoat. He clambered out of the carriage, and came back towards us. As God is my witness, he was beaming with happiness! "Untouched!" he kept saying, brandishing a bundle of paper. "Not a stain, not a single page torn!" Happy! Happy in the midst of that carnage, among those women clutching the bodies of their husbands, those weeping children looking for their mother, and those cries, all that blood! And yet not for one second did I think of being shocked. On the contrary, I too rejoiced. Seeing him smile, I smiled idiotically. I was pleased he had recovered his manuscript. A few weeks later, reading the latest instalment of *Our Mutual Friend* I discovered that I had been right: Book 4, chapter 6, the scene where Lizzie Hexam fishes Eugene Wrayburn out of the river. It's all there – the red-stained grass, the blood in the river, the lifeless body drifting with the current . . . My God, he had made use of that nightmare! He had

appropriated it! I hope the Lord in His infinite wisdom has thought to reserve a special scale in which to weigh the sins of great men and those of the women they have turned from the path of righteousness!'

If Miss Mind had been a papist she would no doubt have resorted to the sign of the cross. As a good low church Anglican she contented herself with a moment's reflection. Then she gazed at the publication[2] I had laid on the seat and leant towards me.

'What do you think he's up to?'

'Who?'

'Why, Jasper of course! Why would he visit the crypt? My sister thinks he's planning to murder his nephew but I can't agree with her. A choirmaster, after all!'

'Don't forget, this choirmaster is an opium addict!'

'That's true.'

'All we can do is wait patiently for the next issue. We may trust Mr Dickens to surprise us yet again . . .

'Yes, you're right, young man, that is the wisest course. Now, look to your right! Keep your eyes open because you'll catch a glimpse of it behind that hill. There! Now! That's Gad's Hill Place.'

I had imagined it to be very grand, flanked by one or two gothic towers, standing in the middle of a vast park of age-old oak trees. What I saw at the bottom of the valley was just a fairly ordinary dark building conforming to the austere and

---

[2]  Evidently this is the June issue of *The Mystery of Edwin Drood*, the last to appear in Dickens's lifetime, in which the reader sees Jasper, the epony-mous hero's uncle, visiting the crypt of Cloisterham cathedral and coming across an empty grave and a mound of quicklime that could be used for the disposal of a body. Those who maintain Jasper's guilt generally take this scene as the basis on which to argue their case. On the many debates surrounding the truncated end of this novel, the reader is referred to the work of Michel Mangematin, *A Hundred Years of Droodian Literature*, Bordeaux University Press, 19**.

philistine taste of the average English gentry. Never mind! A shiver of joy ran down my spine. I in turn gathered up my belongings and declared very firmly to Miss Mind, 'Gad's Hill Place! That's where I'm going!'

I had already been waiting a good half-hour when a tall thin man with a hatchet face came out of the station buffet. He was a little unsteady but on seeing me he straightened his jacket, adjusted his hat and managed to cover the few metres that separated us following a trajectory that was almost a straight line.

'Mr Barrel, I assume?'

His thickened tongue added a comic touch to his strong cockney accent.

'Borel, if you don't mind.'

'Of course, sir: Borel. I've made a note of it. I'm Weller, sir. I was delayed by an important errand but, don't worry, we'll be at Gad's Hill Place in less than a quarter of an hour.'

A few minutes later, having taken a seat in a modest tilbury, I was able to observe at leisure this strange character and to take stock of his apparel: leather boots, gaiters, striped waistcoat, and bizarre hat.

'And is your name really Sam Weller?'[3]

'Well, sir, I wouldn't argue with Weller but Sam's another matter, for my first name is Archibald. Archie, sir, if you will.'

'All the same, what a coincidence!'

Weller gave an ironic chuckle.

'You know what my late father would say about that, sir? "A coincidence is a stratagem that succeeded!" When

---

[3] Sam Weller: name of Pickwick's manservant (see above). He is both the archetypal, dyed-in-the-wool, wily cockney of decided opinions and one of the most original characters in the Dickensian universe. His florid speech and absurd metaphors sometimes border on the pataphysical. His first appearance some way into the novel saved Pickwick from poor sales and established Dickens's popularity once and for all.

Mr Dickens placed the advertisement in the *Rochester Daily* my first thought was that my name might be an advantage. And for good measure I dressed the way I'm dressed today and made sure I had a stock of a few well-turned phrases. Then when I turned up for the job, the expression on his face on seeing me was more or less the same as yours just now. "What's your name, my friend?" "Weller, sir." "Weller?" "Absolutely, sir. It's an ancestral habit in my family to answer to that name. We like it so much, we pass it down from father to son!" At that moment he was standing at his desk. I saw him turn quite pale and sink into his chair as if he had just seen the ghost of Charles I with his head under his arm! Then I felt stupid and came clean: about the advertisement, the disguise, that funny way of talking I had copied from his book. I was afraid he might take it badly but not at all, he burst out laughing. I don't know if you've ever heard him laugh, sir, but I assure you it does a man good to hear it! He couldn't stop! Eventually he got up and put his hand on my shoulder. "So, Weller, what can you do?" "Anything, sir, absolutely anything. 'There's no limit to what the boy is capable of!' That's what my mother said when she found me in my cradle mending my jumper with a salmon bone." Then Mr Dickens laughed again very heartily. "Excellent. You're the man for me!" Since then we've been the best of friends. As he accompanied me to the door he turned to me and said very seriously, "You know, Weller, just then I thought I was going mad . . . or that I had passed through the gateway without knowing it." "The gateway, sir?" "Yes, the gateway that separates the real world from the world of my books . . . and that I shall pass through sooner or later." I'm damned if I know what he meant!'

Talkative and sociable by nature, Weller became even more so when he learned my father's profession.

'Well, I'll be . . .! You know, my father sold wine too – what was left after he'd finished drinking, that is.'

And he asked me a thousand questions about French wines, the soil, the vines, the bottling process, the way the barrels are made. Every detail seemed to interest him enormously. In the hope of extracting some other anecdote about his master I did my best to answer him [I overcame the aversion such topics always inspire in me, for being so closely associated in my mind with my father], and in return won the blind trust and unshakeable respect of Archibald Weller.

We had left behind us the outskirts of Rochester and were travelling on the road to Gravesend. Divided between my eagerness to reach our destination and the desire to extract from my providential source as much information as possible, I confess to not having paid as much attention to the charming landscapes of this part of Kent as they deserved. Yet the speed at which we travelled was ideal for sightseeing: an old mare by the name of Joyce took us at a gentle pace.

'Ah, Mr Bottle . . .'

'Borel.'

'Exactly: Borel! That was the name I noted down a little while ago . . . Ah, Mr Borel, I hope you've a good bottle of Médoc or Burgundy packed in your luggage (at these words Weller discreetly eyed my suitcases, doubtless in the hope of spotting a cylindrical bulge that boded well), for I believe my master could make good use of it right now.'

'What do you mean?'

'Work, sir, work! That man is a glutton for work, as my father used to say whenever he saw Mr Crisparkle, of independent means, go by with his fishing rod. He has not been the same since he came back from America. These public readings exhaust him. One day in Liverpool, the next in Southampton . . . It will cost him his health. Indeed, I've taken the liberty of telling him: "Take a rest, sir. Send an actor in your stead." "An actor, Sam?" He often calls me Sam, it's a joke between us. "You can't be serious! It's me they want to see! And as long as I live, I shall never be sparing of my self for I owe them

113

everything. I belong to them!" It has to be said, not every-thing's rosy at Gad's Hill Place, especially when his daughters are away, like today, and the crow's in a bad mood.'

'The crow? You mean . . .'

'Georgina, his sister-in-law. The nickname suits her, I think. No, what he needs is a real woman. And the worst of it is, he has one, and very pretty she is too, a gem of a young lady, all freshly beribboned, with the voice of a little bird and almond-shaped eyes. Only, you see, Mr Dickens is still mar-ried – separated, but married, and the young lady's not greatly approved of by the household, you understand. But none of this would matter if he didn't have to meet those blasted deadlines for his book!'

Here, I had to curb my impatience. There was a rather seedy-looking pub at the roadside, The Old Deer, where Weller was expected, as he put it, for a 'business meeting'.

'You stay put, old girl,' he said, laying aside the reins.

This instruction seemed to me unnecessary, so hard did Joyce strive for perfect immobility.

The meeting in question lasted only five minutes, in which short time Weller managed to drink probably as much beer as I could have imbibed in a whole evening. Having regained his seat, he clicked his tongue and uttered a sigh heavily laden with hops and malt.

'Now where was I? Ah, yes, the book he has to finish . . . "Master," I said to him, "give up the monthly instalments, they're undermining your health. Write the book in your own time and publish it when you've completed it." But he replied, "No, Sam, I need these instalments. It's like relieving myself of a burden, a sort of periodic bleeding . . . Otherwise, I'd be smothered . . . smothered by the weight of words!" I remem-ber, we were behind the house, where he wants to build a conservatory for flowers. He looked at me sadly and said, "You can't imagine the monster I'm giving birth to . . . My God! Could this horror really exist . . . or is it only within me?" '

'What do you think he was talking about?'

'I don't know, Mr Barrel . . . and I don't want to know!'

This recollection, combined perhaps with the effects of alcohol, plunged Weller into a moody silence at odds with his character. We did not exchange another word for the rest of the journey.

'He'd like you to wait here. He's in the chalet but he won't be long.'

I realized straight away that Georgina Hogarth did not welcome my presence at Gad's Hill Place. Even without her extremely discourteous allusions to the state of her brother-in-law's health and his need for 'rest and quiet', and to the 'ill-considered invitations he often issues and immediately regrets', I could tell just by looking at her. She was a middle-aged woman, simply dressed. The too perfect oval of her face lacked charm and vitality. A cold hostility emanated from this caricature of 'the English spinster of good family'. Strange, the involvement of this man with three sisters. Mary, who died at the age of seventeen, whom he probably loved but with whom he was not intimate. Catherine, his wife, whom he did not love but with whom he was sufficiently intimate to father ten children by her. And now Georgina, a woman he did not love and with whom he was not intimate but who had shared his life for more than twenty years. This 'faithful housekeeper' along with the other two – 'the lover denied to him' and 'the vexatious wife' – forming a kind a morbid triangle from which he never escaped . . .

But what did the vicissitudes of lover, husband, brother-in-law matter? It was the writer I admired! And by a stroke of luck that only the day before was inconceivable, here I was, alone in his office with his books, his desk, his pens, his ink-well! Of course I was not unaware that for some years he had actually been writing in his 'Swiss chalet' on the other side of the Rochester road, to which a tunnel gave him access. All the

same numerous signs of his work were visible around me: recent copies of *All the Year Round* piled on a stool, proofs for correction, mail from his American publisher, furiously underlined in several places. I wandered round the room, committing to memory as many details as possible: the big wicker wastepaper basket (empty), the portrait of his late friend Maclise, the scent of the geranium on the sill of the half-open window, and finally the rather conventional and not very well-stocked library. That of a self-taught man with little concern for good taste, of an avid but undisciplined reader who remained true to the delights of his childhood: *One Thousand and One Nights* in a popular edition, Bunyan's *Pilgrim's Progress*, a very old illustrated Swift, *Tom Jones, Roderick Random*, Urquart's translation of *Gargantua*.

I had not been invited to sit down but tiredness soon overcame my diffidence. I approached a large armchair that stood facing the window. It was littered with a pile of old papers, on top of which was a letter. [With a shudder of displeasure,] I recognized the handwriting.

My dear master, I am sending you the latest book by Flaubert, 'my old troubadour', which is much talked about on this side of the Channel . . . Despite its excesses and ineptitudes, I hope you enjoy it. He's the kind of man you like: a champion of literature!
Your most faithful admirer, George Sand

'My old troubadour . . .'

Dickens seemed in no hurry to appear. I moved the papers on to a small table. The silence, the view of the park were conducive to reverie, and the armchair was deliciously comfortable. I surrendered to my memories with guilty pleasure: was I not the inconstant lover who in his mistress's anti-chamber thinks of another woman.

[Nohant lay under snow. That Christmas Eve, Aurore seemed

relieved to see me: had she forgotten the violent quarrel we had in November? I soon understood the reason for her amnesia.

'You've come at the right time, Évariste! Flaubert's here! He's bored. He doesn't get on with Maurice. He doesn't like puppets. And he doesn't know anything about mineralogy. You see, I don't have time to entertain him. Last night I finished a novel but I immediately started on another: one mustn't get out of practice! Come along, he's in his sitting room. In his dressing gown. Just like at Croisset. How's your father?'

Without waiting for a reply she pushed me into the room and scuttled away, waving her hand behind her.

It was a grotesque situation but running away would have been even worse. Cursing Aurore, I approached the window where] Flaubert was standing with his arms crossed. He was indeed wearing a full-length brown dressing-gown. I was struck by his massive red face, his piercing blue eyes. With his air of unruliness and his white walrus moustache, he looked like the Gaul chieftains in the books of Augustin Thierry.

['I wonder what on earth they're up to,' he said without looking at me.

Outside, bundled up in their fur-lined coats, Aurore's other guests were gathered round her son Maurice. He had propped a ladder against the largest oak tree in the park and was about to climb it, carrying a big bag in his arms.

'I think they're going to decorate the tree for Christmas.'

'Good Lord!' he murmured in astonishment.]

'Évariste Borel. I'm a friend of Aurore.'

'Flaubert.'

He finally turned his gaze on me and there was a mischievous gleam in his eyes.

'So you're Monsieur Dickens's great advocate.'

[In what ridiculous light had Aurore been presenting me? I preferred not to know . . .

'Are you enjoying your stay?'

Flaubert considered me again.

117

'Very much!' he said finally. 'Yesterday evening they exchanged jokes about shit for three hours. We were lucky not to be treated to a farting competition! When I retired for the night I found a horsehair blanket on my bed – I suppose that's meant to be very funny. A friend of Maurice woke everyone up at about two o'clock in the morning, wailing like a ghost! And to think I wouldn't believe Gautier when he told me what it was like . . .'

He twirled his moustache with a lugubrious air.

'What are all these people doing here, Monsieur Borel? These poets, playwrights, musicians . . . When you talk to them of literature they roll their eyes and snigger with a look of embarrassment. I feel as if I'm living on another planet. Don't you?']

I opened my mouth to reply but he immediately went on as if to himself.

'Dickens, yes, of course, a great fellow but second rate. An ignoramus! And what little love of art! He never speaks of it!'

'But does a writer really need to speak of art? Isn't it enough for him to . . .'

'The spirit of a dwarf in the body of a giant!' Flaubert interposed. 'There's a man who doesn't know his own strength! He's capable of creating the most ravishing pieces of porcelain but he destroys them by coming out with those tedious rants about social hardship or those elephantine jokes! Look at his *Pickwick*! The style is careless, the plot slipshod. And his characters! Grotesques! Monstrous puppets! Strongly portrayed, certainly, but with no depth!'

Under the effect of his vehemence the veins in his neck had swollen like those of an athlete grappling with a heavy weight. I in turn felt a wave of anger rising within me.

'Who can claim to know what people's appearances conceal?' I retorted. 'Analysis and psychological veracity are a writer's stratagems. They fill a void, that of truth, which is unknowable! From a hat, a wooden leg, a linguistic tic, Dickens

118

conjures up a character and that character immediately seems more real to us than the figures we pass by in the street, people like us, so we're told. Must we pretend to believe the world has meaning, endowing it in our books with an illusory harmony and order, when we're all grotesque disjointed puppets, fairground freaks!'

Flaubert's attitude instantly changed. He stared at me in total astonishment, furrowed his brow, and began pacing up and down with his hands behind his back.

'Yes, yes, he has this amazing ability, but what purpose does it serve? You write, Monsieur Borel?'

I merely blushed.

'If so, you will understand what I mean. A book must be able to stand alone, without any tricks or sleight of hand, by the sole power of words. And words are only too eager to break free of their role. If you don't assign it to them with authority, forcefully, then they escape the book and all your work is reduced to nothing! They are valiant soldiers, certainly, but they need to be controlled with an iron hand, otherwise there's rebellion . . .'

He had returned to the window. We observed in silence the garland decorating the big oak tree. Someone had set up a camera. Maurice Dupin was applauded as he posed at the top of the ladder. Flaubert had a bizarre smile.

'I admire, yes, truly, I admire Monsieur Dickens and his mutinous vessels. I myself prefer amenable crews and if literature must lead to shipwreck, let me at least retain till the end the illusion of holding the tiller! [Meanwhile I'm going to pack my bags. I shan't stay another minute in a house where oak trees are decorated with baubles!]

The midday sunlight poured into the office at Gad's Hill Place where I had been waiting for over an hour. Fed up with pacing to and fro, I returned to the armchair and picked up another piece of paper from the little table.

*The Nation*, New York, 21 December 1865

'. . . such scenes as this are useful in fixing the limits of Mr Dickens's insight. Insight is, perhaps, too strong a word; for we are convinced that it is one of the chief conditions of his genius not to see beneath the surface of things. If we might hazard a definition of his literary character, we should, accordingly, call him the greatest of superficial novelists. *Our Mutual Friend* is, to our perception, the poorest of Mr Dickens's works. And it is poor with the poverty not of momentary embarrassment but of permanent exhaustion.'

Henry James

I looked up at the window. White smoke rose from the garden. At first I thought it was an ordinary fire of branches and dead leaves but the smell was more like that of burnt paper.

Suddenly a voice made me start.

# VIII

'Hello, Pickwickian!'

I was half-asleep when I answered the phone. The simple greeting that came out of the receiver had the same miraculous effect as Aladdin's cloth.

'What's new in the last three years?'

Those three years in Mimizan flashed before my eyes in the form of ludicrous journeys, speeded up as in a slapstick comedy. From the house to Notre-Dame school. From Notre-Dame to the Plagéco supermarket via Bar de la Marine. From Plagéco to the house.

I sat on the edge of my bed.

'Nothing. What about you?'

'Masses of things. We must meet.'

'I know. The university job.'

'Don't be stupid. I've got some real news.'

'Why tell me?'

Michel gave a burst of laughter. 'Because you're the only other Pickwickian!'

I was beginning to feel a tingling in my extremities, signalling the end of a long, very long, stiffening. It might have been a pleasant sensation but it had taken me three years to put to sleep the part of me that was now awakening. I did not want to go back there again.

'You must come to Bordeaux. I'll be waiting for you at the Clemenceau this afternoon.'

'This afternoon? I'm working.'

'Saturday then. At Krook's! Just like the good old days.' And he added carelessly, 'He often talks about you. He's gone downhill a bit in these last few months. I think it would really do him good to see you.'

121

It was not an argument intended to persuade me – Michel did not doubt for an instant that I would be there, that I would come running like a faithful dog. He simply wanted to offer me an honourable excuse, hold out a bone to my pride.

Krook raised his eyes to heaven.

'Yes, madame, I understand perfectly ... Your dear friend Monsieur de Monbrun ... de Monbron, warmly recommended my bookshop to you ... only I've never heard of the gentleman! One of my clients? Gosh! Are you sure you're not mixing me up with the hardware store opposite?'

I thought he was in pretty good shape, no doubt because Mangematin's sibylline remark had prepared me for the worst. There were of course half a dozen new lines on his face and the blotchiness of it was more pronounced, like a river system in full flood. But this redness gave him an almost fresh-faced look. Most importantly, he had not become stooped by so much as one millimetre: he still grazed the ceiling, as though weightless, like those rugby players suspended in the air by their team-mates in the line-out.

Covering the receiver with one hand, he pointed me to the back room with the other.

'He's already here,' he whispered, 'waiting for you. I'll just get rid of this nuisance and I'll be with you.'

While Krook was as tall as ever, the bookshop on the other hand seemed to have grown smaller in alarming proportions. This phenomenon could be explained by some failure of memory on my part but was more likely due to a considerable increase in the Scotsman's stock: a kind of inexorable sediment that took the form of precariously balanced, skyward-reaching piles like stalagmites, of massive concretions occupying all the tables, spilling from the shelves, festooning even the floor. Books, books everywhere. Krook's premises were undergoing the same thing that every business undergoes when the number of purchases exceeds the number of sales: congestion.

'Ah! You have a few gems for me ... That's very kind of you but not over the telephone ... All right, all right, tell me ... Claude Farrère?

Henry Bataille? Second-hand book stalls are full of them! Anything old isn't necessarily good, madame . . .'

Michel Mangematin was waiting for me in the back room with a smile on his lips – a smile he had surely prepared in advance on hearing the shop-bell ring as I entered. His little sybaritic pot-belly distended a brand-new black Lacoste tee-shirt. His sparse hair gleamed with gel. He studied me at length before directing my attention to something on the table with a lift of his chin.

'Take at look at that and tell me it's not a real find!'

'What is it?'

'As you can see, it's a page from the British Ferries passenger list for the Calais-Dover crossing on the 25th of May 1870.'

It was a photocopy of indifferent quality. You could hardly make out the columns of the original document and the cramped handwriting that filled them.

'Here, look closely.'

Following where his finger pointed, I read with great difficulty a series of names and addresses: Mr Marc Dambreuse, merchant, Lille, Mr Armand Dumarçay, gentleman, Paris 6th arrondissement, Mr Évariste Borel, student, Nohant-Vic . . .'

'So what?'

With a roar of laughter Mangematin gave me a hearty slap on the back. 'I was sure of it! I was sure you'd play the sceptic. Good try but it won't work. You understand perfectly well!'

'Understand what? That your Borel arrived in London a few days before Dickens died? What does that prove?'

'My little François, you disappoint me. You don't think I would have got you to come here if I hadn't been *sure* of myself! Nohant – does that not make you think of someone?'

'Of course it does . . .'

'Indeed! The Good Lady, George Sand, née Aurore Dupin, the "fat beast" as Baudelaire called her. And now, follow me.'

Dragging me along with him, he went charging into the bookshop and stopped dead in front of a long row of bound volumes a piss-coloured shade of yellow.

'Twenty-five volumes! Twenty thousand pages! Who the devil can still be interested in the old girl's dreadful letters? The editor spent a lifetime working on it. He's a madman, this Georges Lubin. Mad but organized. Look, the index takes up a whole volume. Three thousand names in alphabetical order with cross-references to the numbered letters. And here, look, under B: Borel, Eugène, followed by at least twenty-five references!'

'Eugène?'

'Ah, now you're interested! Eugène Borel, wine merchant, mayor of La Châtre, childhood friend of George Sand, father of three children: Marie-Jeanne-Aurore, Jean-Eugène and Évariste!'

'Who does not appear in the index.'

'Ha, ha! You can be so funny. You're like the victim of a shipwreck clinging to the mast! No, he's not cited. Much better than that. Now, let's see . . . volume twenty-two, April 1870 to March 1872, page 528 . . . Read that!'

He made himself a stool out of Lamartine's *History of the Girondins,* and sank on to it with a sigh of satisfaction. Still busy on the telephone, Krook was unaware of this act of sacrilege. ('The Margueritte brothers, madame! The Margueritte brothers! And what do you expect me to do with that?')

'Go on, read it!'

Nohant, 12th September 1870

To Monsieur Bulloz, editor of *La Revue des Deux Mondes*

My very dear friend,

You have probably received or are soon going to receive a visit from
a young man using my name as a reference in order to offer you a
manuscript for publication. This young man, the son of a very dear friend,
had long played on my trust until his outrageous ravings recently
revealed him to me for what he really was: an ungrateful and ambitious
youth, and furthermore totally devoid of talent as you will be able to
judge for yourself.

However, in the unlikely event that this confused fantasist wins you
over with his sensational subject matter and his cheap-jack style, I would

have you know that I would regard publication of his writings in your columns as a personal insult, and would then find myself under the painful obligation of having to end my association with you as both friend and contributor to your journal.

In the confidence that your good judgement will spare us the distress of resorting to such extremes, I am, my very dear friend, yours affectionately.

'Did you read that? "Painful obligation" – damn it, what a bitch!'

There it was again, that tingling sensation, that *something* stirring inside me. I looked at Mangematin and for a few seconds took stock of the hell my life would be if I felt compelled to envy him. I played the role of being unimpressed and doubtful for all I was worth.

'Maybe Sand was right. Maybe he was just a "confused fantasist".'

'Oh no! You're at it again! I'll tell you what happened. Borel has an argument with his "patroness" – I bet it was something to do with socialism. You know full well the fat cow came out with the most idiotic nonsense about that. Then he goes to England, meets Dickens just before his death, obtains the confidences of which he spoke to France at La Coupole. But he's just an insignificant student from the provinces, totally unknown in literary circles. To get his story taken seriously, to get himself published, he needs a recommendation. So then he tries to patch things up with the Good Lady, shows her the manuscript. Bad move! Sand has an unforgiving nature, a reptilian viciousness. Instead of opening doors for him, she double-locks them to keep him out!'

'There were other magazines he could have . . .'

'Do you realize what Sand represented in the Parisian literary world of that time? A union boss! A big shot! A bit like Gide in the 1930s or Sollers today. She only had to praise someone and they would be hailed by all and sundry as a genius. A word of criticism from her and the next day some poor devil would be lynched in the marketplace . . .'

'I'm not talking about the leading literary reviews, I'm talking about all those journals that proliferated from the moment of Dickens's death. All that Droodian literature . . . all those popular magazines that put forward their answer to the mystery of Edwin Drood . . .'

'That's where Borel's psychology comes into play. Remember the scene with Anatole France? Borel didn't want to talk to anyone else. He was afraid profane ears might hear what he had to say. I bet you my copy of Pickwick with illustrations by Phiz that he had far too elevated an opinion of himself and his writing to publish in any old literary rag. You know, I'm sure . . .'

He rose, dusted off his trousers, and came and planted himself in front of me with a weird smile on his lips.

'I'm sure he was someone just like you – a purist! For whom that wouldn't be good enough. Who would sooner say nothing than stoop so low! After all, both of you bear the name of a *poète maudit*. Which leaves its mark on a man, fills his head with notions of grandeur! Well, that's just for starters. Now, here comes the best bit: would you believe . . .'

'What? What did you say?'

Krook's exclamation made the stalagmites teeter and in a space where whispering was the rule it rang out like a fart in a crypt.

'The Young Fate? Number one of a limited edition printed on coated vellum paper?'

The Scotsman emitted a strange sound, halfway between a howl and a laugh.

'Ah! It was this dear Monsieur de Monbrun who told you of my passion for Valéry? Well, I'll have you know, madame, that even when wrapped in silk a turd is always a turd. And over my dead body will any book by Valéry be allowed over the threshold of 17 Rue des Ramparts! As for your Monsieur de Monbrun' – Krook gave us a wink and took a deep breath – 'you can tell him from me, if you please, to fuck off!'

He almost broke the telephone cradle hanging up. Then he gazed at us fondly.

'There! I didn't let someone get the better of me this time! Your old Krook stood his ground! Ah! François, Michel . . . All of a sudden I feel younger. Ten times the man I was! We can handle the Bringers! Krook will show you what he's made of! Skimpole! Bring us three stiff drinks, please!'

Krook put his arms round us like a hooker clasping his two prop

forwards, and steered us towards the back room. He seemed to be still elated by his own courage.

'Now fancy that! Only this morning I read something that reinforced my aversion to that sinister character. Gide tells how he went to visit Valéry one day with a copy of *Copperfield* in his pocket. "You ought to read this book, *cher maître* – he called Valéry "*cher maître*"! – and tell me what you think of it." Without a second's hesitation Valéry takes the book and goes and closets himself in his study for about twenty minutes. Then he returns. "Here you are, my dear friend. I don't need to read any more, I know how it's done." What a vile pretentious swine! I could just about forgive him his marquise comment, but that! He knows how it's done! So that's the be-all and end-all of French literature: to know how it's done. There are people like that, my friends, who never go to a restaurant, no, they prefer to analyse a menu and go sniffing round the chef's rubbish bins to find out how it's done!'

The sound of his ring scratching the bottle brought back so many memories for me that I already felt drunk before I had taken the slightest drop. Krook was beaming. As he filled the glasses, Michel himself looked different to me. He was almost like a caricature of the old university friend. We clinked glasses, our hands freezing at that moment for the benefit of some invisible photographer. I mentally composed a caption for this snapshot, in the likely event that Michel were to become famous: *Bordeaux 19\*\*, in Krook's bookshop. On Michel Mangematin's left, the bookseller. On his right, an unidentified person.* The ringing of the doorbell broke the spell. With a sigh, Krook returned to the shop. Mangematin took a sip, remained silent for a minute, cleared his throat and resumed where he had left off.

'Believe it or not, Évariste Borel had a son. That son, Étienne, had a daughter, and that daughter, Eugénie Borel, seventy-eight and unmarried, is still alive. And you know where she lives? St-Émilion, old boy, St-Émilion! Half an hour from Bordeaux! Her father Étienne married a certain young lady by the name of Bouscart, heir to a famous wine producer. He eventually sold up the family business in La Châtre and moved to the south-west. And guess what I have in my pocket? An invitation to tea at Château Bouscart from Mademoiselle Borel! Listen

to this, it will make you laugh: "My dear Monsieur Mangematin, I'm delighted to learn that someone has a genuine interest in Dear Papa" . . . Dear Papa is her grandfather, Évariste . . . "I knew him very well when I was young, and still remember him with a fondness that neither time nor my little health problems have diminished . . ." It has to be said, the old girl is half gaga with Alzheimer's . . . "I do indeed have in my possession virtually all his numerous writings (alas, I am the only member of the family to remain true to him). As for making them available to you, we would have to meet first so that I could assess (according to very specific criteria that Dear Papa imparted to me just before his death) your ability to appreciate an invaluable body of work and your integrity . . . That will take time, as you can well imagine. To begin with, I would suggest that you come and see me . . ." etc. Virtually all his numerous writings, do you hear? This time, the prize is within my grasp for sure! A little flattery, one or two well-turned compliments . . . Thanks to my legendary modesty I'll have the old girl eating out of my hand! You can put it in your diary: within a year at most the MED will be resolved!'

It was a triumph. My only hope was the fly in the ointment, the fatal flaw, the defective piece of the jigsaw puzzle that at the last minute could not be made to fit. In the meantime all I could do was to put on a brave face.

'Congratulations, Michel, you've done it! But how did you . . .'

'Shhh!'

We could hear Krook's voice, sounding strained, almost unrecognizable. Evidently, he was talking to a woman. Michel leaned out of the door, gave a whistle of approval. I slipped into the shop after him.

I saw her from a distance, between two piles of books, patiently listening to Krook's embarrassed explanations about Belgian publishers.

'A private detective,' murmured Michel.

'What?'

'I hired a private detective, just like in the movies. It was he who went to British Ferries, to Nohant, to La Châtre. He who tracked down the old girl Borel in St-Émilion. I chose him from the telephone directory because of his name: Dick Agency, investigations, surveillance of all kinds. Monsieur Dick, can you imagine! It was too good to be true!'

At that moment, alerted by our murmuring voices, the girl turned towards us and suddenly what Michel was saying to me was no longer of any importance. I walked into the middle of the room, stood right in front of her and said straight out, 'Excuse me but I think we've already met . . .'

'Excellent start,' whispered Michel coming up to join me. 'Carry on like that, you're doing well.'

Then raising his voice and addressing the girl, 'What my friend meant to say, before his emotions momentarily robbed him of his poetic faculties, was that you remind him of those melancholy beauties in the paintings of Dante Rossetti. That on seeing you, he rubbed his eyes, like the cop in *Laura* when Gene Tierney appears in her white raincoat and matching hat. And like Frédéric on the *Ville-de-Montereau*, he had to hold on to the ship's rail. For the strange thing about beauty is that it's like a memory, even when seen for the first time.'

The girl accepted this compliment with a smile before turning to me.

'Yes, we were at university together. We both went to same lectures . . .'

I wanted to tell her I had absolutely no recollection of those famous lectures we had both attended. I would like to have talked to her about Little Angels but my tongue had swollen to enormous proportions and filled all the space in my mouth. A disconcerting incident then occurred: when I shook her hand, my cock stiffened. 'No need to panic,' I thought. 'Every time you see this girl something happens inside your trousers, that's all.' Feeling ridiculous, I devoured her with my eyes. Her hair was not so flaming red, her beauty seemed a little faded, but her green eyes transfixed me. Behind that prim pose of a pretty middle-class young lady from Bordeaux, I sensed the impulses of a jaguar, smouldering mysteries. Somewhere at the back of my memory the fearsome little girl continued to torture Bobo the clown and I identified wholeheartedly with that twitching toy. I was Pip. I had found my Estella.

'I'll take this,' she said to Krook, holding out Robertson Davies's *The Rebel Angels*.

'Excellent choice' – Michel furiously rubbed his hands together – 'and our friend Krook is not the man who is going to contradict me on that. Do you know, there are frequent references in that book to the divine

Thomas Urquhart, one of his ancestors? I personally regard Davies as one of the greatest living writers. I have the other two volumes of the Cornish trilogy, as well as the Deptford trilogy. If you like I can . . .'

'Thank you.'

Before she went through the door Mathilde cast a final glance in my direction.

'My God!' exclaimed Michel. 'What a stunner!'

'Yes,' Krook concurred in a lugubrious voice, 'she's a dish.'

'I bet you my copy of Meredith's *Egotist* that our friend Daumal here is going to score with her and then . . .'

I did not hear the end of his sentence. All of a sudden my legs had agreed to obey me and I soon found myself in the street, running.

A quarter of an hour later she was there in front of me on the banquette in the Bar Clemenceau where I had suffered so many humiliations. I was finishing my second martini and finding it easy to talk.

'It's curious, for years now I've been accumulating documents, quotations, testimonies . . . And sometimes I tell myself I'll probably never write a single line of this book.'

'That would be silly! When you have a passion you should enable others to share it!'

Incredible! Leaning over the table, she was lapping up whatever I said.

'Yes, you're right, now that you say so, it seems obvious. I must apply myself to it . . .'

A kind of frantic foolishness overcame me. I could not help showing off.

'The most important thing if you going to tackle Dickens is to start with *David Copperfield*. It's not his best but it's the way in, the gateway . . .'

'In which translation?'

'Leyris.'

She frowned to imprint Leyris on her mind.

My 'passion'! And what if my 'passion' had been numismatics or the comparative study of the different techniques used worldwide for canning pâté? Would she have looked at me with the same languorous eyes?

There was only one possible explanation: in the great biological lottery

I had hit the jackpot. We 'clicked', we 'got on' – countless other even more trivial expressions jostled in my mind. And worst of all, here I was dragging Dickens into this maelstrom called desire. I fed her a line about the human melting-pot. I was like the verger who tries to use his connection with the archbishop to get into a brothel.

'You know, if you're really interested, I could show you my documents, my notes . . . If you're not doing anything on Monday, for instance, we're on holiday.

'Monday? Yes, why not?'

So that's what the word 'seduce' means: to tame a wild animal.

Sunday was a long torture session. I picked up the phone over a hundred times to cancel the arrangement. In the late afternoon I headed out for the beach on foot.

There was nothing picturesque or marine-like about Bar de la Marine but it was the only one open out of season. In relation to the competition, this gave it a kind of ontological plus-value. Even after Easter the regulars ignored the siren-song of the disco, the elaborate cocktail menus, and the pretty mini-skirted waitresses at the Surf Bar, the Atlantic Club or the California. They continued to haunt this dingy room with its sawdust-strewn floor-tiles, just as parishioners in the queue for the confessional remain faithful to the old clergyman in his shabby smelly cassock while the young, 'modern', electric-guitar-playing priest with his cowboy boots and leather jacket is left with nothing to do.

'So? What do you think, Monsieur Daumal?'

Standing, formally, with a bottle in his hand, Antoine awaited the verdict. I had his son in 1B: a surly kid, already red-cheeked as if rosacea were not a sign of alcoholism in the Ladevèze family but a trade mark, a professional attribute that came with the business – that of running a bar. And Antoine, to satisfy his boy's schoolteacher, had specially ordered in a 'de luxe whisky you'd appreciate'.

'Not bad, not bad at all . . . but it's bourbon not a scotch, Antoine.'

'Good God, you're right! Just a moment while I fetch the right one, damn it!

As usual I had installed myself by the jukebox that was out of order,

131

jammed for ever on Los Machucambos' '*Cuando Calienta el Sol*'. From time to time the door of the bar opened, letting in the smell of the sea and the factory's sulphurous fumes, that distinctive cocktail of Mimizan (which of course I had long ago renamed Coketown) where for two months of the year the holidaymakers basking on the beach compete in the perspiration stakes with the workers in the paper factory.

'Don't worry. It's really very good. In fact I'll have another one.'

'All right, but it's on me!'

Antoine let his heavy body sink into the chair opposite mine.

'So, what about my boy? Is he doing well?'

The amber liquid flowed into my glass, then down my throat, a glorious cavalcade followed by a succession of secondary effects: slight palpitations, dryness of the mouth, insidious migraine, and most of all a weird impression of looking down on everything, of distance.

'Uh . . . that is . . . no, Antoine, he's not doing very well. In fact he failed his essay on Flaubert.'

'Flaubert, Gustave?'

As quartermaster at the Mont-de-Marsan barracks Antoine had for twenty years addressed conscripts with barked greetings in the style of 'Barrère, Pierre!' 'Dupouy, Christophe!' It was a habit that had stayed with him.

'Yes . . . Flaubert, Gustave . . .'

'Damn it! I told the boy that fellow was a tricky customer!

'Yes, well, to be absolutely honest, Didier also has a problem with Rousseau, Jean-Jacques; Baudelaire, Charles; and Rimbaud, Arthur. As a matter of fact, I think he has a problem with literature in general.'

'Oh, he does, does he?'

Antoine filled my glass, as if his son's academic inadequacies could be made soluble with alcohol.

'He has difficulty in grasping the difference between the literary work and reality. He judges both in the light of his own experience. He had to analyse Frédéric Moreau's behaviour in *A Sentimental Education*. This is essentially what Didier wrote in his essay (leaving aside the grammar mistakes): 'Frédéric knows nothing about women. He should have fucked Madame Arnoux right at the beginning and then got on with his career.'

The barman smacked his forehead, scandalized by such ignorance.

'What a cretin that kid is! After all it isn't very difficult to distinguish between a novel and real life: no one in real life comes out with all those daft things they say in novels! Just wait till he gets back from football! He's going to get an earful from me, I can tell you!

As the sun went down I turned on to the bridge and rested my elbows on the rail for a while. Then I staggered off towards the jetty. I walked as far as I could, to where the concrete breakwater meets a pile of black stones. Darkness was falling rapidly, the spray was blinding. As the tide escaped through the channel it gurgled like a drain, with the strains of some juke-box surfacing above that sound, like a sonic turd. One false step, the slightest slip on the algae-covered stone and I too would have disappeared in the depths of those cosmic latrines. But I was too drunk to worry about it.

A car went over the bridge and in the glare of the headlights a man appeared standing motionless by the rail. He was frozen in a strange attitude as if the beam of light had caught him by surprise just at the moment he was about to turn round. His face was illuminated for a few seconds and I saw his staring eyes were fixed on me.

Meanwhile the car turned right and drove parallel to the jetty in my direction: I was dazzled by the headlights. When I was able to see the bridge again, it was empty. Either the man had jumped into the channel or else he had sprinted back across the bridge and disappeared into the alleys of the small fishing village.

As I turned away the sand crunched under my old tennis shoes and from the sound of my footsteps arose a name: Mr Dick. A murmur at first, the name gained volume. It gradually absorbed the figure glimpsed in the glare of the headlights, investing it with undeniable reality and power. A volley of questions and answers filled my head: why would Michel have me followed? Because he had said too much. What is he afraid of? That I might go rushing off to St-Émilion. And get hold of Borel's manuscript before he did.

Tossing and turning in bed many hours later, I still felt Mr Dick's vacant gaze boring through me.

# IX

'You wouldn't happen to have seen a key?'

For three years I had refused to give any thought to the attic. I did not even want to know whether the tenant had emptied it or left it as it was. But since we had got married and Mathilde had moved to Mimizan — since Dickens had come back into my life — this question had been bothering me.

'What key?'

'The key to the attic. A big rusty key. It must be lying around somewhere.'

Mathilde was categoric — too categoric?

'No. I haven't seen any key. Ask Madame Conscience.'

After our first meeting it had all happened very quickly.

Her father, a bailiff at Caudéran, had a big house: I remember the monumental gate, the English-style flight of steps and the bow window looking out over the Parc Bordelais. Inside, prize pieces of furniture were stacked up as though in an antique shop. All that was missing was the price tag. Her mother stroked them as she gave me the sales pitch: 'A Boulle, in virtually mint condition. We got it for a third of what it's worth: one of the perks of the job. The marquetry desk . . . a few traces of woodworm, a sign of quality . . . Careful! That's a Galle. Personally, I don't like pate de verre, but you know how it is, there are some offers you can't refuse . . .' Passing in front of her daughter, she seemed tempted to offer the same style of commentary: 'Delightful young lady of good family . . . Perfect condition . . . needs to be handled with great care, but at her best in a drawing room when properly shown to advantage . . .' In the end she contented herself with a tap on her daughter's cheek.

Meanwhile her father had placed in clear view on the table a single malt that would have made connoisseur Krook turn pale. With his big bald head and long frame, he looked like an upside down exclamation mark. And that is exactly what he was: a mere emphatic reiteration of whatever his wife said. He examined me closely, seeking some secret aptitude that would have justified his daughter's enthusiasm. Not finding any, he shook his head.

'Papa . . . mamma . . . I've decided to live with François. We're going to move in together at his place in Mimizan.'

Her mother was flabbergasted.

'Mimizan . . . Mimizan . . . Isn't there a tannery there?'

'A paper factory.'

'My God! And is it the paper that smells so bad?'

'No doubt through metonymical contagion − the factory produces almost nothing else but toilet paper.'

This was totally untrue but she believed me. Through her eloquent silence she implied everything she thought of a town that owed its prosperity to such merchandise.

'You do whatever you wish, my darling, but don't expect us to come and see you.'

'I should think not!' said her father, rolling his eyes.

I had just said goodbye to a twelve-year-old Linkwood.

At the time Mathilde's boldness amazed me. This leap into the void she had taken seemed to me worthy of Estella. It had everything: courage, determination, strength of character, even a touch of sadism with regard to her poor thunderstruck parents. Only later did this glorious deed appear to me ambiguous: I saw the fear behind the bravura, the dependency behind the bid for emancipation. In the middle of life's ford Mathilde had simply jumped from the back of one tortoise on to another, and it would not be long before I felt on my back her little clenched feet, her body trembling with fear.

When we arrived at my place she bravely preceded me up the cement path overgrown with weeds and took a deep breath.

'It's quite bearable!'

Then she cast an eye on the surroundings, carefully avoiding the

factory's minatory mass and the facade of the tumbledown house, with the closed shutters making it – if such a thing were possible – even more depressing than usual.

'Only two kilometres!' she said with forced cheerfulness, pointing to the sign that indicated the way to the beach. 'Very convenient!'

At first she wanted to take matters in hand. With a scarf over her hair, an apron round her waist, she started tidying up, cleaning, improving the place with a series of little touches: curtains, mirrors and expensive furniture arrived from Bordeaux as if her mother, through the intermediary of a delivery van, were desperately trying to circumvent me by opening a branch of her own shop in my house. Did Mathilde really believe she could transform this hovel into a *House & Garden* style apartment? Now and then little sighs of impotence escaped her and I found her one evening lying exhausted on a magnificent chesterfield sofa, the mere presence of which in the middle of the sitting room would have made old Sitting-Pretty howl with laughter. She pulled herself together when she saw me but I did not for one second believe in her migraine.

As for myself, I wandered through the house, vainly seeking in the midst of an increasingly dense jungle of little round tables, screens, knick-knacks, halogen lamps and designer armchairs the shadow of the wild creature that had rent my heart twenty years earlier.

One day I cracked. We were actually in Bordeaux, in the new Mériadeck shopping centre, looking for a very special bed, a round bed she had seen illustrated in a magazine. I thought it was a strange idea but I had something else on my mind.

'Wait, stop here!' I said, as we were about to cross the broad avenue that ran alongside the centre.

'Why? What is it?'

'I think it must have been just about here . . .'

'What are you talking about?'

'Little Angels.'

Mathilde gave me a scathing look.

'Are you crazy? It was much further away, towards the cemetery!'

A lively discussion ensued. There was nothing we agreed on. Mathilde

could remember perfectly a clean, bright, pleasant building; I, a squalid dump. According to her, the nuns who ran the nursery were angels of tenderness who had flown straight out of some edifying film. She could picture herself, a well-behaved forget-me-not in a posy of little-girl paragons, covering with kisses a doll with laughing eyes.

'And besides,' she added, 'the clown's name was Bobby not Bobo! That proves you've got it all wrong!'

'It also proves I didn't dream it, that we did meet there . . .'

'Maybe, but I wasn't the way you describe me. I was happy at Little Angels, everybody liked me.'

Slowly the conversation worked its way round to our usual bones of contention, such as the key to the attic.

'I'm sure you threw it away during one of your house-cleaning frenzies!'

'What difference does it make in any case!' she retorted, turning red. 'You said yourself there was nothing in the attic!'

'It could be used to store furniture! At the rate you're ransacking antique shops we're soon going to need the space.'

This was the perfect stepping-stone to raising the issue of the round bed.

'Who's going to sleep in the centre?' I asked slyly.

'That's not the point! It's big enough for . . .'

'Whether it's big or not, it has to have a centre. All circles do.'

'You really are ridiculous when all's said and done!'

And she just abandoned me there and went off to meet her mother at a tea room on Place Tourny. Left to myself, I paced up and down outside the post office. All of a sudden, as I passed the telephone booths, an idea occurred to me.

'Hello?'

'Borges, *The Maker*,' I said without any preamble.

At the end of the line there was a short silence, then a chuckle – a kind of gothic rumbling of the belly straight out of Hoffmann or Lovecraft, by which Krook demonstrated his paroxysm of joy.

'Very smart! The endlessly repeating self-reflected image! Michel made a similar suggestion a while ago. But no, no, my dear friend, that

137

isn't my tenth book! Keep trying! Between you and me, I tend to be more in favour of Nabokov: the Argentinian's pachydermic erudition is not very much to my taste. I think that beyond a certain point excessive cleverness borders on pure and simple bullshit! Where are you?'

'Bordeaux.'

'Fine. Michel is going to drop by shortly. Come and join us.'

'Sorry, my parents-in-law are expecting us,' I lied. 'Next time, I promise.'

'You heartless fellow! You're neglecting your good old friend Krook. Tell me at least whether she's as wonderful in bed as I imagine.'

'As a matter of fact, we're just choosing one now.'

'Bah! An old mattress would do me.'

I still had a few coins left. I consulted the call-box's old telephone directory.

'Dick Agency, good morning!'

It was a seductive woman's voice. During the silence that followed I took pleasure in imagining an office like something out of an American film noir, with a metal filing cabinet and a table with an ink-blotter on which the secretary was in the habit of drawing hearts while she was on the phone. I pictured her as a Dorothy Malone glamour girl, or an alluring Gloria Grahame type. Her chignon, her severe spectacles were there only to prepare for the inevitable scene where one dispirited evening Mr Dick would deign to rest his gaze on her, would loosen her hair with a weary gesture and put her thick-lensed glasses on the table, discovering with amazement the splendid creature who had for years been within his reach.

'Hello?'

A glass door opened on to the corridor in a disreputable-looking building. From her seat the secretary could read this enigmatic inscription: ＹＯＮƎＧA ꓘƆＩᗡ.

'Hello? Who is this on the line?'

I hung up. A bewildered-looking old man, struggling with the automatic vending machine, had just caught my attention. He was a vaguely familiar figure but I probably would not have recognized him had it not been for the collection of medals pinned to his chest.

'You'll never succeed if you carry on like that, Monsieur Preignac. That's the slot that issues the tickets.'

'Thank you, young man, but . . .'

His mindlessly moronic face cleared after a long moment.

'Of course! I recognize you . . . you're . . . you're . . . Michel Mangematin's friend! How is he?'

After that there was no stopping him. Preignac recollected with emotion every detail: Michel Mangematin's 'striking' erudition, his liveliness, great presence, humour, brilliance. On the brink of tears he recalled perfectly that time when in the middle of a lecture Michel – 'I take the liberty of calling him Michel!' – had recited the whole of that great scene in Act III of *Othello*, playing the part of both Iago and the Moor, and even Desdemona. God, that was funny! But what talent, my dear young man, what talent!' The only thing he had forgotten was my name. I could see he was groping for it in between emotional evocations of 'our dear Michel'. But that did not stop him. He got round the problem by referring to me with various circumlocutory phrases he thought flattering: 'Michel's lieutenant', 'Michel's equerry', his 'Macduff', his 'Cassio'.

'I realized from the outset he would go far, but all the same! Who could have predicted – consultant to the secretary of state for universities, at his age! Sadly, I hardly see anything of him these days. As you might know, I've retired.'

'I imagined so, yes.'

'I wrote to him twice but he's so busy. His lectures, his work at the ministry, and elections coming soon . . . You know, he's probably going to be elected to the town council of Arcachon? Speaking of which . . .'

Suddenly he was looking at me differently. His addled brain had just thought of something, a bit like a flat battery that emits a last spark when you throw it in the rubbish dump. He took me by the shoulder and drew me a little further along in the classic manner of the Shakespearean aside. With his index finger he pointed to the array of decorations on his chest.

' "Beware that which glitters!" said the philosopher. Alas, it's something I'm only too well aware of but I can't help myself! maybe it's something that goes back to childhood. My mother always used to say,

"Jean doesn't have enough confidence in himself!" With his contacts he'd only have to put in a word. He won't refuse if you ask him. I must have it, young man, I absolutely must!'

'What is it, exactly, that you have to have?'

'But the one I'm still missing! The red ribbon . . . the . . .' He lowered his voice to conclude in a murmur of ecstasy, 'The Legion of Honour!'

I prolonged a pause to savour the situation: the old man was hanging on my lips.

'But Monsieur Preignac,' I said finally, 'if it were up to me you would have had it a long time ago, pinned to . . .'

'That's very kind of you, young man!'

'To your balls.'

'Pardon me?

'You would have had it pinned to your balls. But' – I slapped my forehead – 'how stupid of me! I was forgetting you weren't equipped with those accessories. Well, never mind! They could always shove it up your arse!'

I reddened deeply, stunned by my own rudeness. Then shame gave way to another feeling, one that was pleasant, almost exhilarating. So I could surprise myself. I could become if only for a few seconds the hero of my own life. I wonder if it did not all really begin that day, on the parade in front of the Mériadeck post office. I bowed low to Preignac, satisfied beyond all my powers of expression, though as yet unaware of how I should one day turn this encounter to my advantage.

More than ever before we avoided the subject of Little Angels. At the cost of which, our existence was steeped for a while in a cottonwool-like atmosphere, a pale unreal light. Transfixed in an attitude of happiness, we posed for an invisible artist. Mathilde had given up her home improvements. A strange calm prevailed of the kind that precedes a summer storm. A routine punctuated only by the arrival of postcards that I managed to whisk away before Mathilde found them.

However, one day she was there before me.

'Austin, Texas,' she read, intrigued. 'And no message, just the address. Do you know anyone in the United States?'

'No, it's from an old colleague who was there on holiday.'

'Strange, it's postmarked Dax.'

'He must have forgotten about it and posted it when he got back.'

Over the course of time I eventually mastered the halogen lamp, overcame the small Directoire table, ceased to get my feet tangled in the Persian rug. Relations between us were amicable, sometimes loving, but always reserved: something remained unresolved. I ate my fill, I slept like a log – I even got used to the round bed. In the evenings Mathilde would lie on the chesterfield reading or watching television – current affairs and history programmes – while I corrected homework with one eye on the illuminated screen in the secret hope of seeing some rumbustious wrestlers appear. The factory hummed quietly in the dark. In short I was happy.

At least that is what I tell myself today. Life is a tourist trip: you always postpone the moment for taking the souvenir photo in the hope that the next bend will reveal an even more beautiful landscape. But here you are back in the hotel car park. Everyone gets off and the bus returns to the garage. And you're left sitting on the bench in the dark, wondering why you did not press the button. I could probably echo the words of Jules Renard: 'I've known happiness but that's not what made me happy.'

Mathilde greeted me every morning at breakfast with a smile. It took me a long time, months and months, to understand the meaning of that smile.

And then one Saturday evening we watched a variety show on television. A famous entertainer had just appeared on stage. He was not doing anything. He merely surveyed the audience, looking bad-tempered. There was a moment when the camera showed the faces of the spectators. These people knew the comedian was going to make them laugh. They were watching his every gesture, ready to guffaw at the slightest grimace, at the first witticism. Meanwhile they were smiling. Exactly like Mathilde.

So that was it! Mathilde had faith in me: she was expecting something of me!

It was a terrible revelation. You cannot with impunity give people hope. I finally realized I was going to have to pay for those few stupid

141

remarks I had made at the Bar Clemenceau the day we ran into each other at Krook's.

I did everything to put off the moment of reckoning. Like the comedian, I paced the stage, behaving like a conspirator, cleared my throat, turned to the wings, opened my mouth, and at the last minuted changed my mind. Coming home from school one evening my own house looked strange to me and I knew I was going to have to get my act together.

For a long time I sat in the car examining the front of the house without noticing anything unusual. Yet I was sure there was something that was not as it should be. It was like an old bearded friend who one day turns up clean-shaven, and you keep staring at him without being able to work out what is wrong. And then as I opened the door I looked up. The attic. The shutters were open.

Mathilde was expecting me.

'Come along, I've got a surprise for you.'

She led me up the staircase, opened the attic door – I noticed in passing the lock had been changed. As she stepped aside to let me by I gave her a questioning look. She did not say anything but the smell warned me of the danger.

It was a smell of detergent and sulphurous factory fumes. No trace of that subtle mustiness I still associated with the fateful moment when I had first encountered Dickens. And the light dazzled me.

The place was unrecognizable, the walls covered with expensive wallpaper, the floor sanded and sealed, the ceiling plastered. At the far end was the open window and under the window a desk. In the middle of it, occupying pride of place, was the most up-to-date model of electric typewriter. On the left, an enormous ream of blank paper, 80gsm. But worst of all was on the right: that nice wicker tray, empty at present, waiting to be filled.

'It's . . . clean,' I said to break the silence.

Mathilde was observing me closely.

'You didn't have anywhere to work. It's a little impersonal for the time being but you'll be able to decorate it the way you want to.'

'Yes, of course. Decorate it.'

'You still have a bit of time, if you want. The meal's not ready.'

'A bit of time? Right.'

The door closed. The hinges had been oiled. It was a totally silent trap.

No need to look at my watch: it would soon be eight o'clock. After a last pathetic trundle back and forth, the caterpillar-tracked vehicle had disappeared behind a mountain of sawdust. Engines were running in the car park. Lights came on. The factory was about to welcome the evening shift: like a whore in between clients it was dolling itself up. The siren would soon sound. Meanwhile everyone was enjoying this moment of almost voluptuous relaxation. Everyone except me. Averting my gaze from the empty tray, I stretched my limbs that after two hours' total immobility had gone to sleep.

Just like every evening, Mathilde was being careful not to disturb me. But despite her precautions, if I strained my ears I could hear the sound of cutlery. And I knew that she too was straining her ears. By way of a blind I had typed out a few pages. The regular tapping of the machine had almost succeeded in pacifying me. It was only when reading over my evening's 'work' that the absurdity of the situation became apparent:

I am writing a book about Dickens.

I am writing a book about Dickens.

I am writing a book about Dickens.

I am writing a book about . . .

Yet it was there, this book. At night I could feel the pressure of it inside my skull. An angry mob, the words pressed, massed together. To force their way through, nouns jostled with adjectives, verbs cried, 'Move over!' Sentences drummed a tattoo, seeking to get out. Sublime openings scarcely saw the light of day, already trampled underfoot by no less sublime endings. Yes, but only at night. In the daytime nothing happened. My mind was vacant, desolate, abandoned: a school playground on the evening that school breaks up for the holidays.

A trap. A trap I would never escape. No, I did not blame Mathilde, she had just hastened the inevitable. One day I would in any case have had to sit down at this desk, or some other, and look Dickens in the eye. For too long I had pretended to be in control of my life. But it did not belong to me: it was just a footnote to a book written by someone else. And I knew,

I had always known, that the only way to get anywhere was to write my own book, and close the circle. To make use of *him,* and at the same time root him out of myself as one might remove an organ, drown him in the formaldehyde of a book. Force him out of my body, like a virus. But how? My whole being was infected. What would I say? He had already said it all. It was pointless and absurd: as absurd as drawing a full-scale map of the world.

Yet I tried. I reread all his books, from *Sketches by Boz* to the MED. I picked out familiar phrases here and there: Mr Jingle's syncopated manner of speech: 'Soles – ah! – capital fish – all come from London'; Sam Weller's aphorisms: 'I'll do better next time,' as the little girl said after she had drowned her brother and slit her grandfather's throat.' I made a few notes: Dickens/Dostoyevsky. Dickens/Hugo. Dickens/Gombrowicz. It all came to nothing.

Then one evening as I staggered out of the Bar de la Marine it came to me – I had a preposterous, terrifying, splendiferous idea. True enough, that evening the sea roared, the spray lashed my face, the wind buffeted me. Even an insurance salesman would have fancied himself a Chateaubriand.

I had found the answer. Yes, a book. I would write a book. But not a book about Dickens. At the end of the jetty I braced myself against the wind and brandishing a vengeful finger at the sky I shouted in a slurred voice, 'Not about you, old boy! Anyone but you! I've had enough, do you hear? Enough! I'm going to close my eyes, open a dictionary and put my finger on the page at random. If it happens to point to Guillaume Crétin, well, I shall write a book about Guillaume Crétin ... or Taillepied, or Coquille, or Henri Conscience! Any old writer will do!'

Walking back, I calmed my excitement, I refined my strategy. Before long, trusting to chance began to seem dangerous: there was the risk of being landed with Thackeray, Trollope, Eliot, Collins, or any other writer somehow connected, however anecdotally, with Dickens, and there would be no end to my oppression. No, I had to act with method. Like a geographer wearied by the languid clammy heat and profusion of the jungle in the tropics, I was going to fix my sights on a cold desert region where life

struggles to survive: the ice-cap, for instance! Closing my eyes, I laid hold of my literary sextant. In less than a minute I found my north pole.

'Flaubert!'

The book about nothing as opposed to the all-encompassing book. Drought after the flood. Rubber against lead. Economy. Rationing. Fasting after feasting.

'Of course! Flaubert!'

That night in my round bed I slept like a baby. As if I were the centre of the world.

The next day I woke up in an excellent mood. It was a Saturday, the first day of the Easter holidays. I whistled under the shower then sat down at the kitchen table, feeling ravenous. The coffee smelt good, the toast had already popped out of the toaster, but where was Mathilde? I found her later, still in her dressing gown, curled up on the chesterfield in the sitting room. This was not the first time but I was put out: I would have liked to share my enthusiasm with someone.

'You're not having breakfast?'

'No.'

I could not get any more out of her. As I climbed up to the attic I tried to recall the last proper conversation we had had. To my great surprise I realized it was several weeks ago. Since then, all I had heard from her was 'good morning' and 'good night'. I suddenly became aware how much Mathilde had changed in the space of a few months. She had lost weight. She always seemed tired, even waking up in the morning. She dressed any old how, was totally careless about her appearance. The flaming hair that had been her great pride was just a memory. Now lank locks fell over her sunken eyes or stuck to her cheeks, cheeks wet with perspiration – or tears? Obsessed with my own sterile confrontation with the blank page, I had ignored these alarm signals. But that day, just when I could see the solution to all my problems, they suddenly worsened. I had my hand on the door knob, not knowing whether to go back down and clear things up with her. But I was eager to put my idea into effect. Work awaited me. We could see about the rest later.

I went over to the bookcase. The books to the fore – Dickens's books – immediately tried to attract my attention, raising their hands, like diligent

145

students anxious to please their master. But I had decided to ignore them. I rummaged at the back of the shelves, those dark corners where the dunces tried to make themselves invisible, playing noughts and crosses by the radiator. I found what I was looking for quicker than expected.

*'As it was hot, with the temperature at thirty-three degrees,*
*Boulevard Bourdon was absolutely deserted . . .'*

*Bouvard and Pécuchet,* annotated by Thibaudet in the Pléiade edition. Forgetting Mathilde and ignoring the ringing phone, unusual at such an early hour, I immersed myself in reading. After spending so many years by the Thames, enveloped in fog and the sounds of Victorian London, the Paris street-names seemed deliciously cosy and those of the characters – Bouvard, Pécuchet, Barberou, Dumouchel – afforded me the somewhat craven comfort the traveller feels when after a long journey he glimpses the spire of his native village at the end of the road.

I did not go down until around one o'clock. Through the glass door to the sitting room I saw Mathilde's face, devoid of expression, turned towards me. Her lips were moving slowly. By the time I joined her she had fallen silent again. I just managed to catch the end of her last sentence:

*'. . . before six o'clock today.'*

'But who called? What is it that has to be done before six o'clock?'

I tried the gentle approach, entreaty, threats: nothing worked. Mathilde evidently considered she had done her duty by passing on the message: the fact I had not been there to hear it did not seem to concern her. Refusing to say any more, she became engrossed in watching an American serial. For a few minutes I followed the comings and goings of these improbable characters: the husband with his impeccably blow-dried hair kissing his wife on the forehead before getting into his car; his wife waving goodbye on the doorstep, the expedient smile on her face congealing as soon as the cadillac has the turned the corner down the street; the hurried steps towards the telephone, the feverish hand dialling the

146

number: 'Hello? Is that you, Danny? All clear! He's gone on a business trip for three days! I'm waiting for you, my darling . . .'

With consternation I recalled the not so distant past when Mathilde was borrowing *Age of Innocence* and *Mrs Dalloway* from the library in Mimizan and watching *Eight and a Half* at the Friday evening film club.

That afternoon I could not really concentrate on the next instalment of *Bouvard*. The incident preyed on my mind and when at six o'clock precisely the telephone rang I rushed to answer it before she did.

It was my headmistress. I had forgotten to write the form master's reports on the students in my class.

'This is getting beyond a joke, Monsieur Daumal. I feel as if I am working with a ghost. And your colleagues call you Belphegor! You're never there when you're needed, you have no authority, no influence, you're almost invisible, and the students make fun of you. I'm giving you one hour to write those reports or you'll have to go and haunt some other establishment! There's no lack of responsible individuals who could do your job properly . . . yes, monsieur, even in Mimizan!'

Mathilde appeared not to have stirred in the meantime. Without a word I slipped on my mac and went out in the rain.

The house became hostile again. My patient efforts to domesticate the furniture were reduced to nothing. Every time I saw Mathilde move her lips I rushed towards her, knocking over all obstacles in my way – breaking vases, tearing out wires – with the sole aim of not letting a few precious words escape. Those words that issued sparingly from her mouth and were immediately suspended like the dripping wax that clings to a candle when it goes out. I kept in mind the painful episode of the forgotten school reports. By virtue of the very fact that she refused to repeat them, every word of Mathilde's acquired a grotesque importance for me. I could not miss a single one, for I was afraid of missing the announcement of some catastrophe: the start of a fire in the garden, a smell of gas in the kitchen, a hurricane warning.

I was literally hanging on her every utterance. I was no longer living with a woman but with a sort of depressing oracle whose exasperating

147

laconicism racked my nerves, toyed with my life. I nearly always came running in vain: she was simply yawning.

The attic changed from a prison into a refuge. But my Flaubert project stalled. Once my initial enthusiasm had cooled, an impression of déjà-vu came over me and spoilt my discovery of *Bouvard*. It was as though, lost in the middle of a labyrinth and thinking I had at last found an untrodden path, I saw on the ground the footprints of my own shoes and a thread from my jersey tied to the wall. I had already passed this way before.

Gradually intruders crept into my book: the pompous Madame Bourdin reminded me irresistibly of such a matron I had come across in *Nicholas Nickleby*. The obtuse Monsieur de Faverges conjured up for me Podsnap in *Our Mutual Friend*. As for Bouvard and Pécuchet themselves, these two city-dwellers all at once spellbound by the appeal of country lanes, these ignoramuses suddenly responding to the siren-call of science, were they not the distant heirs to the Pickwick Club? Chased out of the door, Dickens came back in through the window. Besides . . .

Besides, *Bouvard* was among the most famous incomplete works in literature, just like *Drood*! When this finally dawned on me – after several weeks' unfruitful work – an immense weariness overcame me.

That evening, listlessly flicking through my Flaubert and feeling glum, I came across this passage:

*'They finally resolved to write a play. The difficulty was the subject. They tried to think of one over lunch, and drank coffee, that liquor essential to the brain, then two or three tots of spirits. They retired to bed for a nap, then came down and took a turn around the orchard, eventually going out in search of inspiration, marching along side by side and coming home exhausted. Or they would barricade themselves indoors. Bouvard would clear the table, set some paper in front of him, dip his pen in the ink and sit staring at the ceiling while with legs stretched out and head bowed Pécuchet pondered in the armchair,. Sometimes they felt a quiver and as it were the flutter of an idea. Just on the point of apprehension, it would be gone.'*

Outside the crawler vehicle skidded on the sawdust. It was too much. I tipped back my chair and laughed like a lunatic. Then I unplugged my typewriter, left the attic vowing never to return, and locked the door behind me.

I entered the bedroom quietly. Mathilde had not closed the shutters but it was already dark and in the reflection of the factory lights all I could make out was a figure lying in the middle of the bed. Impossible to tell whether she was asleep or not. There was a fifty percent chance she might hear what I said: that made it easier for me.

'I'm very tired, Mathilde. Very tired.'

I sat on the edge of the round bed. She was fully dressed, lying on her stomach with her head buried in the pillow, her hands alongside her body. In the gloom our two figures stood out against the white sheet: a diameter and a tangent. One half dead the other half alive.

'I lied to you. I'm never going to write a book. Either about Dickens or anyone else. It's all a bad joke. I thought I was marrying a man-eater, and what do I get? A neurotic suburbanite. You wanted a Rimbaud and you ended up with Pagnol's Monsieur Topaze. There, I feel better now for having got that off my chest. Are you asleep?'

I stretched out beside her.

The London drizzle penetrated my pyjamas but neither Borel nor Stevenson paid any attention to me: one of them just kept talking as if he were afraid that death might intervene and interrupt his confession, the other listened, screwing up his eyes. Suddenly Borel raised his voice a little. He said my name. I had only to approach, lend an ear, and all would become clear. The MED. Mr Dick. But at that very moment Stevenson saw me and placed a figure to his lips.

# X

Leaning on her carer, the old lady laboriously descended the steps of the square in front of the church. Several people greeted her deferentially but she responded only by nodding, then turned to the young woman to say something to her. The organist played the final chords. The priest appeared in the doorway and pulled the two door panels shut.

The women slowly made their way across the small square. With great difficulty the old lady installed herself in the back of the Renault 16 and sat staring into space while the young woman headed towards the chemist, passing less than ten metres from the café terrace. When our eyes met she imperceptibly slowed her pace and frowned. Her face was vaguely familiar.

I waited till she came out and the car had moved away before paying for my drink and ringing in my turn on the chemist's doorbell.

'Good afternoon. I'd like some aspirin.'

'Do you have a prescription?'

The man was in a bad mood. His lunch had been interrupted twice within the space of five minutes. Through the open door behind the counter I could see the corner of a table with a plate, a bottle of mineral water and some breadcrumbs on it. There was a smell of veal stew in the air, mingling with that of the medications.

'No.'

'Then I can't give you anything. I'm the duty chemist. Duty chemists are only for emergencies.'

'Oh, of course, sorry.'

I made as if to go but with my hand on the doorknob I turned back.

'That old lady in the Renault 16 — that was Mademoiselle Borel, wasn't it?'

150

The man remained impassive. A little sauce had run down his chin.

'I met her a few times . . . when I was working at Ginestet.'

'Ah, you're in the wine trade. Everyone's in the wine trade at St-Émilion. You'd think that's all there was in the world – wine. And then people complain of being sick . . .'

'She doesn't look very well either.'

'Old Mademoiselle Borel?'

He shrugged his shoulders.

'With her, it's not the wine, it's old age. Age and spinsterhood: it's bad for the system. Alzheimer's. An advanced case. Imagine a piece of gorgonzola left in the sun in the middle of August – that's what her brain's like.'

'It's sad.'

'I suppose so. You have to die one way or another. Motorbike accidents, or cancers of the throat – they're no fun either. So do you still want this aspirin?'

As I parked in front of the house I caught a glimpse of Mathilde through the window. She was on the phone. I rushed inside to snatch the handset from her.

'Hallo? Yes, this is François Daumal . . .'

It was like a dream. As if the distant voice came from a different planet.

'Yes, of course . . . All right . . . I'll be there tomorrow as soon as I can . . .'

'Who is it you've come to see, monsieur?'

The nurse's commercial smile vanished instantly. Her receptionist colleague, busy on the phone, eyed me severely.

'In the medical wing, room 18,' said the nurse drily.

I heard them whispering behind my back as I crossed the hall that smelt of wax polish, decorated with a fake plant that had achieved the miracle of shedding half its leaves and with a pale reproduction, hardly any bigger than a postage stamp, of *Le Déjeuner sur l'Herbe*. In the corridor I walked past an old woman creeping over the waxed parquet

with tiny little steps. I passed in front of the televison room. A few old folk were dutifully watching a documentary on lemmings. The door to room 18 was ajar. I heard very clearly the end of a conversation.

'There you are, dear, now you'll be comfortable. Are you sure you don't want a little more Basque cake?'

'No, thank you, pet.'

'I'll come back and see you later.'

'But you needn't bother, I'm fine, I assure you!'

'Tut tut! I want my favourite old lady to have everything she needs!'

'Christine, you're an angel!'

The nurse opened the door but did not see me straight away. She blew a kiss into the room before turning to face me.

'Yes?'

'I think I've got the wrong room.'

'Who are you looking for?'

'Madame Fourcade.'

Christine's reaction was even more surprising than that of the two receptionists. Her face darkened. She breathed in noisily, and began to quiver.

'You have not got the wrong room, monsieur.'

She emphasized the word 'monsieur' with frosty politeness, like the police in films when they try to contain their anger in the face of a particularly repulsive criminal. For a dozen seconds she barred my way looking me straight in the eye. Then she gave a kind of movement of disgust and walked away rapidly.

I recognized the perfume before anything else: Dawn Chorus. If I closed my eyes, I could have been at home. Not in the house I had just come from an hour earlier, leaving Mathilde sprawled in front of *Dallas*, and where I now lived as the result of a simple wrong turning taken by Destiny, but the *real* house, the one of my most distant memories, when the chesterfield did not yet exist, and fifty tin soldiers correctly aligned represented in my eyes the culmination of happiness on earth. An earth where, thanks to my naivety, everything still seemed possible, even if the possible in question amounted to the uncertain outcome of the movements of a few figurines round a hat-box; an earth where Napoleon

still had every chance of winning against Blücher. A virgin continent, at once vast and ridiculously small, where Dickens had not yet arrived.

'Well, what are you waiting for? Are you intending to remain standing in the doorway?'

Imagine a tree. One of those age-old oak trees that goes back to the Paris Colonial Exhibition, Sarah Bernhardt and the left-wing coalition of the inter-war years. Provided it is old when you first come into the world, it remains unaffected by time. When you were shaking your rattle as you scampered across the lawn, it was already ancient. When you were sitting your baccalauréat, still it was ancient. To abide by common sense, you admit the prospect of its demise – as the result of a lightning-strike, logging, a landslide – but you don't really believe it. The idea of its demise is a mere rhetorical device, a kind of variable that you factor in through sheer mental gymnastics. But in your consciousness, in your flesh, there is no doubt: the tree is everlasting.

Why should I have asked after her? The postcards had rooted her in the centre of my life. She was everywhere and nowhere: Washington, Seattle, Dax, Mimizan – what was the difference?

'You don't look well, son!'

Yes, that's her all right, the same as ever. Attentive, indifferent, friend, foe. Rough bark, silky foliage. Of the two of us, I was the one that had changed.

'Well, sit down, dear! You're going to give us a turn . . .'

While I was clumsily drawing up beside the bed a much too low fake-leather armchair, the door opened.

'Excuse me, dear, I forgot the tray.'

Christine crossed the room, doing her best not to notice me. But there was not enough room between the bed and the armchair to get to the bedside table. I stood up and passed her the tray. Then she could not really avoid meeting my gaze. Her lower lip trembled. She began to speak very fast.

'I wanted to tell you, monsieur, that . . . all of us here agree that . . . to have a grandmother like Madame Fourcade, and . . . not a single visit . . . not one phone call in all these years . . . it's a downright scandal! And you ought to be ashamed of yourself, and . . . and . . .'

'Now, now, my little girl,' said Sitting-Pretty, squeezing Christine's hand, 'calm down. He's young, you know how it is. He has other fish to fry, that's all . . .'

'Even so . . . even so, it's . . . Oh, you're much too kind!'

Not knowing what else to say, Christine swallowed her tears and went off with the tray.

Sitting-Pretty's laughter rang out strong and clear as if it had been bottled up in a preserving jar for twenty years.

'Don't you worry yourself, my boy, I didn't miss you at all! They were the ones who insisted on letting you know when they could see I was going to peg out . . . Oh, that doesn't frighten me, I'm even rather curious to see what it's going to be like . . . and besides, I've sent a scout on ahead of me! Look!'

She laughed again. Then with an abrupt gesture she lifted the sheet.

It was magnificent. A perfect orb. A dizzying zero, bandaged in the immaculate white of Christine's dressing. Suddenly Sitting-Pretty was no longer a helpless old woman but a work of art, a human totem dedicated to the cult of geometry. What you could still see of her – the freckles on her face, prominent rope-like tendons in her neck, sparse hair, shorn eyelashes, corpse-like hands – formed the silk cocoon of the chrysalis. The amputated leg was the butterfly.

'It took them weeks to make up their minds. One of them wanted to amputate below the knee, the other above! In the end I told them: "Bloody hell! There's a dotted line! Follow it!" Well, I didn't say it like that. I didn't say "bloody hell". I don't use bad language any more. I miss it a bit, of course, but otherwise I enjoy myself. I enjoy myself enormously! Don't look so miserable, you idiot, it makes you look like your mother!'

She had pulled up the sheet again but I continued to see the white circle of her stump – as when you stare at a light for a long time and it goes on shining beneath your eyelids.

'At first I drove them crazy but it was no fun. It's the norm here, all the old folk are nasty. So one night an idea occurred to me in a dream: I was going to play at being nice! That made me laugh so much I wet myself. And I've done it! I've triumphed, I tell you, the whole

world now adores me! The nurses smuggle me cakes and liqueurs. "My dear Melanie," I say, "you're an angel." But to myself I'm thinking, "Dreadful bitch! You know what you can do with your chocolate éclair!" In the dining room all the men want to sit next to me. There's even one, a young lad of seventy, who's asked me to marry him. "Now, Maurice, you old rogue, you don't mean it! At our age . . ." "The truth is, you have such a lovely smile, Marguerite!" Oh yeah! And you know why I smiled at that *ihl de pute*[1]? I pictured the wedding night . . . with that little shrivelled slug hanging out of his pyjama flies. Once a week the Catholic priest comes to see me, and the Protestant one too, can you believe it? I did tell him I believed in neither God nor the devil but he replied, "There's no need to worry, Madame Fourcade. Your soul is so beautiful you will surely number among the justified sinners." Ha! ha! ha!'

She had a good long laugh, with her head tipped back. Then she took a handkerchief from under her pillow and wiped her eyes as she examined me.

'You look yellow!' she concluded.

I had made the same observation in the mirror that morning after a dreadful night spent dreaming about the chemist in St-Émilion. The man was taller, with broader shoulders than in reality, his shop was gloomier, and it smelt of incense. On the shelves all around me I could see bottles filled with opaque viscous liquids, large ceramic jars bearing fanciful Latin inscriptions or drawings of strange animals. The church bells kept ringing. There were also strange noises from the street, exclamations, whisperings, but I could see nothing from inside. The window was a mirror that reflected my own image. Occasionally someone turned the doorknob very slowly and my heart would stop beating but no one ever came in. 'Be patient, she'll come, she's bound to come,' said the chemist going off into the back room. I was alone but I could hear a crowd arguing bitterly on the other side of the window. And suddenly Mademoiselle Borel was standing in front of me, wearing the chemist's

---

[1]   Provençal insult, meaning son of a whore.

white coat. She was holding a jar in which a pickled foetus floated. A name was etched into the glass: Évariste Borel.

'It's always like this in the beginning,' I murmured in my dream. 'I'm going mad.'

'Not surprising with all the paper you've chomped your way through, all the ink you've swigged ... You need to throw up and piss now, otherwise it'll choke you to death ...'

Feeling ill at ease, I got up to open the window. Sitting-Pretty followed me with her eyes as I walked round the bed. On a shelf stood a half-full bottle of wine, an already opened packet of lady's-fingers, and the old atlas turned to the page showing the United States.

'Your wife told me you were trying to write a book but that it wasn't going well ...'

'You mean to say ... Mathilde has spoken to you?'

I leaned out. In a slow mesmerizing voice the commentator was describing the fate of the lemmings, their ultimate suicide in the North Sea. One old boy coughed, another said, 'Shh!' You could also hear the sound of bottles, of rubber wheels squeaking on the linoleum.

'What else do you expect her to do on the phone? Show me her family photos?'

'And ... what did she tell you?'

'Everything. That you weren't speaking to each other any more. You hadn't touched each other in months. She was unhappy. She's a beautiful girl, I hear.'

'How do you know?'

'Madame Conscience. She calls me from time to time. Beautiful girls don't always make you happy but when they leave you it's bound to be worse than before.'

I felt increasingly uncomfortable. I envied my car down there in the car park, enjoying the dreamless sleep of objects, snuggled up among its fellows in the cosy anonymity of sheet metal and cylinders. Whereas I was alone. An old woman I had not seen for fifteen years knew more about my life than I did.

'What you need is a commission.'

'Huh?'

She looked at me the way she did in the past when I was reading Dickens in the sitting room in Mimizan, with the ironic curiosity of natives watching an explorer go by, whom they think is bizarrely dressed.

'A commission. That's what my father needed. When he didn't have one, he moped. Of course he could have worked in the meantime: made some tables, cupboards, then tried to sell them, but it was no good. He needed a client to come into the workshop and say, make this or that for me. Then he was happy. He'd stop turning things over in his mind and get on with it. Is it true you have a round bed?'

She shook her head with a look of commiseration.

'You've got off to a bad start, my poor boy. I was sure this is what it would come to. I knew it as soon as I saw you bury your nose in those wretched books, just like your fool of a grandfather. You'd better be going if you don't want Christine to have another go at you. You'll never guess what she asked me yesterday? To adopt her, the ninny! Can you see me adopting anyone? As if you didn't have enough with your own children!'

In my haste to get away I took a wrong turning. I came out through the service entrance at the far end of the building and then walked back alongside it to the car park. I got to below the window of room 18, and this is what I heard:

'Alabama?'

'Montgomery.'

'North Dakota?'

'Bismarck.'

'South Dakota?'

'Pierre.'

'There's no catching you out today, dear.'

My throat was dry. I felt an emotion I could not name.

# XI

Charles Dickens frowned as if bothered by the smoke. Or because he was thinking. And what else would he have been thinking about if not the *Mystery of Edwin Drood*?

But was now the time to be thinking? Shouldn't he have done that before starting the book? Before getting tangled up in this story, this banal detective story whose weaknesses and limitations had become apparent to him. Around him the thick walls of Gad's Hill Place could not protect him from his own misgivings. The only view afforded to him by the open window looking out over the garden was of a drab undistinguished landscape, framed by those ridiculous geraniums the mere sight of which now filled him with horror. The idea that a few months earlier had seemed so powerful, so brilliant, had turned into a flock of words that made their way — bleating and leaving ink-droppings — down the increasingly narrow path of an anecdote leading nowhere. He could not retreat. Nor could he could advance, for the vertiginous precipice of failure awaited him at the end of the road. Like a shepherd on the hillside, he was doomed to watch his sheep shitting ink, chewing to a pulp the sparse meadow of possibility. The true, great, only book he wished he could write glittered beyond reach in a blaze of glory on the far side of the valley.

So what? So it all came down to a matter of a dead body and a murderer, a suspect and a criminal. What could be more pathetic than a mystery whose solution was already known? For the thousandth time he mentally rearranged the pieces of this ridiculous jigsaw puzzle: Edwin the victim, Jasper the guilty man, Landless the obvious suspect ... He recalled a conversation with Wilkie Collins. 'Charles, what you need is a plot! A plot! Your characters are lifelike, but in want of a plot they go

158

running around, to left and right, aimlessly. Like chickens! Headless chickens!' But had he not hit on a plot? Had it not come to him, the idea round which everything falls into place, the brainwave that brings out the lustre in words the way a cloth polishes brass.

He was not so sure any more. Now he was desperately searching for a way to protract the mystery to the end, to raise this colourless detective novel *Drood* to the level of Shakespeare and Dante. No doubt he would have been able to think better strolling among the plastic oak trees on the green felt lawn of the architectural model. But he could not get up because he was made of lead. And he did not flinch at the approach of the gigantic fingers that laid hold of him.

'Do you want me to close the window?'

'No, don't bother.'

'No, don't bother . . .' Three words together, more than in a whole week! And there was also the make-up foundation, the pretty pink blouse on her thin body, and then the amazing fact of being side by side in the car on a Saturday evening, on the way to visit a friend, just like any other couple. Except the friend in question was Michel Mangematin.

'You know, Mathilde, it probably won't come to anything.'

These days I always spoke to her in a slow pedantic voice, certain of getting no response. But this time I saw out of the corner of my eye that she was waiting to hear the rest.

'There's nothing to say he'll agree. I'm sure he has two or three post-grads preparing their theses who could do the work better than I could, unless he were to do it himself. And even if he agreed, if he did commission me to do this book, I don't know whether I'm capable of writing so much as a line – even of a crib for busy students.'

On learning that Dickens was to become part of the syllabus for the teachers' qualifying exam – Representations of the Criminal in the Nineteenth-Century European Novel: Hugo, Dickens, Dostoyevsky – I had instantly thought of Mangematin's imprint at the University Press of Bordeaux, and Sitting-Pretty's famous 'commission'. Of course the humiliating nature of such an approach was immediately obvious to me. I

had no difficulty imagining Michel's cynical smile but I could think of no other excuse for visiting him.

'All the same I'm going to try. We can't go on like this, you and I. We have to try . . . to save our marriage . . .'

No sooner were the words out of my mouth than they seemed to me to constitute a new height of absurdity. But to my great surprise Mathilde endorsed them, nodding earnestly.

'Yes!'

The spontaneity and scope of this 'yes!' terrified me. Rather as if I had carelessly suggested, as we walked along the shores of a raging ocean, 'You know I could swim that! And she had replied, 'Go on, I dare you!' And way off, far out to sea, buffeted by gigantic waves, at the mercy of the current, floated the wreckage of 'our marriage': the pedestal table, the halogen lamp, the chesterfield, the round bed.

They were still floating an hour later as Michel with a havana cigar between his lips fingered his miniature Dickens and surveyed the imposing model with a look of satisfaction. That was new, the cigar. It was part of an arsenal of distinctive signals deliberately selected to suggest patrician well-being and easy-going bohemianism: the majestic ceilings of his apartment in Rue St-Genès, the library ladder, the indoor tweed jacket, the Nick Molitieri tee-shirt, the slippers with holes in them, the can of beer on the Directoire desk.

'Gad's Hill Place II! It's a done deal! We've bought the plot, at Arcachon. Planning permission will come through any day now. If all goes well, work will begin in September. It'll be stupendous, unique.' He addressed the miniature directly, 'A temple in your honour, Charley! Everything's going to be made identical! I've contacted two antique dealers in London: they're taking care of the furniture. And the architect has been working like a lunatic. This here is the house, and here's the chalet . . .'

Krook coughed. 'Excuse me, Michel, but I'm very familiar with all this. I think I'm going to help myself to another drink.'

'I'll come with you,' I said, following him to the sitting room where the same subtle calculation of effect prevailed: crystal chandelier, expensive drinks, an old copy of *Libération* and a set of mustard-jar glasses on a silver tray.

'What's all this about, Krook? How is he going to finance such a project?

The bookseller seemed to me slightly stooped. He had practically not opened his mouth since our arrival. Now, standing in front of the bar, he made me think of those old company secretaries who know perfectly well where their employer keeps his booze but cannot help glancing over their shoulder as they help themselves to the best malt.

'He's not the one that's paying. It's the NDC.'

'The NDC?'

'The New Dickens Club. Founded by Miss Burdet-Jones, a retired school teacher from Glastonbury, who was mad about Dickens, and won two million pounds on the lottery. For years the NDC contented itself with producing an eight-page monthly magazine listing new Droodian publications, and organizing an annual dinner every 9th June, on the common next to the park at Gad's Hill Place, to commemorate the great Charley's death. Until Michel became an active member. You know him: within fifteen minutes he had the old girl in his pocket. He made himself indispensable to her. The official headquarters of the NDC were still at Glastonbury but it was he, on the telephone, who took all the important decisions, he who persuaded Burdet-Jones to undertake this Pharaonic project. Initially, Gad's Hill Place II was to be built somewhere in Kent, not far from the original, but when the old girl died . . . Oh, I must tell you how she died! It's pure Wodehouse!'

Krook offered me a generous ration of Glenturret. Out of the corner of my eye I did not miss a jot of what Mangematin was up to in the next room. I could hear his melodious voice, his well-worn patter like a country priest's sermon. I could see him hunched over the model, as close to Mathilde as decency would allow.

'Believe it or not, Burdet-Jones had one passion apart from Dickens: wild flowers. One day when she was waiting at a level crossing with her companion she spotted a speedwell on the railtrack. She immediately got out of the car to pick it and was hit from behind by the London-Liverpool express! The old girl left all her money to the club, most of whose members are French and close contacts of Mangematin: English specialists from all the top universities, writers, two or three senators, a

former minister of culture. He got himself elected president without the least difficulty and obtained the support of all the official bodies on either side of the Channel for his Arcachon project. He could have filled his own pockets while he was about it, but he didn't. The NDC's accounts are transparent! Truly crystal-clear. And I know what I'm talking about, I'm the executive treasurer. No, it's not money that interests him, nor even power, it's . . . what exactly?'

He glanced at me questioningly.

'I've no idea, to be honest. That guy's a mystery. His success, his career, the university, politics – it's all dust in your eyes, the visible part of the iceberg, the happy outcome of some obscure plan known to no one else but him. Or maybe he doesn't know himself where it's all leading . . .'

Krook filled our glasses with a steadier hand. Gradually, under the influence of the Glenturret, he was becoming once more that scintillating, exotic and imperious individual who had so impressed me when I was a child. Far from dulling his gaze, alcohol sharpened it, and I found in his eyes the old wariness with which, despite our friendship, he had probably never ceased to regard me.

'And you're the same. But in reverse, of course, the reflection in the mirror. When he succeeds you fail, when he triumphs you grin and bear it. But your humble life as a school teacher, your frustrations as a failed writer are no more authentic than his worldly cocktail parties and electoral campaigns. You too are hiding something. Seeing the two of you together suggests that putting your two mysteries together is all it would take to obtain a clear solution, a result so simple I could slap my forehead and cry out like Inspector What's-his-name, "Good grief! But of course!" But it can't be done. You're like fire and ice, or rather two boxers, two exhausted boxers who only can remain standing by clinging on to each other.'

Michel had placed one hand on Mathilde's shoulder. With the other he was pointing out a detail of the architectural model. Their cheeks were almost touching. Mathilde was not looking where he was pointing. She had taken the minature of Dickens between her fingers and was staring at it, frowning, as if those lead lips were going to dictate how she should behave.

'Your wife is one of the most beautiful women I've ever seen,' murmured Krook, sighing, 'but you don't seem to realize it. It's as though you enjoyed seeing him flirt with her. If you knew the number of nights I've spent with her . . . How I've envied you! I'm sure I remember the day you met better than you do. Even now when I'm tidying up the bookshop I say to myself, 'She looked at this shelf . . . she stood here, and there . . . Lord, if I had a wife like that I'd keep her under lock and key. I'd give anyone who came near her a punch on the nose. And I'd get her to eat meat . . . because she's lost weight, you know, a lot of weight . . .'

'The bookshop? But in your letters you said it wasn't doing well, you were going to sell up.'

'François, you haven't heard the latest!

Michel came striding over. He kept his eyes fixed on Mathilde and rubbed his hands together vigorously.

'You see before you a wealthy wholesaler, sole supplier of Bordeaux university.'

Krook smiled a little sadly. He had become a company secretary again.

The meal was excellent. Michel talked non stop, to Mathilde especially, and she listened, a little bemused, like someone who has found an attractive object lying on the ground which she has absolutely no need of it and wonders if she can be bothered to bend down and pick it up. I had already decided to forget about my excuse before we started on the oysters but there was another burning question I wanted to ask, that I had great difficulty in holding back until the cheese was served.

'And how far have you got with Borel?'

Mangematin laid his fork on the edge of his plate and gazed at me with an air of amusement.

'It's obvious you didn't train at the Actors Studio . . . "And how far have you got with Borel?" The way you act casual weighs a ton, my friend! Is he any more credible when he says "I love you"?'

Mathilde lowered her gaze without replying.

'I'd be surprised! François does it the way they used to . . . I can picture him in *Saboteur* . . . the role of the spy . . . all grimaces and

glowering looks. I bet he's never told you about Borel! No, of course not, it's forbidden territory, the "dark secret" of the repertory. My style's more modern . . . instinctive if you like.'

He stared at her until she lowered her eyes again. Then he abruptly turned to me.

'Nowhere. Didn't you know?'

'How would I know?'

'It's not very far, St-Émilion. You might have driven over there.'

'Did the old lady throw you out then?' asked Krook.

'Not at all!'

Michel picked up his fork and shovelled an enormous piece of gorgonzola into his mouth.

'The old girl took me into her arms,' he went on with his mouth full. 'She called me her dear child! I visited the library where Évariste's writings remain under lock and key, hundreds of page, essays, poetry and . . . "Come back soon. I'll show you everything, my dear child!" The problem is, Mademoiselle Borel is like a crystal set. With a well-placed thump you can get a few snatches of transmission out of it but most of the time it's silence, or sizzling noises. Sautéed brain à l'Alzheimer, served on a bed of sickness. I thought I was achieving my aim by seducing the patient but she had forgotten about me before I had even got through the garden gate. It's the nurse I should have been sweet-talking. The nurse, her memory stick, her back-up disk, who picks up from the ground the shards of Mademoiselle Borel's intellectual faculties and sticks them back together at her convenience, like fragments of porcelain. No glue, no vase. No nurse, no manuscript. It's as simple as that. Unfortunately it just so happens the nurse is not very fond of me.'

In the process of talking and eating he had regained his slightly ironic urbanity. And he continued in the tone of the old university friend reminiscing.

'The nurse . . . little Nathalie . . . One of your many conquests, François, do you remember?'

Instinctively I looked at Mathilde. She was sending me desperate signals. I had no need to read her lips. I knew she was expecting me to

strip off my clothes and plunge into the icy waters of the ocean, to bring back to the shore one by one the pieces of our matrimonial wreckage. To say, for instance: 'That's enough, Michel. I came to ask you a favour. You've taken advantage of that to try and seduce my wife. But I don't need you. I don't need you to write my book. We are going to get up, Mathilde and I, and you will never see us again. This is the start of a new life. The two of us. François and Mathilde. Without Michel.' That's what Mathilde in her immeasurable candour was hoping.

'The day before my next visit I received a letter. A letter from little Nathalie. Mademoiselle Borel's state of health had recently deteriorated, she wrote. And this was not unrelated to my earlier visit: it had exhausted her. Too much excitement. Too many painful memories of the grandfather she loved so dearly, who had died in her arms, etc, etc. So I picked up the phone, I called half a dozen, a dozen times . . . but I always got Nathalie . . . "No, you can't speak to her . . . she's asleep . . . she was in a terrible way yesterday evening . . ." And then one day I finally got the old girl! "Mademoiselle Borel? It's Michel Mangematin . . . Do you remember me?" "Who is this?" "Michel Mangematin . . . I came to see you a little while ago . . . we talked about . . ." "Yes, of course! Monsieur Mangematin! How could I have forgotten!" "I would very much like to come and see you again, Mademoiselle . . ." "But of course! Come tomorrow!" "Tomorrow? Well, yes . . . that's settled then." "See you tomorrow, Monsieur Mangematin . . . but you will be careful with the roses this time. Last time you pruned them too hard!" End of transmission.'

Krook screwed up his eyes. I was wondering how he could still follow the conversation after all the alcohol he had consumed.

'And why didn't you just go there?'

'I did. Closed door. Silence on the intercom. I told you, end of transmission.'

'So you're throwing in the towel?'

'No, I'm passing on the torch. Why not to François? His fling with Nathalie gives him an undeniable advantage!'

'Évariste Borel doesn't interest me any more.'

Michel put his hands round his own throat and mimed the guest who chokes to death with amazement.

'I owe you an apology,' he said having knocked back a large glass of wine. 'You've a greater dramatic range than I thought! I was almost taken in. Yes, yes, honestly, that was very good. Mathilde, you have a veritable Talma here, a Lemaître, a Dullin! Admittedly the style's a tad old-fashioned, but God, what a performance! Keep him, he's perfect . . . unless of course you were hoping to update the repertory a little.'

'Now then, Michel, don't overplay your hand. Remember, so far . . .'

'But no further. No, Krook, I haven't forgotten. Moreover, I have something here we can all agree on: sovereign Lagavulin! It makes an excellent liqueur!'

'Cheers!'

'Cheers!'

Meanwhile, Mathilde's silent telegraph sent more and more SOSs. 'What should I do, François? Your tortoise-shell back is as slippery as a reef. I'm bound to fall into the water, I'm going to drown. Or else I'll have to get into this strange vessel plying these waters. What do you think? What should I do?'

Trapped between the pepper and the mustard, Dickens seems indifferent to the whole world.

'Cheers!' I responded.

It was pitch dark. The factory lights lent a kind of depth to the tarmac. Mathilde had gone to Bordeaux that morning. To see her parents. She had this notion after long and mysterious phone calls of which I had caught a few snatches even though she took care to lower her voice. 'And why should I? . . . (five words) . . . No, that would be crazy . . . (six words) . . . There's no sense in it . . . (six words) . . . I need to give it some thought . . . (five words) . . .'

At four o'clock in the morning she still had not come home. I had left the *Sud-Ouest* newspaper on the telephone table, open at the death notices page.

'Hello? Monsieur Krook?'

'Is that you, François? Do you know what time it is, my boy?'

'I know, but this is important.'

'Important, my foot. Just a minute . . .'

Krook moved the handset away from his mouth but I distinctly heard him cry, 'Skimpole! Where on earth did you put my slippers?'

'It's about the book . . .'

'Which book?'

'The one in your library.'

'What the devil do you mean by . . .'

'The tenth book. I've got it.'

# XII

Dickens tore the article out of my hands, shouting, 'Henry James! That mealy-mouthed young whipper-snapper! I saw through him right from the start, when he was dancing attendance on me at my hotel in Boston or pursuing me with his 'my dear master' this and 'my dear master' that!'

He picked up the wastepaper basket, threw the article and Aurore's letter into it, as well as all the old papers he could find, grabbed me by the arm and dragged me out of the room.

'A Yorkshire terrier! A Yorkshire terrier beribboned with literature! Syntax is a substitute universe for him! The more convoluted his sentences, the more he fancies himself a subtle psychologist . . . and he wanted me to publish him in *All the Year Round*!'

Dickens did not release me once we were in the garden. From the strength of his grip and the furious look on his face anyone might have thought he had just caught me with my hand in a jewellery case. With a few strides we joined Weller by the bonfire. Bare-headed, with his sleeves rolled up, the servant was tossing on to the fire by the pitchforkful an enormous quantity of papers spilling out of a wheelbarrow – old newspapers, draft manuscripts, photographs, bundles of letters tied up with string or with ribbon, and even a few books, among which I thought I recognized the work of the Old Troubadour. Weller cast sidelong glances at me as he worked, while Georgina Hogarth observed the scene with a disapproving eye from where she stood at the drawing room window. Now and again, lifted by the current of hot air, a loose sheet of

168

paper escaped from the flames and twirled gently before falling to the ground. Dickens would then angrily kick it into the fire, on top of which he eventually emptied the contents of the wastepaper basket. His face expressed by turns anger, sorrow, regret, bitterness, then melancholy. Finally he released his grip and looked at me properly for the first time.

'So, monsieur,' he said in French, 'you're Madame Sand's nephew.'

'Not her nephew,' I replied, blushing, 'her godson.'

'Ah, godson. That explains why you don't look at all like her.'

Dickens was only fifty-eight but he looked much older. Compared with recent photographs published in the press, his face seemed to have grown heavier, as if he were in the process of turning into his own statue. The skin of his cheeks looked like old leather. He tried to conceal his scalp under a lock of fine grizzled hair the wind kept lifting in a ridiculous tuft on top of his head. His long, frizzy, bushy beard gave him a vaguely biblical look. It also emphasized the droopy appearance of his jaw – 'When the jaw droops,' my grandmother used to say, 'the rest soon follows' – while his moustache, much too fine in comparison, drew attention to his thick lower lip instead of masking it. His small piercing eyes sometimes narrowed in an almost terrifying manner. A curious mixture of energy and inflexibility, of pomposity and liveliness emanated from him. No matter how straight he stood, buttoned up in his Victorian patriarch's uniform, there was something about him that suggested drunkenness, disorder, and his very short stature conjured up both choirboy and little devil.

With a rather clumsy gesture he tapped me on the shoulder.

'Let me tell you something, Monsieur Borel, Henry James was right about one thing: I am superficial . . . constitutionally superficial. I can't hide what I feel. And I'm incapable of putting off till later anything that needs doing. These papers

had to be destroyed. Keep burning, Sam, keep burning! Be ruthless! Now, I'm at your disposal.'

His voice summed up his whole personality: a little fluty music in tones of the English aristocracy with a robust Kentish accent and the verve of the common people. A well-learned urbane recitative with a few broad couplets slipped in, and even the odd bark.

'When I was child,' he went on, 'I relied on my first impression to form an opinion about people. And I was rarely proved wrong. Then I was told appearances were not to be trusted, that you had to look beneath the surface of things, in the words of Mr James. But beneath the surface there's nothing! Every human being is entirely contained in a frown, a smile, a wave of the hand . . . There's nowhere to hide. A word, just a single word, suffices. A name. I say "Bob Fagin", and Bob Fagin, almost fifty years later stands before me. Once again I see his foxy face, his weasel eyes, I hear his drawling sarcastic voice: "Follow me, young man" – he was just my age, twelve years old– "this is where you'll work!" And I can smell the wax, the glue, the Thames . . . Now I've returned to the good old ways. It took me half a century to realize that the young Charles was right! So, let's spare ourselves the conventional politenesses, the formal introductions . . . You've seen me for what I am, and I already know you.'

'How so?'

'Your letter, Monsieur Borel! I've never received one like it.'

With the end of his pitchfork Weller stirred the last remaining half-consumed bundles of paper. He blinked, wiped his brow and declared, 'Damned hot! Hurray! It'll soon be summer, as the melting snowman said . . .'

Dickens gave me a cheerful slap on the shoulder and roared with laughter.

Georgina Hogarth spent less time eating than wiping her

mouth. She treated food like importunate visitors you are required by good manners to entertain but whose departure you impatiently await with one eye fixed on the clock. Dickens wielded his fork with rustic enthusiasm. The menu was Pickwickian: simple, hearty and tasty. Lamb cutlets, braised vegetables, followed by cherry tart, all washed down with chilled water and a small beer.

'We'll go to Cooling and come back on the main road.'

Georgina laid down her fork and looked daggers at me as if it was I who had spoken.

'Cooling! Charles, you're not serious! Your gout!'

'My gout is absolutely fine! I feel as light-footed as an elf. Seeing all those papers burning has made me feel twenty years younger. My inner engine needed that blaze of joy! And I have to defend England's honour with Monsieur Borel here. The French are sturdy walkers!'

After some discussion it was decided that Weller would follow us with the trap in case of an untimely attack of gout.

'But there won't be any need, Georgina. I tell you again, I feel wonderfully fit!'

For the first few hundred metres he gave evidence of this. He was a remarkable rambler whose long strides made you forget his small stature. His regular pace, with the twirling of his walking stick marking the rhythm, gave a false impression of slowness, but I was very soon bathed in sweat, and I realized I would have to grit my teeth to keep up. For a few minutes our path led across some fields. He looked straight ahead without seeming to take any interest in the surrounding countryside. Yet much later in the afternoon he referred to a scarecrow, dressed in a man's pair of trousers and a woman's blouse, that he had seen in the middle of the field and that I had not even noticed. We entered a wood, neither of us slackening our pace or exchanging a single word.

At the top of a rise I resorted to the pitiful ploy of a shoelace come undone to catch my breath. I stood up again too

quickly: my head swam, my legs trembled . . . Another of those wretched dizzy spells! I closed my eyes. On reopening them I was almost amazed to see Dickens. Leaning on his stick, he crossed and uncrossed his legs, looking at me with a mocking gaze.

'So, you like my *Pickwick* . . .'

No one in France [not even Aurore] would have dared say anything like that. But it immediately occurred to me that I liked Dickens's books precisely because they were straightforward and uncircumspect.

'Yes, in my opinion it's your finest book.'

Generally, a writer does not greatly appreciate anyone speaking well of his early books. The most vicious reviews often begin with a brief eulogy of a novel published by the author forty years earlier; they then go on all the more to savage his latest work – exactly as James had done in *The Nation*. But at the very moment I was about to regret my candour, Dickens began to smile.

'You speak very well of it in your letter . . . better than many London critics. You know, when I wrote the first chapter I had absolutely no idea what the second would contain?'

'So I've heard.'

'It was all so easy then. My mind was teeming with flights of fancy. I pulled on the thread and the spool unwound. It was an extraordinary sensation! For months I was working simultaneously on *Pickwick* and *Twist*, and already thinking of *Nickleby*. My hat was never empty: numerous rabbits and hundreds of multicoloured ribbons kept coming out of it. I was inexhaustible, invulnerable! But things changed . . .'

We had set off again at a more reasonable pace. I thought at first he was holding himself back in order to chat at leisure, then I noticed he had a slight limp in his left leg. Nevertheless when Weller caught up with us to offer his services, Dickens flatly refused.

'Well, master, if you've no objection, I think Joyce would like to stretch her legs a bit.'

Joyce, a scrofulous old nag with a sagging rump, turned an affable dozy gaze on us. She seemed as keen to 'stretch her legs' as a sliced salmon to swim upstream.

Dickens nodded with the utmost seriousness.

'Yes, Sam, it would do her good. We'll meet up at the usual place.'

Walter gave a ringing 'gee up' but Joyce did not budge. Stopping had been disastrous: her hoofs seemed stuck in the ground. The rider stood up and cracked his whip like a charioteer. Joyce again marked her disapproval with a protracted moment of total immobility. Then she set off without warning and even began to trot as they went downhill. Weller held on to his hat with one hand as if the speed at which they were going was in danger of whisking it off. Dickens smiled as he watched them go.

'What's happening to me is strange, Monsieur Borel. I didn't think it was possible to tire of being God.'

We left the cover of the trees behind us. The path climbed a hill at the top of which stood a few dwellings, and a squat little church surrounded by graves. The sun was still shining but a fresh breeze had risen that made our walk less pleasant. Dickens dug his walking stick deep into the ground. I could hear the speech impediment coming through in the words he spoke, the slight lisp that his detractors have so mocked.

'Once, just once, I almost gave up on a novel. It was *The Old Curiosity Shop*. Little Nell had to die and I couldn't bring myself to accept it! I liked being God at that time. I simply found the task too great a burden, too cruel . . . but there wasn't yet this mist. This dark mist that obscures the end of *Drood* . . .'

On reaching the hamlet Dickens turned left towards the church. We sat on a dry stone wall. The place was strangely *alive* . . . Anyone who has ever seen an English cemetery will

understand what I mean. The greenness of the grass seemed more intense than elsewhere. Animal droppings were evidence that a flock of sheep had passed through it. I thought of David Copperfield watching from his bedroom window the sheep grazing round his father's grave. I thought too of Pip who, from the shape of the letters engraved on their tombstones, tries to imagine what his father, mother, and five brothers looked like. Each grave had its own personality. Every headstone leaned slightly to left or right at a particular angle to the ground. Their shadows extended protectively over the graves or encroached on another headstone – perhaps by way of establishing contact with each other. No streets or crossroads in this realm: Cooling's dead scorned the cadastral system. They settled wherever they pleased.

A fresh grave had been dug in the shadow of the church. You could almost imagine the future tenant testing the comfort of the earth as one might try out a mattress with one's hand, then glancing to the left and right to assess the neighbourhood.

Joyce was waiting with her master in front of a building that went by the simple name of the Cooling Inn. A modest cart draped in black stood beside it. Just opposite, carved into the church's stone porch, a merry monk held out a pitcher: as in the words of that English folksong 'We Be Soldiers Three', 'Charge it again!' he seemed to cry out to the innkeeper. His big bare feet, with grotesque toes, rested on the door frame.

'I'd called him Brother Edwin long before embarking on *Drood*. There's something brazen about his presence. It's a challenge. A relic of your immoral and dissolute Catholicism in our stern Anglican world . . . I find him a little repulsive, yet I'm very fond of him. Doesn't he look as if he wants to join us?'

He turned to me and murmured, ' "Your characters seem to be carved out of words like a sculpture carved out of stone, but a living stone endowed with all the characteristics of flesh.

Even after the book is closed they're still standing there beside their models. If our gaze passes too often from one to the other, we come to regret being born of man and woman and not of the chisel and mallet." A nice turn of phrase, a little bombastic perhaps, but I don't dislike it . . .'

Dickens smiled at my amazement. These phrases were word for word ones that I had written in my letter. He fell silent for a moment, sighed, then gestured southwards.

'Look over there. Behind the trees.'

'Gad's Hill Place . . .'

'My father often brought me here when we lived in Chatham. He would point to that house and say, "Charles, my dear, if you're good and work as hard as you can, one day you'll be able to live in a beautiful house like that." Not so long ago I realized those simple words had governed my life. Between the young Charles I was then and the successful Dickens I've grown up to be, there's my father's pointed finger . . . A much more formidable instrument than the sculptor's chisel. A compelling exhortation.'

And indicating with a lift of his chin the freshly dug earth he added, 'The trajectory of a man . . .'

Then Brother Edwin rose. That at least is the impression we had when the church door opened and his toes appeared to move away from the door panels as if having been tickled.

Four men emerged bearing a wooden coffin. Then came a woman in mourning flanked by two small children, a sour-looking old woman, and the carter, with his whip still in his hand. He was followed by the priest bringing up the rear.

There were no flowers, singing, incense, or surpliced choir-boys. [Which is probably what my mother would have wanted instead of the candles, wreathes, crashing of grand organs and pompous sermon that father insisted on having for her.] Without conferring we got off the wall and remained standing awkwardly with our arms crossed. The family gathered round the grave. The children observed the hole with curiosity.

Then a hand grabbed hold of me and dragged me behind the church.

Dickens was scarlet-faced. He was breathing with difficulty and bent over as if he had just been punched in the stomach.

'I can't help it,' he said, getting the words out painfully. 'This happened to me at the burial of my old friend Maclise . . . At . . . at Thackeray's funeral I had to be led away to avoid a scandal . . . It's just that each time I think of the unbelievable . . . astounding absurdity of all this . . . Even the gods die, Évariste . . . Anubis died, and Zeus, and Jupiter . . .'

He was holding his sides and trying to control the spasms that distorted his face.

'Even Dickens has to die . . . and I find that . . . terribly . . . funny!'

Tears sprang to his eyes and he abandoned the attempt to contain his laughter any longer.

8 June

'Monsieur Borel? Monsieur Borel, wake up!'

For a few seconds I thought I was at the bottom of a well. The voice I heard sounded sepulchral. The head stood out, far, far above me, against a circle of shimmering light. I sat up abruptly and saw him standing at my bedside. In one hand he held an oil lamp, in the other a bundle of papers wrapped in a folder. My bewilderment seemed highly to amuse him.

'What . . . time is it?' I stammered.

'Gone six. It's already light. I thought all Frenchmen were up at cockcrow . . .'

He went over to the window and with a jerk drew back the curtains before putting out the lamp.

'Sorry to barge in on you but we don't have much time. I have to be in London this evening.'

'What's that?' I said, pointing to the folder, now placed on my bedside table.

But I already knew the answer.

'You're the first,' he said simply. 'No one has yet read a single line of the manuscript of *Drood* apart from the typesetter and the proofreader. Neither Forster, nor my daughters. Not even Georgina. They've had to wait until publication like every other reader[1].'

'Why me?'

He hesitated a moment with his hand on the doorknob.

'Why not? Come and find me in the chalet as soon as you've finished. And . . . be lenient with me, professor . . . My handwriting's peculiar, especially my *th*s!

The cardboard folder was covered with various notes – dates, names of places or characters. All crossed out with a single pen-stroke, except this enigmatic phrase which Dickens had circled and underlined twice: 'Sorj Penjah. Don't forget.'

I pulled out of my suitcase the June instalment which ended with these words: 'And thus, as everything comes to an end, the unaccountable expedition comes to an end – for the time.' It was the extremely suggestive scene Miss Mind and I had discussed: Jasper visits the cathedral tower and crypt with the apparent intention of reconnoitring the scene of his future crime and of stealing the key to a tomb from Durdles, the stonemason, no doubt in order to hide the body of Drood there later. Then I read and reread the first lines of the manuscript: 'Miss Twinkleton's establishment was about to undergo a serene hush . . .' But I was incapable of connecting the printed text of *All the Year Round* – its elegant typography, Fildes's beautiful engravings – with the dreadful scrawl of the manuscript. It was as if a learned professor returned to the classroom after his lecture and under the influence of drink held forth incoherently. Moreover, the first twinges of a migraine were beginning to afflict me.

---

[1] This is a white lie on the part of Dickens (or a fabrication of Borel's?). As several witnesses testify, Dickens read out whole chapters of his book to Forster before publication.

Nevertheless I applied myself to the task of making headway through the thick forest of symbols and erasures. I struggled. Its wordiness, like creepers, hindered my progress. Metaphors plagued me like mosquitoes. There was nothing in this lengthy extract to justify any hope of the slightest surprise or dramatic coup. On the contrary. Here was pathetic confirmation of the suspicions I had conceived in reading the preceding chapters. And what if the American had after all been right? Dickens was exhausted. Dickens was aping Dickens. Dickens was in his death throes. *Drood* would be a monument to his death.

Laying aside the manuscript, I felt a much deeper unease than the mere irritation of a disappointed reader. Something had just been dashed to pieces. [I recalled Aurore's acerbic remark – 'Why get so excited about an Englishman? Has France not enough geniuses?' – and father's scorn – 'Go and ask Mr Dickens to pay your allowance instead of me!'] I recalled my own misgivings: my perplexity at the ponderous rhetoric of *Little Dorrit*, the difficulty I had getting to the end of *Our Mutual Friend*. And all of a sudden my anger turned against myself. In the dressing-table mirror I saw a person with no talent clinging to the coat-tails of a chimera. A young hothead who at more than twenty-five years of age had no experience of the world except through the intermediary of someone else's words. [Finally, a terrible suspicion overcame me: had not this obstinacy in clinging to a sterile passion, this basic incapacity to live my real life, added to my mother's anguish? Was I not responsible as much as father, and perhaps even more so, for her decline, her . . .?]

This idea was unbearable to me. I put the manuscript under my arm and went out. It was already very late in the morning and the sunshine immediately aggravated my headache. As I passed by the vegetable garden I came across Weller, busy smoking his pipe and watching a salad plant grow.

'Knock hard, Monsieur Barrel! He's very busy. I heard his

pen scratching furiously . . . By the way, he's going to have lunch in the chalet . . . If you don't want to end up being left on your own with Miss Hogarth, like the stag partying with a hunting rifle, I'll take you in to Rochester. I've some business to attend to there. It's a remarkable town: a cathedral, two abbeys, a museum, a library, no less than fifty-eight taverns . . . and two or three other things that will interest you,' he added with an air of mystery.

I simply nodded and turned into the underpass that according to Weller's directions led directly to the Swiss chalet. There I halted, relishing the calm of this cool and shady place, but a carriage thundered by on the main road above my head. With one hand resting on the moss-covered wall, I closed my eyes. When I came out at the other end I had made my decision.

I could see the Swiss chalet at the end of a little path. Only the day before I would have avidly scrutinized every detail of its exotic architecture but my heart was no longer in it. My only plan was to return the manuscript, obtain if possible a little laudanum to relieve my headache, and make my way to the station at the earliest opportunity. All the same I lingered for a moment on the threshold, fascinated in spite of myself by the sight of Dickens at work: exaggeratedly hunched over the paper, he clutched at the table with his left hand while his right hand flew from line to line. He seemed exhausted, as if the diabolical pace imposed by his hand required of him an even more strenuous effort than our long ramble the day before. Occasionally his pen would be raised from the page. Then it would make furious deletions in a paragraph, like the deep furrows that suddenly etched themselves across the writer's brow.

Nothing could have distracted him. That is why, after having knocked at the window several times in vain, I decided to go in.

'What do you want?' he said curtly, without looking at me.

The blood rushed to my temples. 'I'm returning your manuscript, sir! Did you not ask me to do so?'

Slowly he laid down his pen and looked up at me, without throwing off his air of vexation.

'Well?'

It had been my vague intention to soften my criticisms. But it seemed from his almost insulting attitude that he wished to cut short any mincing of words. On reflection I think that is exactly the effect he wanted to achieve.

I have forgotten the exact tenor of my words – I think my throbbing migraine and the ironic gaze with which Dickens kept scrutinizing me gave excessive virulence and bitterness to what I said – but I remember more or less the way I concluded:

'You ask for my opinion, sir, I will give it to you. If a study of social behaviour was what you intended, your aim has not been achieved. Your characters are undistinguished, motivated by crude passions, banal sentiments. The imagination that constitutes your genius is rarely to be found here . . . and if you aspired to a mystery novel, it's even more of a failure. The reader realizes from practically the very first line that Jasper is the murderer. The whole novel is then just a long drawn-out exercise. As for knowing whether Drood is dead or alive, that's a very weak ploy.'

'Very weak, indeed,' he murmured.

I fell silent, scared by my own audacity. But at the very moment I was desperately racking my aching brain for some concession I could make to salvage his pride, Dickens amazed me. He leapt up and immediately started dancing a kind of triumphal jig. Then he paced up and down rubbing his hands.

'Excellent! Excellent!' he exclaimed. 'Monsieur Borel, you are in every respect worthy of your letter. The best critic imaginable!'

He planted himself in front of me and laughed openly at my appalled expression.

'Have patience for a few hours more, my friend, and be ready to leave for London. This evening we'll dine early and take the 7.15 train. And then all will be revealed! Meanwhile, I still have a little work to finish off.'

He grabbed hold of me by the shoulders and gave me a friendly hug but by the same motion pushed me towards the door.

'How do you spell it?'

'P-E-N-J-A-H.'

Weller pondered while Joyce was overtaken by a junk dealer pulling a handcart.

'No,' he said, 'that doesn't mean anything to me. No Penjahs that I know of. Maybe it's a character in a novel . . .'

'Not one of his, at all events.'

Two rows of modest dwellings heralded the outskirts of the town. Weller shrugged his shoulders.

'Who knows what fanciful idea might have passed through his mind . . . The funny thing is, the fanciful ideas he has become gospel for millions of others. Look to your left!'

On the signpost the name of Rochester had been blotted out with red paint. Someone had hung up a banner across it bearing this inscription in the same colour: Cloisterham.

'And that's not all! The owner of the Travellers' Inn has changed the name of the wretched place. Now it's called Drood's Inn! A piano teacher in Chatham Street has had to leave town. No self-respecting citizen would entrust him with their children any more.'

'Why's that?'

'Because the poor fellow's name is Jasper! Last month there was a town council meeting to consider rerouting an insalubrious street and apparently some smart alec suggested writing to Mr Dickens, that he might correct it with a stroke of his

181

pen! Nearly everybody laughed but I'm sure one or two heads there were nodding!'

A few minutes later Joyce came to a standstill in front of a fairly decent-looking public house.

'Are you sure you won't come in and have a bite to eat?'

At the mere thought of the smoke-filled room, redolent with cooking smells and alcohol fumes, my stomach heaved.

'No thank you, I think I'm going to visit the cathedral.'

'Then I have just the man you need. Tommy! A client for you!'

A little chap of about twelve years of age immediately came running up and planted himself in front of me and delivered his patter: 'Three shillings for the cathedral, master! I will show you the tower where the crime was committed and the crypt where the body was hidden!'

'How do you know all that! The book isn't even finished yet . . .'

'That's the way it happened, master, I swear to you! My uncle saw it all! He was there when that fiendish choirmaster pushed the young gentleman into the void!'

'What did I tell you?' sighed Weller. 'I'll come and find you at the cathedral in an hour's time,' he added before disappearing into the pub.

In exchange for the famous three shillings I managed to get rid of Tommy but I had more difficulty in forgetting Weller's remarks. As I acquainted myself with the town it seemed to me stranger and stranger. The sun, slightly veiled with a heat haze, blurred the contours of objects like a clumsy draughtsman. There was almost nobody outside. On a patch of open ground two dejected-looking urchins threw a ball to each other, half-heartedly, as though instructed to do so by a theatre director concealed somewhere. And the imposing keep of the castle, towering over the heap of old buildings on the banks of the Medway looked like a stage set, as did the splendid buildings of the Guildhall and Eastgate House. Even

the fruit and vegetables on the market stalls seemed unreal. As I approached the cathedral I had the impression of slipping into another universe.

That impression became even stronger when I saw Gundulf's tower rising between the two transepts. I passed through the porch, walked into the nave and I soon had to sit down in front of the great choir screen, overcome as much by this feeling of strangeness as by tiredness and my throbbing migraine.

It was then that an idea occurred to me. I noticed first of all that although I had wandered randomly through this unfamiliar town and very far distant from each other though its most famous buildings were, I had come across all of them, one by one, in exactly the same order that my guidebook, bought in London, chose to present them. I then noticed it was impossible to concentrate my attention on the architectural riches that surrounded me. Vague conventional terms were all that came to mind – blind arcades, Roman bays, chapter house – without conjuring up the slightest tangible reality, like the indefinite echoes of a dream.

A dream! That was it! This barely formulated idea took hold in my mind and could not be dispelled. There was no other way of explaining the bizarre events of the last two days: Dickens's extraordinary attitude, my own shilly-shallying, the disconcerting ease with which my dearest wish had come true, then turned against me. What remained to be discovered was, since when had I been dreaming. I spent a long while considering the problem.

Maybe I was still on the train. Maybe Miss Mind had not yet wakened me. But it was possible that Miss Mind was part of the dream. That I had never left my room in Fleet Street, where I still slept, laid low by the effect of the beer. And there was no end to it. Dumarçay, Mr Dick, my journey to England . . . A dream? My father's treachery, my mother's death, the argument with Aurore, my studies in Paris, my passion for

Dickens, my first communion at Châteauroux . . . How far back to go? To what parting of the ways? And how deep to dig before at last striking a solid and reliable surface beneath the fine dust of the mirage?

I leapt to my feet and headed towards the tower. The guidebook warned of a steep staircase. It was already past midday and I had eaten nothing since the previous evening. Would my legs carry me so high up? But I immediately began to laugh. Since when have dreamers suffered hunger pangs?

In *Drood* the gate to the tower was kept locked with a key which the cathedral handyman Durdles produced from his pocket. In reality – but could I still use that word? – the gate stood wide open, a sign simply conveying the awkwardness of the climb. Indeed I had to lower my head to avoid hitting the steps above. My town shoes slipped on the stone. The ledges projecting from the central pivot brushed against my ribs. Spiders' webs settled on my face. The air was thick with a strong smell of mildew. So many insistent, surprisingly distinct sensations that did not tally well with my new theory! In any case, whether dream or reality, the staircase was very like the one in the novel. Here and there it gave on to little galleries from where I could see the nave and the angels that adorned the vault. No rook started to caw but the proximity of such a creature was confirmed by the amount of bird droppings. And when the staircase narrowed even more, I began to feel the cruel want of Durdles' lantern.

After a few minutes I thought I discerned daylight above my head. In my haste to get to the top I straightened up and banged my head violently on the vault above me. At that precise moment I seemed to hear a noise coming from the bottom of the staircase but I attributed it to the pounding in my head. I climbed the remaining steps with one hand held to my forehead and the other clutching the central pillar. At last, coming out of a final turn in the staircase, I saw what was bound to be a stairhead. I gave a sigh of relief, convinced I was

emerging into the fresh air. Instead I found myself in a fairly spacious room of a breadth and depth that nothing led the climber to anticipate.

I recognized the place at once: the room with the man who had his back turned to me. An intolerable smell of sulphur hung in the air, and it was not the sky above Kent I could see through the window but the mountain, the strange moving mountain. The man was gazing at it too. It crumbled before our eyes and there soon appeared behind it an indistinct menacing shape.

'Charles, I think this departure for London is too hasty.'

Dickens put away his watch and settled a vacant gaze on his sister-in-law. In contrast with the previous day he had hardly touched his plate. His complexion was leaden, his eyes dull, and I saw that his hands, stained with black ink, were trembling slightly.

'After what happened to him,' continued Georgina, 'Monsieur Borel surely needs to rest. Could you not postpone this trip till tomorrow?'

I was not so naive as to think that my turn in the cathedral had won me Miss Hogarth's compassion. It simply made me an unexpected ally. Besides, Dickens's stubbornness was only too obvious: she could not very well pretend to hold me responsible.

'I have an appointment with Chapman at eight o'clock tomorrow morning,' he said wearily. 'If I don't leave this evening, I shan't get there in time. Monsieur Borel is welcome to spend the night at Gad's Hill Place and travel to London tomorrow.'

This prospect did not greatly appeal to me.

'Thank you, but I feel much better.'

'That may not be true of everyone,' Georgina shot back drily.

Then she clicked her tongue and laid down her fork with a

gesture of annoyance. Dickens did likewise but with extreme slowness, as if the fork had grown too heavy for his hand. I lowered my eyes. I felt a tightness in my chest. A moment of almost supernatural calm then descended on the dining room at Gad's Hill Place. And I could not help seeing in this inter- lude a premonitory sign of what was going to happen a few minutes later. From a distance we probably looked as if we were at prayer but the tension was palpable. Something was trying to enter the room. An event was brewing, so tremendous an event that to forge its way through the mesh of everyday life – the softness of the early-evening light, the chequered pattern of the clean rough-textured tablecloth, the old leather chair-backs – it had to instruct Time to interrupt its course, and thanks to this breach steal into our midst like a prowler in a sleeping household.

Eventually Dickens gave a sigh, Georgina tossed her head, brushed away a few crumbs of bread on the tablecloth. But the intruder was already among us, and though I suddenly launched into an account of my misadventure in Rochester it was only in order to try and forget that presence.

Georgina was barely listening. Dickens seemed lost in thought. He did not react at all when I related Weller's anec- dotes and only showed any interest when I came to my ascent of the tower and my vision of the man with his back turned to me.

'Strange,' he murmured. 'I have a recurrent dream like that. I'm wandering about in one of my novels. There's a series of rooms whose layout is impossible to understand, a vast laby- rinth I can't find the way out of. But sometimes I glimpse someone at the end of a corridor with his back to me. I approach him to ask for directions. He doesn't respond. I put my hand on his shoulder . . . and then I wake up.'

'Usually I only see the back of his head but this time he turned round.'

'What did he look like?'

'Difficult to say. My gaze was constantly drawn to the mountain, and that dark mass surmounting it. But our eyes met. I'm sure I've never seen him in reality yet I had the impression that his face couldn't have been any different from the way it was . . . As if I'd met him elsewhere, in another life. As if his features – his courteous somewhat commiserating expression, his smile with a touch of irony in it – corresponded to an image within me, an image that had been with me all my life . . . a kind of model . . .'

I was conscious of the great confusion in my words and I was surprised to see Dickens nodding several times.

'Did he say anything to you?'

'Just a single sentence: "Well done, Évariste, only a few more pages to go." '

There was a long silence. Dickens seemed to be pondering my words. I saw the same furrowed brow I had noticed as he was writing in the chalet that morning.

'And then?'

'Then I found myself on the ground, on the freezing-cold stone. I saw Mr Weller leaning over me, administering restorative slaps. The room, the mountain, the smell, the man with his back turned to me were gone. We were at the top of the tower. After a moment I was able to get to my feet and admire the view of Rochester lying below us. I remember that Mr Weller said, "This parapet seems very high . . ." I think what he meant was . . .'

I hesitated for a moment. I kept my eyes on Dickens, watching for his reaction.

'What he meant was, too high. Too high for a man like Jasper to push another man off.'

The novelist gave a start, then a wan smile.

'Monsieur Borel! Now there you go as well, mixing up Cloisterham and Rochester! Besides . . .'

He seemed to be inwardly debating the advisability of completing his sentence. He raised a piece of meat to his

mouth, put it back on the side of his plate, breathed deeply.

'Besides, it isn't Jasper who topples Drood! It's . . . a name.'

'Charles, are you feeling all right?'

'A name,' repeated the writer gazing at me sadly. 'The whole book rests on this name. When a word comes to life, nothing can stop it.'

And turning to his sister-in-law, he added, 'No, I don't feel well. Not well at all. Not for the past hour.'

Then I saw the evidence that had not escaped Miss Hogarth's anxious gaze: Dickens was a frightening sight. No longer were his features marked only by extreme tiredness but also suffering. His eyes were glassy, his lower lip trembled, his nostrils dilated with the strain of his laboured breathing. He raised his hand to his brow to wipe the sweat from it.

Exceedingly worried, Georgina stood up. 'I'm going to send Weller to fetch Dr Steele.'

'Steele is useless!' replied Dickens. 'I'll see Reynolds in London tomorrow.'

But a further change altered his physiognomy. His jaw dropped slightly, his eyes widened. He had the perplexed, bewildered expression of a man who has just read some incredible story in the newspaper, or is vainly striving to grasp the meaning of some mysterious puzzle. He began talking very fast, stumbling over every syllable. In this flow of indistinct utterances, two words recurred several times.

Meanwhile Georgina had walked round the table. 'Come and lie down for a while, my dear.'

'Yes,' said Dickens. 'On the floor.'

But in attempting to stand, he escaped his sister-in-law's arms and fell heavily to the ground. As Georgina rushed for the bell, I leant over Dickens. He lay on his back with his legs crossed, one arm by his side, the other folded across his chest. His head had rolled sideways, with his face squashed against the floor. A thread of saliva trickled from his parted lips. Only

the whites of his eyes were visible. He heaved. His chest rose. Then he stirred no more.

A maid had responded to the ring of the bell. She soon reappeared with a pillow and blanket in her arms.

'Have you told Mr Weller?' asked Georgina.

'He's not in his room, ma'am!'

'He must be in the stables . . . or the greenhouse! Hurry, you little fool!'

Miss Hogarth ran to the window, where she called out several times. Meanwhile I wrapped Dickens in the blanket and laid his head on the pillow. But I performed these actions mechanically, without entirely appreciating the gravity of the situation. I was still dwelling on the writer's last words. I almost felt like shaking him to drag more out of him.

'Is he . . . dead?'

'I don't know,' I replied. 'I can't find his pulse. We need a mirror.'

# XIII

Nathalie was awaiting my response.

Basically it was the first time I ever had an idea. I mean an idea in the true sense, not an obsession. One that belonged to no one else but me. That required for its accomplishment a series of actions organized in accordance with the laws of causality. And, if the plan was correctly executed, one that would come into effect outside my brain in what for me was the fairly novel form of a consequence. It was very intimidating.

'Uh . . . that's perfect, Nathalie. Thank you . . . thank you very much.'

But these expressions of gratitude seemed to me rather inadequate in relation to the service rendered. Nursing the remains of my martini, I hastily fumbled for something to say.

'It's very pretty . . . your dress.'

'It's not a dress, it's a skirt.'

She abruptly rose and tore the bar bill from my hands.

'It's not for you I'm doing this,' she said coldly. 'I was humiliated and I haven't forgotten it, that's all.'

I watched her walk away towards the Renault 16. 'Well, well,' I said to myself, 'so she also inherited the car.' And I pictured Mademoiselle Borel waiting patiently, the day I had seen Nathalie outside the chemist. But waiting was not the right word, or patiently for that matter. In order to wait you have to know the difference between the past and the future. To be patient, you have to have the notion of time passing. Whereas Mademoiselle Borel had no frame of reference or instrument of measurement. Mademoiselle Borel was bound hand and foot to the burning sun of the present, like those doomed victims who were once chained naked, in the full heat of the day, to the white-hot sacrificial stone. No memory, no forgetfulness. Not the least patch of shade anywhere near.

But darkness had come. Évariste's blood had ceased to flow in her veins. Évariste's memory had chosen to meet death in this strange terminus.

At the next table Mr Dick stood up almost at the same time as I did. I decided to ignore him.

Madame Conscience was away. She had left me the keys so I could go and water her plants now and then. And so it was there, hidden among the fig-trees on her verandah, I was able to watch Mathilde moving out.

Mathilde's parents were the first to arrive. They had circled the house three times. I saw them wrinkling their noses, holding their heads in their hands, dismayed at the idea their daughter could have been living *in a place like that*. Then came the removal van. Her father found the key under the doormat and everyone set to work. The removal men went in and out. Her mother, stationed on their way between the house and the van, bestowed on each piece of furniture a caress or a kind word, like a schoolteacher greeting her pupils after the summer holidays. At his wife's side Mathilde's father checked off each item against a list in a little notebook.

At about ten o'clock an old black Renault 4L arrived from town and parked between the two houses. A short man with a thick neck, about sixty years old, climbed out cautiously. He observed the procession of furniture for a while, then turned and noticed me.

'Excuse me. François Daumal, he's next door, isn't he?'

'Yes.'

'He's moving out?'

'Not him. Just the furniture.'

'Ah . . . the furniture.'

He looked at me furtively, trying to make sense of this. His old double-breasted jacket now had only one button. The worn collar of his shirt was stained with sweat and grime. Now and again he looked at his watch and glanced at the car.

'So this is where he lives . . . It's not bad . . .'

That morning, as ever when there was no wind, the factory fumes

were at their worst. Cars roared away when the lights turned green, fleeing the pestilence.

'Well, at least it's quiet . . .'

Getting no response he concentrated his attention on the removal men.

'Look, a round bed. That's odd, I've never seen one of those before. And that bald man over there is . . .?'

'A bailiff.'

Hearing that word his face fell. His disappointment was so violent I had to stop myself laughing.

'A bailiff,' he mumbled to himself. 'Christ! All this way for nothing!'

He cleared his throat, tried to button up an imaginary second button over his paunch, then gave me his broadest smile.

'The situation I'm in is just too idiotic! I'm a personal friend of Monsieur Daumal and, would you believe, I had my bag and my money stolen at the petrol station. To cut a long story short, I was absolutely counting on him for the money to fill up the tank.'

'Wait for him. He probably won't be long.'

'The thing is . . . I'm just passing, you see, I have a very important business meeting shortly, in Bayonne. That's modern life for you . . . a whirlwind! So little time to devote to friends . . .'

To prolong the pleasure, I very slowly emptied half a watering-can.

'I'm very embarrassed to ask you this, but . . . could you possibly advance me the money? Tell him Robert came by to see him. He'll pay you back without fail. Thank you, that's very kind of you . . . Please say a big hello to François Daumal from me!'

My father ran a finger under his collar, bowed formally, and disappeared in the taxi. Either he had not recognized me, or he had pretended not to. I did not know which of these two possibilities was the more deplorable.

After the removal men had left I returned to the house, the empty house. The few pieces of furniture that actually belonged to me had long since been thrown out to make room. Everything else had been taken away, checked against the list in the notebook. In its own way every piece had left its mark. The halogen lamp: a very distinct blotch where the ceiling,

too close to the light bulb, had darkened. The sofa: another patch, much bigger but less distinct, tracing the outline of its disappeared form: a kind of fossil image. But it was a bit minimal as company.

However, there was the phone, all by itself, on the floor by the window. Naturally: the telephone belonged to the state. And now in the middle of that emptiness it occupied pride of place. It finally came into its own as a listening device installed by Big Brother.

'Dick Agency, good morning.'

The same voice as the first time, but weary, almost peevish: Gloria Grahame in rehab. Through the window I could see two men in overalls repainting the factory chimneys.

'Good morning. Monsieur Dick, please.'

'I'm his partner. How can I help?'

'I . . . I'd rather speak to Monsieur Dick, if you don't mind . . .'

Silence.

'You are . . .?'

'Conscience.'

I heard her flicking through the client file in search of the name.

'Monsieur Dick died last year, Monsieur Conscience. I've taken over the business, and I can assure you that our methods haven't changed. So if you'd like to explain the problem . . .'

That explained the change in her voice: rent too high, clients too few, the stress and anxiety of running a small business. I pictured the lines on her face, the white hair pinned up in a bun that Monsieur Dick would now never loosen. Two letters were missing from the glass door: ɣɔᴎɘ A ʞɔi .

'The thing is . . . forgive me, but it's a delicate issue and I wanted to speak to a . . .'

'. . . to a man, right?'

Her dejection was palpable. How many times had this specious argument been thrown in her face?

'Sorry, sir, but there is no man at the Dick Agency. As a matter of fact, I undertake the investigations myself. Besides, in delicate cases, as you put it, women are often more . . .'

I hung up but remained standing there at the window.

193

The two painters were making rapid progress. Their enormous rollers were devouring the soot. It seemed to me they would not be able to stop there: carried away by their own enthusiasm, they would paint the road, the cars, the sky, until they had covered everything in a layer of oblivion-like matt white. I was about to go up to the attic when Big Brother rang. The Dick Agency. The Dick Agency was calling me back. The woman with her hair in a bun was going to explain all.

'Hello, François.'

It was Mathilde.

'Yes?'

'Michel asked me to call you. He wants us to get a divorce.'

'Ah. I didn't know you were married.'

'For us to divorce, you and me!'

'Sorry, my mind was wandering. What time is it?'

Slowly, the painters climbed down from the scaffolding. The sky looked even greyer.

'François? Are you all right?'

'Fine. Well, that's settled then.'

'Uh . . . you mean, you've no objection?'

I could sense that she was disconcerted, perhaps even a little disappointed.

'No, not at all.'

'You'll . . . you'll need to get a lawyer. Do you know someone?'

'No, but I'll go and wander round by the law courts one day. There are loads of them over there. Like hot-dog sellers outside stadiums . . . or florists near cemeteries . . .'

'We could use the same one, if you like. Mine's called Duclos-Lacaze.'

'Right, Duclos-Lacaze. That's a good name for a lawyer.'

'Are you sure you're all right?'

'Absolutely. Everything's fine.'

Cutting from *Le Sud-Ouest*, 9 June 198*

### What everyone's talking about . . .
Stephen Le Roy-Trent's social and cultural column

This is it! The Big Night! Time for dinner jackets, bow-ties, frills, dress suits, décolleté gowns! The strange neo-Victorian mausoleum that has sprung up like a mushroom in the midst of our cosy houses and which detractors are already calling 'the Mangematin folly' opens its doors for the first time this evening. Mangematin – a glorious name, associated with the history of our railway station. However, some people will be surprised that the last of that family line, though he makes a great deal of his local connections, should have chosen to celebrate an English writer who died more than a century ago and never set foot in Arcachon.

For our own part, we will not join those envious critics! It cannot be denied that our young fellow citizen has the wind in his sails: his university and ministerial career is one long series of red carpets. There are already rumours he may seek to contest the position of mayor next year, reclaiming the torch once carried by his great-grandfather and his great-uncle. His book, *The Mystery of Edwin Drood Revealed* will be in all the bookshops tomorrow.

And as if that were not enough, there is talk of an imminent wedding. But shh! We mustn't look too far ahead! Let that at least remain a mystery . . .

'So, what's new, Bephegor?'

Months had gone by. Since my dismissal from Notre-Dame School for chronic absenteeism, Antoine certainly treated me with greater familiarity but he had not forgotten that for a year I had borne arms with his son in a war fought on the foreign soil of culture, exposed to the despicable ambushes of Parnassian or Symbolist fellagha. Comrades for ever, in life, in death! Despite my downfall I retained his respect and my personal bottle of whisky under the counter.

He flopped down heavily at my table and glanced at the newspaper.

'Dickens, Charles? Never heard of him!'

'Try this for size: over twenty-five thousand pages in the Pléaide edition . . .'

Antoine gave the whistle of approval with which he no doubt greeted the record number of potatoes peeled. I drained my third glass.

'You know what's strange, Antoine? The universe is swarming with . . .'

195

We were caught in the brightness of a flash of lightning. Then came a crack of thunder. And immediately afterwards torrential rain, lashed by the wind, transformed the windows of the bar into the wall of an aquarium. On the other side of it appeared Mr Dick.

'The universe is swarming with people who've never heard of Dickens and are none the worse off. It's a little as if I'd spent the whole of my life digging a hole in a concrete wall with a teaspoon, and suddenly vast crowds started coming in and out of the door, a simple door I hadn't noticed. As if . . . Pour me another one, I'll be right back . . .'

When I came out the street was deserted but I had no need to hurry. I walked towards the bridge and soon I saw him close to the rail. Standing in the middle of an elongated spit of sand the wind had blown on to the pavement, he was gazing out to sea. He did not turn round at my approach. I did not try to see his face. We already knew more than was necessary about each other. Yet I wanted to touch him. I placed my hand on his shoulder, then slowly ran it down his arm until I made contact with his fingers: soft as clay.

# XIV

'Excuse me, sir, but this is a fancy dress party. May I see your invitation?'

The doorman was polite but in the dinner jacket he wore he looked like a bulldog in a raincoat, and was blocking the door with the full breadth of his shoulders. A gas lamp hanging in the peristyle porch poorly illuminated the impeccable lawn, the mass of geraniums giving off their strong smell under the bow windows, and the marble plaque on the gate: Gad's Hill Place II. I had been driving with the windows open listening to Sarah Vaughan. I felt wonderfully relaxed, with the tenth book in my pocket and an amber lake in the pit of my stomach: Antoine's whisky.

I scribbled a few words on a page from my diary.

'Could you give this to Monsieur Mangematin? Then I'm sure he'll be happy to receive me . . .'

The bulldog stuck his head inside, hailed a waiter in white livery and dropped the message on his tray. As I was imagining this live torpedo heading towards its target, a very familiar voice rang out behind me.

'So, my young friend, having trouble getting through customs?'

Krook had lost most of his red hair and was bizarrely stooped. His face was puffy, his eyes bloodshot. I felt the trembling of his hand when I took it in mine. He was wearing a long grey donkey jacket, as elegant as a sack, old boots, and a funny black skull-cap on his head.

'It's Skimpole's fault!' he said, catching the meaning of my expression. 'That imbecile has lost the ring! How do you expect me to stop drinking if I don't have my ring any more?'

'And this . . . outfit? Who are you disguised as?'

The Scotsman gave a sinister little laugh.

'Well, of course, I'd have preferred Pickwick or Micawber but they

197

were already taken. So I fell back on the character I play best: Krook. The rag-and-bone man in *Bleak House*, the one who turns into a pile of ashes, remember? Although recently I feel more as if I'm turning into lava . . .'

At that moment Michel appeared on the threshold. His stomach and shoulders were squeezed into a tight-fitting jacket with a buttonhole. His baldness was ill-concealed by an oilskin cap. I suppose he was intended to look like young Copperfield, wandering round the ill-reputed Black Friars neighbourhood. With a gesture of irritation he pushed aside the doorman, barely spared the old bookseller a glance, and stared at me long and hard.

'You, of course,' he murmured. 'What's all this about?'

'Please, Michel, not right now. First I'm going to visit your museum, have a drink. It would be silly to spoil your little party by creating a scene, don't you think?

'You're drunk.'

'Exactly!'

He hesitated only a moment, then nodded to the doorman and turned on his heels. The door remained wide open.

'Open, sesame!' chuckled Krook. 'So what did you write in your little note? He seemed odd . . .'

'Almost nothing. I asked him if Monsieur Dick had *also* checked British Ferries' registers for the 7th June 1870.'

The Scotsman shrugged and preceded me into the house.

It took a while for my eyes to adapt to the flickering candlelight that was reflected on the polished parquet and oak panelling, and made the doorknobs gleam, like the recollection of a fire. The drawing room, that you came straight into, was quite spacious but full to bursting: men and women seated on sofas, leaning on the mantelpiece, or wandering round in little groups, picking their way among the tables and armchairs, like film actors following a chalk line on the ground so as not to step out of the frame. There must have a good thirty people in that room. Practically all of them were deep in conversation but I could hardly hear them. Perhaps because of the whisky. And that buzzing in my ears. Their mingled voices made scarcely more noise than a confessional-box

whispering. The words escaped through the open window and went twirling like fallen leaves to perish among the bushes or on the grass.

My good mood went with them.

Pecksniff, Boffin, Murdstone, Betsy Trotwood and Mr Dick. Bill Sykes. Fagin. Pickwick and the Pickwickians. They were all there. All except Estella.

'Impressive,' I murmured.

'And there's more! That door over there leads to a corridor giving access to several rooms, in each of which Michel plans to have a tableau designed to celebrate every one of Dickens's novels, with wax models representing the characters. A real Madame Tussaud's . . .'

Waistcoats, starched white shirts, frock coats. Stiff collars. Broad silk cravats. Chignons, ringlets. Bodices with endless rows of buttons and a cameo or brooch pinned to them. A dozen pairs of butter-coloured gloves congratulated each other on the console table. In the umbrella stand, knobbed walking-sticks and umbrellas chattered as discreetly as their owners. And dozing on the coat-stand above the coats, were bowlers and top hats, still-life fruit hanging on the tree of elegance.

I raised my hand to my brow. 'What are we doing here, Krook?'

The Scotsman gave me a peculiar look. 'You mean here in particular or the universe in general?'

'And who are all these people?'

'You. Me. The members, my friend. The members of the Dickens Club.'

He had found the way to the bar and dragged me along by the elbow.

'Now, Sam Weller, there, for example, in his striped waistcoat and old white hat, is pretending not to recognize me but I had dealings with him at the hospital when I had a go at drying out: he's a gastroenterologist, and he drinks like a fish . . .'

'What has Dickens got to do with these dummies?'

'There is a connection albeit unintentional. Today they think they're very clever because they're in disguise but what they don't realize is, the trousers, shirts, dresses and jackets they don every day are even more ridiculous masquerades! Grotesque, absurd caricatures. Typically Dickensian in my opinion . . . without the charm and the humour. Figures like you and me. Whisky?'

'Yes. And who are they? They look familiar . . .'

'Of course they do! The Poussins . . . alias Micawbers . . . brother and sister in real life, husband and wife in costume . . . She's the librarian in charge of the English section, he runs the literature section . . . and I owe my escape to him . . . Hey there, young man, no ice! You're going to drown them!'

He snatched the glasses from the bartender's hands while the male Poussin passed close by, obviously avoiding us.

'Go to hell!' murmured Krook just loud enough to be heard. 'Look at his sister stuffing herself with canapés. A monstrous appetite, a proto-zoic brain! And what a sorry specimen he is! I'm sure he doesn't even know what punch is. And what's more, he's had to use make-up to fake his red face. I would have been much better . . . But perhaps not. I wouldn't have wanted to compete with W.C. Fields. Not for the world. The greatest Micawber of all time. In Cukor's version . . . A man after my own heart, W.C. You know what he used to say: Always carry a flask of whisky in case of snakebite. And furthermore always carry a small snake.'

At the bookseller's laughter several heads looked up. All the little huddles broke up, a cluster of mice scattered by the cat's claw.

'But what do mean by your "escape"?'

'That business of supplying books didn't suit me. I did it for a while as a favour to Michel until Poussin took it into his head to order Valéry! There were orders I met faultlessly: Balzac, Nodier, Flaubert, Proust, Ricardou, Bakhtine, Genette . . . anything but Valéry. So after two regis-tered letters that I threw in the bin I lost the concession. Now I can breathe freely! I'm going to be able to go bankrupt with my head held high, in an orderly and disciplined manner! I'll simply wait until every book has found an owner worthy of it, then I'll close down . . . if I last long enough!'

For a moment he reflected on his own words, which we consecrated with several slugs of whisky.

'And that fellow over there, who's he?

I lifted my chin to indicate an affable-looking little old man with a round belly who was wearing with a certain assurance the spectacles,

white waistcoat and fob watch of Mr Pickwick. Around him had gathered a little circle of admirers.

'But he's the society's leading light! Michel went to fetch him from his log cabin in the Black Forest ... Weissinger, the great German philosopher ...'

'The inventor of Penjah's paradox?'

'The very same. It's a curious story ...'

'I know ...'

'That doesn't matter! Grant me the pleasure of telling it ... In the 1930s our man was attending lectures by Wittgenstein and Popper in Cambridge. During the summer he gets bored and goes to Wimbledon for the tennis tournament. It was the end of the great era of the American champion Tilden. He had won the year before. In the first round he was drawn against an obscure Hindu player, Sorj Penjah, 'the man in the turban' as he was nicknamed by the press because he wore his traditional headdress on court ... For an hour and half it's a walk in the park for Tilden: he's leading 6-0,6-0, 5-0 with a service game to follow ... His victory's no longer in any doubt. The spectators have deserted the court, all except Weissinger who remains alone in the stand, acting on an ''ontological intuition'', as he will later describe it ...'

Out of the corner of my eye I was still watching out in vain for Estella's arrival on the scene. Copperfield was playing host. With a good stop-watch I could have calculated the importance of each guest by measuring the time he spent with them. The Poussins, for instance, only warranted about twenty seconds, whereas Weissinger was given six whole minutes. Michel came up to me and opened his mouth to say something but then thought better of it.

'... and the unbelievable happens! Penjah saves three match points, fights back inexorably, wins the third set, the fourth ... and the match! There's a famous photo taken after the match, showing Tilden rigid with amazement and the umpire checking his scorecard, rounded-eyed, to make sure he isn't dreaming; Penjah has already left the court. Weissinger returned to Cambridge and during the night, so legend has it, he had his inspiration. He built his famous theory of the *wirklicher-als-das-Wirkliche* – the more real than reality – according to which the universe

we are familiar with is only a degenerate form of the 'real' reality, a compromise between the possible and our imaginative capacity, a kind of asymptote, with Freedom forming the x axis and Reason the y axis, continually approaching the 'Great Reality' – *Grosse-Wirkliche* – without ever meeting it . . . except at particular moments when the real intrudes, when the Great Reality becomes actual and the 'impossible-but-more-than-real' contests the 'supremacy of the probable' . . . in short, when Penjah beats Tilden. Brilliant discovery for some, grotesque regurgitation of platonism for others. The controversy rages: nothing better for a philosopher's reputation. But in '33 Weissinger commits one small error.'

'The famous Heidelberg speech.'

'A ringing tribute to Hitler who is "making the real Germany actual", who is raising the Reich to the level of the more-than-real, and swamping under the waves of the Great Reality the pitiful dykes of the probable! Our man is ruined. Even the Nazis are compelled to acknowledge he's as mad as a hatter. They discreetly transfer him to an obscure provincial secondary school. In '45 he loses his job. Then he takes refuge in Dickens, his great passion, who becomes the sole subject of his publications from then on, the "super-novelist", the one who writes what is "more real than reality" . . . It's the famous turning-point in Weissinger's career . . .'

Becoming aware that I was observing him, the philosopher smiled and imperceptibly bowed his head. Inside my own head, a murmur gradually swelled.

'You must read his Dickensiana . . . Sheer madness . . . "Dickens's universe is the only universe", "The walls of Dickens's novels are more solid than brick, their tables heavier than oak" . . . Not to mention some even better examples. To think that more than a thousand post-graduates have already written their theses on this nonsense! Are you not feeling well?'

I felt as if my feet measured only a few centimetres and that the tiniest movement on my part would result in my falling over. On the outer edge of my field of vision the gloves on the console table displayed a bewildering tendency to grip each other in warm handshakes, while the hats on

the coat-stand leapt from branch to branch like fat little monkeys. I thought I also saw a crinoline dress go by but a kind of lightning flash suddenly blinded me and I had to clutch the table for support. Krook examined me with concern. He himself was in that swaggering phase of inebriation that follows exhilaration and precedes stupefaction.

'It's because of this filthy Lowlands whisky, this Presbyterian piss! They advertise it as pure malt on the label when it's only a blend, and adulterated besides! Waiter! Are you sure you haven't anything better than this?'

'I'm all right. It's just that I haven't eaten anything since this morning.'

I came across another Pickwick in the gents. Not only had Preignac failed to follow my advice, he could not bring himself to keep his Legion of Honour completely out of sight, and its red ribbon was hanging out of his waistcoat pocket. Preignac's disguise was as pitiful as Weissinger's was to be respected. How could that old egotist possibly have portrayed inexhaustible goodness and touching naivety? Diplomatically – or quite simply because he had forgotten – he made no reference to our conversation at Mériadeck.

'But it's . . . it's . . . Macduff, upon my word! Delighted to meet you here, young man . . . I'm very glad your little falling-out with our dear Michel did not last long. But tell me, what are you dressed up as?'

'A structuralist. A structuralist expert on Dickens.'

'A stru . . . Ha! ha! very funny . . . really very funny! See you later, my friend, for the speeches . . . We're obviously counting on you!'

After he had gone I splashed my face and remained hunched over the basin for a long time, still exhausted by my walk across the reception room. My feet had not yet regained their normal size. With every step I had taken, I felt as if I had cleared a precipice. The pounding of the blood in my temples gradually abated but the crinoline dress continued to flit beneath my closed eyelids.

As I was about to leave I noticed a little door in the corner, for the staff, marked Private. I opened it and came out into a corridor with a great many rooms off it, and smelling of wallpaper glue and wet paint. On each door were copper plates on which inscriptions had been carefully

engraved in italic: *Bleak House, The Old Curiosity Shop, Oliver Twist*. I chose *Great Expectations*.

An electricity system of some sort must have been activated by opening the door, because the windowless room gradually brightened as I stood on the threshold. First of all, an old clock appeared at the far end of the room, its pendulum still. Then, against the left-hand wall, a long sideboard on which were placed a platter of rotten fruit and a little carriage clock stopped at the same time as the pendulum clock. The light slowly diffused towards the centre of the room, where there stood a long table prepared for a banquet. Spiders had draped their webs over the glasses and plates. Right in the middle, occupying pride of place, was an enormous triple-layered cake – but the bottom layer had half collapsed, sapped by the work of the cockroaches scuttling through the meringue arches, the cream festoons covered with a black fungus. The whole thing gave off a smell of dampness, of sour milk.

There was still an area of darkness on the right. Barely distinguishable was a metallic reflection. Of something vaguely resembling a wheel.

Suddenly, a final spotlight came on, as in the theatre, and I saw the wheelchair. I saw the old relic in her absurd wedding dress, with her tufts of grey hair sticking out in all directions.

Sitting-Pretty observed me in silence with that surreptitious little smile of hers. Then she moved her fingers.

'Come closer, so I can see you. Right over here.'

As I walked across the room the spotlight went out, plunging her face into shadow.

'So this is how your story ends . . . That bitch gave you a hard time, did she? Come closer! I'm not going to eat you!'

I thought I should have been surprised. That surprise in such circumstances would have a good starting-point, an encouraging sign, a bit like the imperceptible fluttering of eyelashes seen in the patient coming round after an operation. For two or three minutes I imagined *what might have happen*.

Interior. Night. He takes a deep breath, closes his eyes. When he reopens them, the cake, armchair, old lady are all gone. The room is empty. He remembers what he came here for. He feels calm, determined.

Exterior. Night. He's driving, listening to music. Mathilde is dozing beside him. The factory chimneys soon glint in the dark. Elliptic scenario, minimalist montage. Very small budget. But it was still too complicated for my neurones, too expensive for my sinews. A fickle sponsor, my determination backed out of the production at the last minute, and I was lumbered with the equipment, costumes, scenery, and extras, for which I could never pay.

'What should I do?'

The words popped out of my mouth like a piece of chewing gum, masticated for too long and stuck in some corner, that you come across much later, with disgust, when you're doing the housework. For sole response, I heard the squeak of the wheelchair that left two pale lines in the dust like the tracks that a sheepshearer leaves in the animal's fleece. Without bothering about the cockroaches, Sitting-Pretty grabbed a piece of cake, took a glass of wine, the contents of which had turned into a purple powder, and held out these props to me.

'A little drop?'

'Yes, please.'

The waiter eyed me suspiciously and remained close by while I drank, probably expecting me to knock the glass over. A bad idea, this cocktail. My head was spinning again. I should have eaten something but the canapés had all disappeared, most of them into the maw of the female Poussin who had sunk into a love seat, affecting the melancholy attitude of one who has exhausted all the pleasures of life. My palate had forgotten even the consistency of solid food. I felt totally hollow, empty, light, as if I had to feed off my own flesh since birth. And it was only this impression of lightness that allowed me to remain standing, with my back to the room, in front of a large pier glass gradually clouded by my own breath.

Everything was blurred. Like cells between the slides of a microscope, blobs moved about on the silvering, conglomerated, split up. Suddenly a yellow shape detached itself from the cluster of amoeba.

Sole reality in the midst of phantoms, she slowly came closer. In the tilted mirror she descended on me as I had once descended on her at the

Good Children's Home. I closed my eyes, fervently hoping she would absorb me, assimilate me, and that my problems – of synopsis, style, financing and casting – would be forever resolved. When I opened them again, she was talking to a stranger.

A man of about thirty, dressed like a tramp, with greasy hair, three day's growth, and who was having some difficulty in remaining upright. The loner type you meet in bars whose pathetic gaze you carefully avoid.

'Why have you come?'

'For you,' seemed a good reply. I discreetly whispered it to the stranger.

'For you. I came for you.'

Mathilde did not looked convinced. She shook her head. In the glow of the candles her hair had become once more bright red.

'It's no use. It's too late.'

'How do you know? How do you know it's too late? Do you have a little internal clock that tells you when to do things? Tick tock! Ah, sorry! Too late. The moment's passed. Time to get divorced . . .'

Personally I thought the clock tirade was quite impressive but Mathilde persisted in her act of lofty intensity. Her Estella act. Her Bobo the clown act.

'We can't talk here,' she whispered.

'Ah! You've also got a little in-built compass . . . All right then . . . There's a bar at the end of the street. The Space Café.'

'But I have to . . .'

'Later,' said the stranger, not noticing Krook who was observing the scene from less than a metre away. 'The bar's open until two o'clock. I'll wait. It's just that . . . there's something you ought to know. It'll only take a minute. After that, if you want, I'll leave you alone. I won't try to see you ever again.'

Mathilde made a gesture of surrender.

'OK. When everyone's gone.'

Krook watched her walk away, shaking his head.

'My God, what a waste! I did warn you, but . . . Ah! What a fine pair we two make: the cuckold and the man who denies himself sex . . . Ideal material for a La Fontaine fable!'

I concurred by closing my eyes. When I opened them again, there was no sign of Krook. The room was almost empty. I must have fallen asleep standing up, like a horse.

Suddenly there was a rumble of thunder. The wind swept in through a window that was not properly closed, extinguishing all the candles. And in the darkness, Weissinger, herald of the Greater Reality, crazed with fear, began bellowing, '*Mehr Licht! Mehr Licht!*'

'That doesn't alter anything, François. Nothing at all.'

Between the Bar de la Marine and the Space Café there was an epistemological gulf comparable to that separating the horse-whip and reins from automatic transmission and sat nav. At the Space Café the consumption of alcohol seemed an obsolete rite no longer conducted with anything but irony. The bar, tables and chairs were made of piping. The waiters wore space suits, and young girls straight out of a post-modern remake of *Forbidden Planet* wandered about aimlessly, it seemed, escorted by Peter Gabriel clones. A percolator in the shape of Robby the Robot plotted the final uprising of the androids.

How did I get here? No doubt by means of some space-time shortcut. I could not remember my journey from Gad's Hill Place II. I had just materialized at this bar table, equipped with a microchip containing a few confused memories of a certain François Daumal. In any event Mathilde actually turned up. She listened to me without a word. Now she was shaking her head with an air of regret, while the last echoes of what I had been telling her blended with the sound of some anaemic pop music.

'You know what I sometimes think?' I resumed, signalling to the waiter. 'That this chair, this table, these glasses and all the rest . . . that everything is in Dickens! It's . . . Could I have another beer, please?'

The cosmonaut looked daggers at me as if my order was in danger of compromising a delicate take-off manoeuvre.

'It's some hybrid matter, at once true and false, real and unreal. And I'm sinking into it. My fingers pass through objects, my feet tread on some kind of talcum powder . . . and only you can . . .'

'So what? In what way does that change anything for us two?'

Mathilde was talking with the kind of vehemence that those who can't make up their minds resort to in order to convince themselves. I could almost see the panic-stricken thoughts running round the mouse-trap of her mind.

'Only you can make me feel that I exist . . .'

'Give me one good reason! One good reason for coming back!'

Robby the Robot spat out a long sausage of chantilly cream.

'I . . . I love you?'

I was quite aware of the disastrous effect of that question mark. But it just slipped out, the same way that a car follows its own trajectory when a driver loses control on a difficult bend: too late to brake, too late to recover. And Mathilde's face came rushing towards me, like a plane tree. Her eyes were glistening, her eyelashes quivered for a fraction of a second. She was about to change turtles. She did not believe my declaration of love, no, worse than that: she wanted to believe it. And there we were on the edge of a swamp again: two inches from getting bogged down in the mire of emotions.

I got a hold of myself. I said the first thing that came into my head, no matter what it was.

'Listen to this: "The characters seemed to rise before our eyes as we turned the pages, the landscapes unfolded in their bleakness and their cheerfulness, with their smells, their charms, and objects too appeared before the reader as they were conjured up by some invisible power, hidden who knows where." Do you know who that's about?'

Mathilde sighed. 'Dickens, I suppose . . .'

'No! Flaubert! I found it in Maupassant. But it's just the same . . . The characters rise, objects appear . . . Chesterton talks about Dickens in the same terms . . . and you know what that means? That there's only one writer, the one that speaks inside our heads . . . Now, for example, you see the toilet door? There nothing behind it for the moment . . . but suppose I want a piss . . . Suppose I get up, I walk over to that door, I go inside . . . then *he*'ll rush to install blue tiles, a porcelain basin, an electric hand-dryer . . . perhaps he'll even put in a guy washing his hands . . . *He*'s the one who decides . . . *He*'s in the process of writing: "*he's in the process of writing*" . . . By concentrating a little, creating an inner space, we might

be able to hear his voice whispering in our ear . . . whispering what we ought to say . . . our responses . . . He's writing: " *You understand*?" You understand?'

'I understand you're crazy!'

She got up and almost ran to the door.

'That's exactly what I would have written if I were in his place!' I thought, draining my glass.

# XV

The Swiss chalet met the same exacting standards of meticulously detailed reconstruction as the main house. Eaves with decorated barge-boards, oak siding, the upper floor reached by an outside staircase, an access tunnel passing under 'the London road' – actually a mere strip of gravel at the bottom of the garden, marked with a milestone: *Rochester 3 miles*. Even the vast Arcachonnaise villa whose rococo mass was discernible in the neighbouring pine forest did not succeed in completely destroying the illusion. The white paint on the shutters was not yet dry.

On the desk, strewn with books of that period and facsimiles of Dickens's manuscripts, were also several contemporary documents – workmen's bills, mail from Michel's editor, handwritten jottings of his in a spiral notebook, copies of *The Mystery of Edwin Drood Revealed* – as well as the bronze paperweight.

'You're working late,' I remarked.

'The review copies have to go out tomorrow. I spent a lot of time organizing this party, but it was worth it, don't you think? Preignac as Pickwick! And Weissinger! You know he had to be given a tranquillizer?'

And he burst out laughing. Indeed he seemed perfectly relaxed, as if someone had come up to him during the evening and told him that the madman wandering round his house was not dangerous, that he should be treated with indulgence and not with intimidation.

'By the way,' he said casually, 'how did you get in? I locked the gate when the last guests left.'

'Mathilde met me a little while ago at the Space Café. When she came back she forgot to lock it behind her.'

'I see.'

I thought he was going to question me further about our meeting,

but no: he offered me a seat, settled himself in the large office chair, crossing his hands behind the back of his neck, and observed me with a warmth tinged with irony.

'So, my dear old Pickwickian! Here we are, as they say on the other side of the Channel. The extras have gone to bed. Only the main characters remain . . . you and me, the two of us! What final twist have you got in store? What peripetia? And what role do you want to play? A good guy or a bad guy?

Taking my seat, I let my gaze wander over the wall hung with photographs: Catherine, Mary and Georgina Hogarth. All of Dickens's children. A view of the house at Gad's Hill – the real one. And a charcoal drawing of John Dickens, the impecunious father, the model for Mr Micawber. I detected a resemblance to Mangematin as he appeared at that very moment, slightly in profile, head thrown back, with his ingratiating smile and encouraging nods. Something told me our conversation was not going to go as I had imagined.

'You know what Hitchcock used to say . . . The film only works if the villain is convincing . . . but we know each other too well . . . and besides, forgive me but . . . I don't think you quite have the physique of a George Sanders or a Basil . . .'

'Borel never set foot in Gad's Hill Place,' I cut in.

His lack of reaction threw me.

'Go on.'

'He was already deeply depressed when he left France. He couldn't cope with his mother's death. He blamed his father terribly. As far as I know, Dickens never replied to his letters. On the night of the 6th June, his travelling companion Dumarçay found him semi-conscious in his room in Fleet Street. Borel seemed not to recognize him and muttered incoherently. Dumarçay had him repatriated on the 7th. On the 11th, after a hysterical confrontation with his father, he was confined to a clinic in Châteauroux run by Pinet, a former colleague of the famous Doctor Blanche.'

'Who told you all this? Nathalie?'

'Yes. Old Mademoiselle Borel had all the documents: a letter from Dumarçay, Pinet's reply to Borel's father, and even an article by Pinet,

211

published in the *Medical Bulletin,* on "the disturbing case of the young man EB".'

'The *Medical Bulletin* . . .'

Michel seemed to regret bitterly not having read every issue of this publication from 1870 to the present day. Otherwise, he listened to me attentively but without showing the least surprise. It was like recounting the Battle of Wagram to an expert in Napoleonic strategy.

'What does the article say?'

'Broadly speaking, Pinet thinks Borel is suffering from an obsession resulting from a severe emotional disturbance . . . The nature of this fantasy is of little importance, he says. What matters are the circumstances in which it developed . . . Frailty due to tuberculosis . . . Inability to grieve for his mother . . . Oedipal relationship with his father . . . of course he doesn't use that word but it's what he would have said forty years later . . . "Mr Dickens, in this case, obviously represents the father EB would like to have had . . . The patient experienced his silence as an abandonment . . ." And he concludes that it would be pointless to try and convince him of his delusion, that this fable was now somehow part of his personality . . . so truer than the truth . . . but on the other hand the patient might enjoy long periods of remission and even hope to lead a normal life between bouts of illness . . . And that is what happened. Borel married, had children. For almost thirty years he honorably carried out his duties as teacher of literature at Châteauroux secondary school, which did not prevent him, whenever the occasion arose, from dishing out his fable to anyone who would listen . . . Stevenson, at Conan Doyle's after the seance . . . Anatole France, at La Coupole . . . and his grand-daughter Eugénie, who seventy years later recalled her grandfather's strange stories about "a writer with a funny beard", and "a peculiar book" whose ending was known to no one else but him . . .'

Michel seemed pensive. He went and stood in front of the window, peering into the darkness as if the London coach was going to bring him a visitor.

'A fiction then,' he murmured. 'I knew it! There was something odd about his account . . . a peculiar way of presenting his characters . . . a kind of . . . novelistic tendency, that's the way to describe it! I suppose

he must have read all the contemporary press coverage, Forster's account, Georgina's, that of Dickens's children ... but even so, the descriptions remain hazy, stylized, as if he were struggling over the simplest details ... the layout of the rooms in the house ... Dickens's clothes, his voice ... and all his allusions to dreaming ... It's not actual experience ... it's a created work!'

'So why did you publish it?'

'What did you expect me to do? What publisher would have been interested in the musings of a failed Symbolist poet? No, I needed the alibi of erudition, of literary evidence ... I couldn't just leave it in a drawer ... and then there's the solution to MED! The solution is brilliant! Whether Borel met Dickens or not, I don't care ... He's right ... Shaw thought the same ... Chesterton thought likewise ... It wasn't a dream that inspired Stevenson's *Jekyll and Hyde*, it was his conversation with Borel the night of the seance! *Jekyll* is just a reworking of *Drood*! After my book no one would have dared maintain the opposite ...'

'Why do you speak in the conditional?'

'Oh, I suppose you're going to write to my publisher, to the Academy, to the press ... but I don't care ... my goal can always be disallowed but I scored it! I saw the ball go over the line!'

'I shan't be writing to anyone.'

'Oh yes?'

This time I managed to intrigue him. He batted his eyelids, a chessmaster caught out by an unexpected sacrifice, the bizarre move of a rook or a knight. I regained the initiative. The problem was I no longer knew why I had moved the rook. My head was aching too much. Only the heaviness of the tenth book in my pocket reminded me of my 'plan', but in a purely formal manner. Like a knot in a handkerchief, a memory jogger scribbled on the corner of a table – Don't forget X. Pointless, precisely because you have forgotten who X was. There was something heavy at the bottom of my pocket, therefore I ought to make use of it. If my pocket had contained a pencil-sharpener I would probably have looked for a pencil to sharpen. The plan had become meaningless now that I had lost Mathilde for ever.

Yet the little voice urged me on. The same little voice I heard while reading the documents Nathalie had given me, while rummaging in second-hand shops looking for quills and old papers. 'You never truly loved that woman. It wasn't *for* her but *against* him that you elaborated this plan, against Michel Mangematin. It's even possible your whole life is a kind of palimpsest, erased and rewritten solely with him in mind. Everything. Your return to Mimizan. Your marriage. A fiction intended to ruin him – and yourself in the process. A conspiratorial wink at the tenth book.'

'I saw you rewarded Preignac for his services.'

He turned very pale. Regained his composure slowly, with set jaw, eyes fixed on my mouth.

'When the old girl Borel died I was unsure how to proceed. After your fiasco at St-Émilion I couldn't send the manuscript directly to you. That would have seemed odd. It would have raised your suspicions. It had to come to you indirectly. You had to have the impression that you'd contrived to get hold of it. Preignac was the ideal intermediary. Former dean of the department of comparative literature. Specialist in English literature, a local authority in that field. A serious old gentleman. Exactly the kind of person to whom a "responsible" executor, uncertain of its value, might send a manuscript "of possible interest to literary history". I was sure he wouldn't miss his opportunity. That he would be eager to get it to you. He was entitled to: there was nothing in Nathalie's letter to prevent him.'

A flash of lightning illuminated the sky. The milestone sprang out of the darkness like those gravestones in gothic films.

'It took me a long time. I thought I'd never succeed. But the tenth book helped.'

I laid it down in front of Michel.

'Vrain-Lucas, a close associate of the mathematician Chasles. A very resourceful writer. With a sure vocabulary, a steady hand, a keen intellect. This is a compilation of his entire works: his forged Pascal, his forged Rabelais, his forged Socrates, his forged Pliny. And even some forged letters from Joan of Arc to her companions in arms, from Caesar to Vercingetorix. His forged Lazarus, ante and post mortem.

214

He too found the ideal intermediary. Chasles, a man beyond all suspicion, who believed implicitly in the authenticity of the works he published. Remember Krook's words: a book that "contains all others" . . . "the very quintessence of literature" . . . It's obvious. Virgil pillaged Homer. Rabelais took a little from each of them. Swift copied Rabelais. Sterne plagiarized Swift, Diderot was inspired by Sterne. Dickens shopped around: a little Rabelais, a little Swift, lots of Fielding, Sterne and Smollett – with a little borrowing from Collins towards the end. And Stevenson, you said so yourself. Rehash, plagiarism, pastiche, homage, imitation, inspiration – call it what you will. As Beckett said – and he read a lot of Joyce, and Kafka, who was also a great reader of Dickens – "the sun shines on nothing new". At least Vrain-Lucan didn't claim authorship. He rendered unto Caesar . . . what didn't truly belong to him. I found some old unused notebooks and then I followed his advice. How to choose the pen, what ink to use, how to age it artificially and to copy a particular handwriting: Borel's letters to Sand – authentic letters, which Nathalie also sent to Preignac, and that you were able to compare with the British Ferries register. Do you have anything to drink?'

Michel lent over the table. He had the horror-stricken look of someone who has just learned of some catastrophe. Except that this catastrophe, in his mind, did not seem to relate to him but to me.

'Why did you do it?' he asked quietly. 'What is it you want?'

'Nothing. Mathilde.'

'Nice pat answer . . . I'm sure she'd be very flattered. And why? Why do you want Mathilde? You were unhappy together.'

'It was a mistake. Mathilde thought she'd married someone else: a writer. One way or another that's what I had to become.'

'Good God!' he exclaimed, holding his head in his hands. 'It's not possible! You can't believe what you're saying!'

'He's right,' murmured the little voice. 'You don't believe it.'

Gusts of rain beat down on the chalet roof like a demolition squad. Michel sighed. His Copperfield suit was coming apart at the armholes. I saw him as I had never seen him before: a bald pot-bellied little man, round-shouldered, with a weak mouth. The gloss of superiority that

215

overlaid him in my eyes had all trickled off like the paint on the shutters removed by runnels of rain. I felt guilty. I was like a forgetful child who has left a beautiful drawing on the garden table and when he finds it the next day it's nothing but splodges.

Now that he had lost his firm features, his bright colours, now that he was only an ill-defined silhouette, I could confide in him. I even thought in a certain way I owed it to him. He was the only person who would understand.

'Michel, there's something else . . .'

But he cut me off.

'What do you expect of me? A press release? Professor Mangematin admits he has been taken in by an ingenious forger, whom he warmly recommends to unscrupulous publishers and clapped-out writers . . .'

Interrupting his tirade, he picked a copy of *The Mystery of Edwin Drood Revealed*. With a stroke of his pen he scored out his name on the cover. I thought he was going to do the same to all the other copies when suddenly his face changed expression. He froze in an expectant attitude, open-mouthed, frowning, a new idea gradually dawning on him – an idea so strange, so fantastic that he could not take it in all at once. He pointed his finger at me and I read in his eyes – where there was a gleam of astonishment, almost wonder – that I had irrevocably lost the game.

I could have taken anything, endured anything. Him shouting abuse at me. Flying at my throat. Throwing me out. Wringing his hands, grimacing in pain. Simply walking out on me, draped in tragic silence.

Instead of any of those things, he started laughing.

It was not his usual laughter, which had so often bruised my pride, that superficial part of my being whose wounds always healed in the end. No, this time he bit deeper, down to the bone, and I was gradually disappearing, torn to pieces by those terrifying jaws. Michel was no longer Michel – friend, enemy, master, pupil or rival. He was no longer a man but a laugh.

'Why are you laughing?'

'Why am I laughing? You really don't know why?'

He was still laughing but he had leaned towards me and was looking at me almost tenderly through his tears.

'Ah, my dear Pickwickian! Don't you see, you've just destroyed everything that made our lives worth living? Everything that might still have meaning for us?'

With a wave of his arm he included the contents of the room: the books, portraits, autograph letters, bronze bust of Dickens. And the garden beyond. Gad's Hill Place, Mathilde, Krook, Arcachon, Bordeaux, Mimizan. The universe. I was out of my depth. This was all way above me. I laid a hand on his shoulder. I murmured gently, 'Michel . . .'

'Tell me, what are we without Borel? Without Dickens? Without the MED? Without literature? Now there's nothing left . . . or rather, worse than nothing! A prank! A schoolboy prank! You wrote your life while at the same time conscientiously erasing it as you went, like a pencil with a rubber on the end of it. You've just proved our own inexistence! Isn't that funny enough for you?'

'Michel, I . . .'

'Ha, ha, ha! It's fabulous, my dear Pickwickian! Fabulous! A monument to the glory of the void! Laugh with me, my friend, come on, laugh! That's all you've left us with! That's all that remains to us!'

'Michel, I'd like to introduce you to Mr Dick.'

# XVI

They were all with us in the room. They must have come in silently, one by one, through the door left open by the maid. I could not see them but I could sense their presence. This crowd of mourners. Grief-stricken. Forsaken.

Clara Peggotty, the Copperfields' servant, wiped her big red eyes with a lawn handkerchief. Mr and Mrs Micawber nodded their heads sadly. Grinwig had already declared several times that he would eat his. Quilp, the dwarf in *The Old Curiosity Shop*, pushed his way through the legs of the others in order to be able to see better. Standing on Dickens's left and right, Copperfield and Pip, dressed in black, looked like two prodigal sons summoned in all haste to their father's bedside. There were sighs and mumurings. And these lowered voices expressed, beyond their sorrow, a common sense of helplessness, of culpability almost.

He had pulled them out of nothingness. He had made them immortal. And yet he was dying. That was the outrage, the unbearable paradox. They would have given anything to rectify this injustice. Even the murderer Bill Sykes, with his wildly rolling eyes. Even the ghastly Uriah Heep, who, while wringing his hands, called for a doctor in a mawkish voice. Even the obtuse, egocentric, unfeeling Podsnap, who 'with a peculiar flourish of his right arm' had a habit of 'clearing the world of its most difficult problems, by sweeping them behind him', even he felt distressed and asked, 'Can we not do something?'

Then, giving expression to the general feeling, kindly Pickwick knelt down beside Dickens. He was the first-born, conceived in the enthusiasm of youth, at that heroic time when irresolution and remorse did not yet exist, when sorrow was just a comma, and death a full stop whose emphaticness a new sentence would very soon take the edge off. Alas!

218

Talent and imagination had deserted the universe. No one would correct its lapses and shortcomings any more.

Despite his paunch, his spectacles, his bald head, Pickwick sobbed like a child.

He pulled out his handkerchief, tried to wipe Dickens's brow. But his hand passed through it. He looked at the others helplessly. Their world was not ours. They existed only in our heads. There they dwelt, minuscule and boundless, evanescent and indestructible. Of such consequence that the old man in Bristol, the young girl in Boston, the child in Bordeaux firmly believed in their existence. And yet so unsubstantial that a single word was enough to dispel them:

'Here!'

Wrested from my vision, I looked round in vain for Pickwick, Davy, Pip, Mr Dick: darkness and Georgina's voice prevailed over them. Then I grabbed the mirror.

Imperceptible at first, a light mist slowly covered the glass: it was like a leprosy devouring Dickens's reflection.

'Monsieur Borel,' said Georgina calmly, 'leave me alone with him. Please.'

'Fool!' I kept upbraiding myself in this way as I climbed the staircase, walked along the corridor leading to the guest room where Forster, Longfellow, Collins and Andersen had stayed before me, as I opened the door, I contemplated the remade bed, the sofa, the armchair on which the last instalment of *Drood* was lying.

Fool! I had imagined a savage bearing a dagger and scimitar, a shady-looking moor that the Landlesses had smuggled into England with their luggage. Now the anagram leapt out at me in all its simple-minded obviousness: the solution to the Mystery was contained in ten letters. John Jasper and Sorj Penjah were one and the same. In an opium-induced delirium the choirmaster had aped his author, creating a character out of nothing, merely by naming him. He had killed under a pseudonym. Was this discovery, which proved at once the incredible power of literature and its painful futility, a cause for laughter or amazement? It was everything, it was nothing: whichever.

I opened the wardrobe and began to pack my belongings in my

father's old travelling bag. I felt empty, amorphous. I fancied I could easily have been folded up and put in the bag in between two shirts. No strength at all in me, only that poignant wretched nostalgia. The nostalgia of the microbe who remembers having been God – or vice versa? Dickens was dying downstairs. Up here I was almost dead.

Leaving Gad's Hill Place a moment later I found Weller on the steps outside. He looked stunned. His arms, his head dangled awkwardly like those of a puppet. He stared at me unseeing.

'Lord!' he said. 'What's to become of us?'

He took a few steps towards the stables then, changing his mind, he ran off towards Rochester as fast as his legs could carry him.

## Recommended Reading

If you enjoyed reading *Mr Dick or The Tenth Book* there are other books on our list, which should appeal to you. If you like books with stories within stories and literary game playing, we recommend the following books:

*The Double Life of Daniel Glick* – Maurice Caldera
*Music, in a Foreign Language* – Andrew Crumey
*Pfitz* – Andrew Crumey
*D'Alembert's Principle* – Andrew Crumey
*The Dream Maker* – Mikka Haugaard
*The Arabian Nightmare* – Robert Irwin
*The Limits of Vision* – Robert Irwin
*Exquisite Corpse* – Robert Irwin
*Satan Wants Me* – Robert Irwin
*A Box of Dreams* – David Madsen
*The Angel of the West Window* – Gustav Meyrink
*Tales from the Saragossa Manuscript* – Jan Potocki
*Enigma* – Rezvani
*Stephanie* – Herbert Rosendorfer
*The Architect of Ruins* – Herbert Rosendorfer

These can be bought from your local bookshop or online from amazon.co.uk or direct from Dedalus, either online or by post. Please write to **Cash Sales, Dedalus Limited, 24–26, St Judith's Lane, Sawtry, Cambs, PE28 5XE**. For further details of the Dedalus list please go to our website www.dedalusbooks.com or write to us for a catalogue

### *Pfitz* – **Andrew Crumey**

'Rreinnstadt is a place which exists nowhere – the conception of a 18th century prince who devotes his time, and that of his subjects, to laying down on paper the architecture and street-plans of this great, yet illusory city. Its inhabitants must also be devised: artists and authors, their fictional lives and works, all concocted by different departments. When Schenck, a worker in the Cartography Office, discovers the 'existence' of Pfitz, a manservant visiting Rreinnstadt, he sets about illicitly recreating Pfitz's life. Crumey is a daring writer: using the stuff of fairy tales, he ponders the difference between fact and fiction, weaving together philosophy and fantasy to create a magical, witty novel.'

*The Sunday Times*

'Built out of fantasy, Andrew Crumey's novel stands, like the monumental museum at the centre of its imaginary city, as an edifice of erudition.'

Andrea Ashworth in *The Times Literary Supplement*

'*Pfitz* is a surprisingly warm and likeable book, a combination of intellectual high-wire act and good traditional storytelling with a population of lovers and madmen we do care about, despite their advertised fictionality. Certainly Crumey's narrative gymnastics have not affected his ability to create strong, fleshy characters, and none more fleshy, than Frau Luppen, Schenck's middle-aged landlady, a great blown rose of a woman who express her affection for her lodger by feeding him bowls of inedible stew."

Andrew Miller in *The New York Times*

£7.99   **ISBN 978 1 873982 81 5**   **164p**   **B. Format**

*The Arabian Nightmare* – **Robert Irwin**

'Robert Irwin is indeed particularly brilliant. He takes the story-within-a-story technique of the Arab storyteller a stage further, so that a tangle of dreams and imaginings becomes part of the narrative fabric. The prose is discriminating and, beauty of all beauties, the book is constantly entertaining.'

Hilary Bailey in *The Guardian*

'Robert Irwin writes beautifully and is dauntingly clever but the stunning thing about him is his originality. Robert Irwin's work, while rendered in the strictest, simplest and most elegant prose, defies definition. All that can be said is that it is a bit like a mingling of *The Thousand and One Nights* and *The Name of the Rose*. It is also magical, bizarre and frightening.'

Ruth Rendell

'. . . a classic orientalist fantasy tells the story of Balian of Norwich and his misadventures in a labyrinthine Cairo at the time of the Mamelukes. Steamy, exotic and ingenious, it is a boxes-within-boxes tale featuring such characters as Yoll, the Storyteller, Fatima the Deathly and the Father of Cats. It is a compelling meditation on reality and illusion, as well as on Arabian Nights-style storytelling. At its elusive centre lies the affliction of the Arabian Nightmare: a dream of infinite suffering that can never be remembered on waking, and might almost have happened to somebody else.'

Phil Baker in *The Sunday Times*

£6.99    **ISBN 978 1 873982 73 0    266p    B. Format**

## *Box of Dreams* – David Madsen

'An amnesiac man awakes on a train with a (but not the) Dr
Freud, is forced into women's clothes, and is taken off to a
gothic castle with mad counts and nymphomaniacs. Plot
summary doesn't really help with Madsen's curious and at
times ingenious novel. It's dreams within dreams within
dreams; but they are so relentlessly extravagant and persist-
ently onanistic that there's nary a 'pinch-me' moment.'

SB Kelly in *Scotland on Sunday*

'On reaching the castle, the plots explodes into a carniva-
lesque mystery where we meet the delectably promiscuous
Adelma and her madly patriarchal father who are supported
by all manner of grimy personae. Madsen's whimsically
grotesque characters are his strong point. As the layers of
Hendryk's experience are peeled away under the smoggy
baroque tone of the novel, an insanely off-key symphony is
produced which, despite the characters repulsiveness, moves
forward with charming ease.'

CW in *The Crack*

'David Madsen first crawled into our consciousness with his
magnificently unhygienic *Memoirs of a Gnostic Dwarf* set in
Rome at the court of Leo X. This, his third novel, is altogether
more sober in tone. But that's by Madsen's standards. We still
see a peculiarly British heartiness brought to esoteric themes
and the result – in defiance to all erotic rules – is oddly arous-
ing. This is a richly comic tale on the "Walpurgisnacht" story,
in which nothing goes right for the protagonist, and joy and
fulfilment are forever just out of reach. Brisk, bracing and
always funny.'

Murrough O'Brien in *The Independent on Sunday*

£8.99    ISBN 1 903517 22 2    205p    B. Format